KODOMO MANGA

KODOMO MANGA SUPER CUTE!

HarperCollins books may be purchased for educational, business, or sales promotional use. For information, please write: Special Markets Department, HarperCollins*Publishers*, 10 East 53rd Street, New York, NY 10022.

First published in 2009 by
Collins Design
An Imprint of HarperCollins*Publishers*
10 East 53rd Street
New York, NY 10022
Tel: (212) 207-7000
Fax: (212) 207-7654
collinsdesign@harpercollins.com
www.harpercollins.com

Distributed throughout the world by
HarperCollins*Publishers*
10 East 53rd Street
New York, NY 10022
Fax: (212) 207-7654

Editor and director of the project
Josep Mª Minguet

Art direction, text, and layout
Rubén García Cabezas
(Kamikaze Factory Studio)
for Monsa Publications

Translation
Globulart

Library of Congress Control Number 2009929190

ISBN: 978-0-06-192755-3

Printed in Spain
First Printing, 2009

Illustrations
Alicia Ruiz, Àneu Martínez, Aurora García, Belén Ortega, Bénelo Nsé, Eli Basanta, Helena Écija, Inma Ruiz, Irene Rodríguez, Miriam Álvarez, and Rosa Iglesias.

Page four artwork courtesy of Miriam Álvarez.

KODOMO MANGA SUPER CUTE!

KAMIKAZE FACTORY STUDIO

CONTENTS

INTRODUCTION

Preface
Tools and materials
Digital workshop

PREFACE

WHAT IS KODOMO MANGA?

Kodomo is a Japanese word that means "kid." However, in Japan it is also used to refer to any tale or illustration made for children, between six and twelve years of age.

Thus, kodomo manga literally means "comic or tale for kids."

Some of the best known kodomo are *Doraemon, Tamagotchi, Digimon, Hamtaro, Hello Kitty, Panda-Z* or *Pokémon.*

Kodomo mangas are published in weekly magazines such as *Coro Coro Comic* or *Comic Bonbon* (which ceased publication in 2007), to be later compiled as volumes, which are the ones collected by enthusiasts.

The plots in this type of series are appropriate for all audiences, have easy-to-follow storylines and are usually educational.
All of them are accompanied by many kinds of gifts, toys, and varied printed material.

Their animated counterparts are aired on TV on a weekly basis, and the video games based on them are distributed internationally.

It should not come as a surprise, then that it is one of the predominant styles in console games. Companies like Nintendo have taken the lead in this genre, on which they have always relied, creating sagas as popular as *Zelda,*

Super Mario, and *Kirby,* which have also spawned their respective animated series.

Their success owes much to their simple, naïve art aesthetics and easygoing attitude, which also makes them appealing to many adults. This has led to an increase of this style in other fields such as advertising, design, and fashion.

Big companies and brands like the aforementioned Nintendo, Sanrio, Bandai, Oysho (Inditex), Dodot, Vooz, and Zinkia use this style for their series, products, and advertising campaigns, due to its clean, simple, and direct appearance, which helps to reach audiences of all ages.

Western design studios and illustrators such as TADO, Meomi, Friends With You, Charuca, and Toki Doki have been influenced by the peculiar aesthetics of these productions.

There is even a very popular dressing style, called *kawaii* (Japanese word for "pretty"), that emerged from the appreciation for these kinds of creations, which has been shown in exhibitions all over the world.

TYPES OF KODOMO

Cartoons for kids comprise different graphic styles or finishes, depending on the medium chosen to develop them.

Kodomo manga
These are black and white comics, although at times they also include some pages in color. Intense strokes are used, with forced expressions and simple finishes. Color is usually applied by hand, using watercolor or technical pens; digitally colored illustrations are not uncommon.

Kodomo anime
It usually refers to the animated version of successful comic series, books, toys or video games for kids. When it is adapted for TV, shapes are polished and stylized so that animators can do their jobs more easily.

Coloring is usually flat and uses bright colors. This has been our main reference when making this book.

Design Kodomo
The drawings are highly minimalistic, with simple colors, and they use rounded shapes and thick lines. Proportions are very unrealistic, with heads the size of the rest of the body and small limbs with little detail.

They can combine different techniques and finishes depending on the medium where they will be reproduced.

Kodomo games
Illustration for both toys and video games share very similar graphic styles, using the finishes of the kodomo

anime (use of flat colors), and design kodomo (mandatory stylization of the figures and use of thick lines).

Kodomo book
Illustrated books for children are also referred to by this name, even though their style is somewhat more artistic and less commercial.

KODOMO STEP BY STEP

There are hundreds of techniques for drawing kodomo illustrations. In this book, we'll try to show the styles, themes, and finishes that are most popular and recognizable, with examples of varying difficulty and different techniques and finishes.

The key to creating a good kodomo illustration lies in simplifying, polishing the image, and working on it, so that the minimum number of elements expresses the intended idea.

Rubén García
Kamikaze Factory Studio

TOOLS AND MATERIALS

To create this book, we relied on ten professional illustrators and designers, all of them specialized in creating graphics with a manga aesthetic. We thought it would be interesting to include a brief list with the materials and tools they have used to create the exercises contained in *Kodomo Manga*.

However, it is advised to have the following items at hand when practicing with the exercises in this book: DIN-A4/Letter/Legal paper sheets (at least 80 gr/m2), mechanical pencils with blue or black leads to draw sketches, Staedtler eraser, technical/Rotring pens for the inking process, scanner, colored pencils, and image-editing and illustration software such as Adobe Photoshop CS3 and Illustrator CS3 (or later).

Alicia Ruiz
Mechanical pencil, lead (0.5 mm 2B). Inking done with Copic Multiliners, Neopiko or Staedtler markers (0.05 mm). Digital coloring applied using a Wacom tablet with Corel-Photo Paint 9, final touches with Adobe Photoshop.

Àneu Martínez
DIN-A4 paper (80 gr/m2 or heavier), black HB pencil, Staedtler erasers and Faber-Castell Knetgummi Art Eraser. Digital inking and coloring done with Adobe Illustrator CS3.

Aurora García
Mechanical pen with 0.5 mm HB Faber-Castell lead. Inking with black Sakura Micron 0.3 marker. Digital coloring with a Wacom Intuos 2 tablet, Adobe Photoshop CS, and Open Canvas 4.

Belén Ortega
DIN-A3 paper sheets, blue pencil, 2H and 2B pencils, mechanical pencil with 0.5 mm leads. Inking with Staedler technical pens. Digital coloring done with a Genius tablet and Adobe Photoshop CS.

Bénelo Nsé
Koh-I-Noor Hardtmuth 1500 pencils (H, 2B, 4B, HB), Koh I-Noor Soft Eraser Round 70. Digital inking and coloring with Adobe Illustrator CS3.

Eli Basanta
Gvarro sketching paper (297x420 mm), onionskin paper, mechanical pencil with 0.5 mm lead (2H and HB). Inking with UniPin technical pens 0.05, 0.1, 0.2 and 0.4. Digital coloring with a Wacom Graphire 3 tablet and Adobe Photoshop CS3.

Helena Écija
Gvarro sketchbook, HB pencil. Inking and coloring with a Wacom Graphire 3 tablet and Adobe Photoshop CS3.

Inma Ruiz
100 gr/m2 DIN-A4 paper sheets, mechanical pen, 0.5 mm blue lead. Inking with Neopiko multiliners (0.03, 0.05 and 0.1 millimeters). Digital coloring with a Wacom Bamboo tablet and Adobe Photoshop CS2.

Irene Rodríguez
Navigator paper (DIN-A4 sheets, 90 gr/m2), blue Faber-Castell pencil, Pentel mechanical pencil (0.3, 0.5 and 0.7mm lead). Inking with technical pens: Sakura 0.05 mm, Staedtler 0.2 mm, Artline 0.3 mm, Deleter 0.5 mm. Coloring by hand with Plastidecor crayons and wooden pencils (Caran D'ache, Conté, Cedro, Rolan, and Alpino). Digital coloring with a Wacom Graphire 4 tablet and Adobe Photoshop CS3.

Miriam Álvarez
DIN-A4 paper sheets, HB pencil, Staedtler eraser. Digital inking and coloring with Adobe Photoshop CS3.

Rosa Iglesias
3D Studio Max 2009 and Adobe Photoshop CS3.

DIGITAL WORKSHOP

Today it is a must for any illustrator to have at least a basic understanding of image digitizing. Since all of the exercises were done or retouched with Adobe Photoshop CS3, we will focus on this software program, in this introduction as well as in the rest of the exercises.

SCANNING

A good scan is the most essential element to start the process. If we start with a black and white image, we will import the drawing as a gray scale image; this will speed up the scanning process.

Scanning resolution must be set at least to 300 dpi, although all the exercises in this book were scanned at 600 dpi to have an image of greater quality and resolution.

If we scan the drawing as a pure black and white bitmap, the resolution should be at least 1200 dpi.

Once we have the line drawing on our computer, we will clean it so that there is sufficient contrast between black and white areas.

Going to the Image menu, inside the Settings item there is a submenu: Levels and Curves will help us tweak the image to reach the desired appearance.

Once our image is ready, we will use the Image menu again and change the Mode to CMYK, since we are working on an image for printing, thus needing an image with four channels for each ink. If you would rather start working in RGB mode and then change the image to CMYK, be warned that colors may vary.

If we scan a drawing that has been colored by hand, it will be in RGB mode and darker than our original. The first thing is changing it to CMYK mode and tweaking it with the tools Levels, Curves, and Channels. It is also important to have our computer screen well adjusted and calibrated.

DIGITAL COLORING

Our line is displayed as the Background layer in the Layers pane, which means it is locked. We unlock it by double-clicking on it, thus making it Layer 0. Starting from here, we can create new layers in which we add color to the drawing.

In a standard coloring process, these layers are set to a Blending mode of Multiply or Darken. This way, color overlays the black line drawing as if the white parts were transparent.

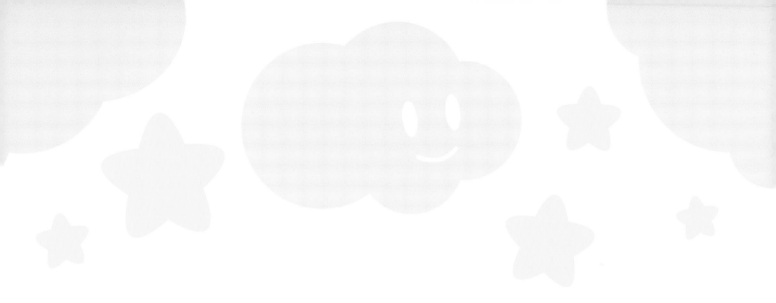

There are other ways of doing it, but this is the simplest, fastest, and most efficient one. To apply digital color, different tools from the Toolbar can be used.

Marquees, Lasso, Brushes, Fills (Paint Bucket and Gradient) – any method is fine if we use different layers and remember how blending modes work.

The effects achieved by using the different Blending modes can prove very useful to applying overlaid gradients, creating outlines with strokes on the outside, shadows, highlights and many more. It is advisable, though, not to overuse this type of resource or the finish can come out as too cold and digital.

The use of overlaid textures is an interesting option to give a more traditional feel to the coloring.

Lastly, we must point out that graphic tablets are not mandatory for the coloring process; however it is true that, once mastered, they speed up the process and allow us to work with brushes in a much more comprehensive manner.

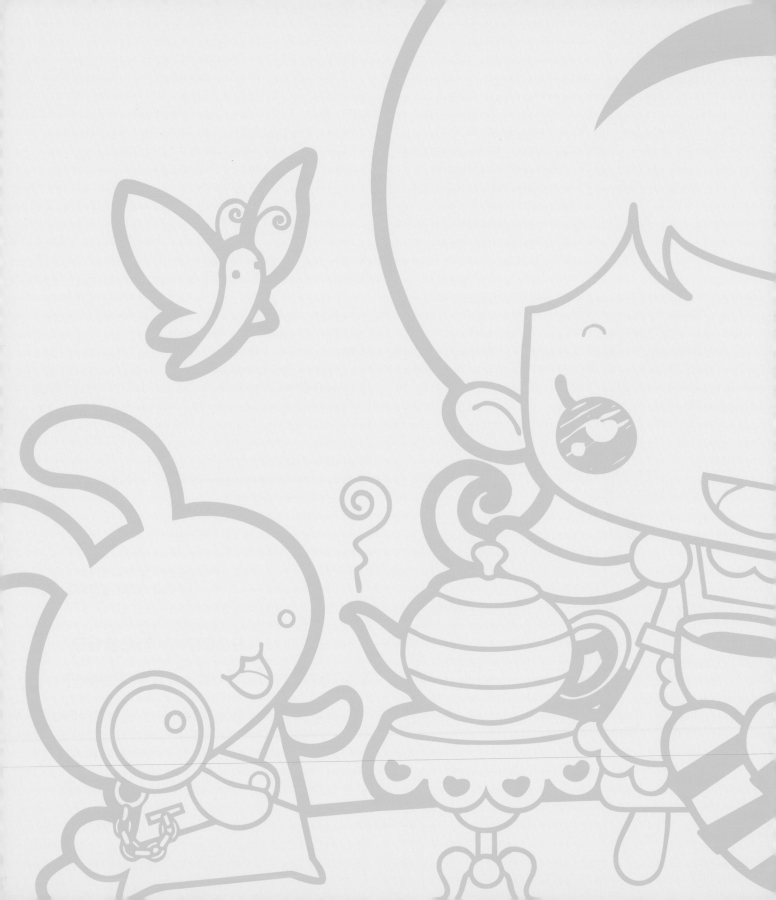

Fables

SLEEPING BEAUTY

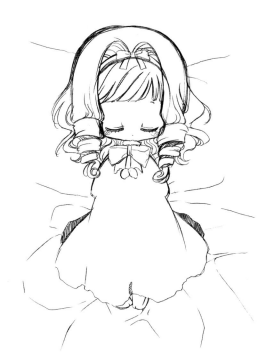

Choosing only one scene from this classic tale is a difficult task, so we decided to use one which had some fairies in it. For the picture's aesthetics, we wanted to make them look like little dolls.

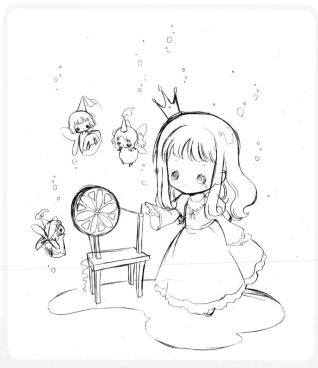

1. Sketches

The image of Sleeping Beauty on the bed seemed too sinister and the prince that can be seen in the other sketch overshadowed her presence. In the end, we went for the scene with the spindle that would prick her finger, which has a magical overtone and allows for a more accentuated use of lighting and highlights.

2. Outlining

The characters' structure is very simple, so we will also include the spindle to start defining the final composition of the scene.

3. Volume

When we draw the spindle, we have to consider the perspective so that it adds depth to the image. The fairies are outlined with an oval for the head and a body with the shape of a rounded rectangle, with one of its sides tilted.

4. Anatomy

The size of the princess' body is three times that of her head. The pose is very simple as we still try to make her look more like a toy than a realistic-looking girl. The fairies are like small stars and have very little detail.

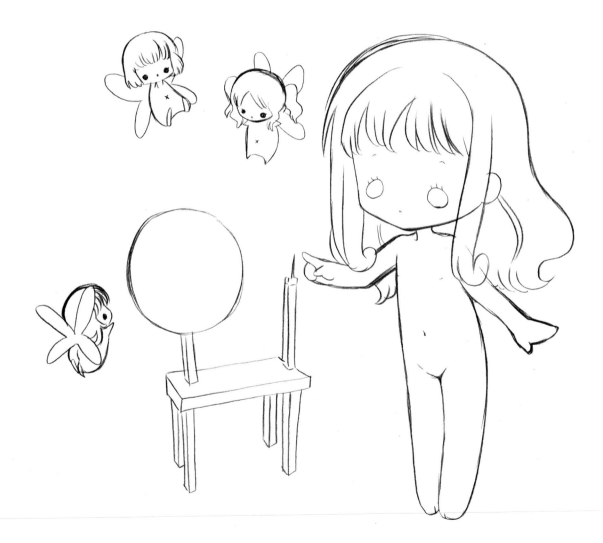

5. Details

The detail of the small crown lets us know that we are before a little princess. Her dress is wide and full of embroidery, to make it stand out. The distaff in the spindle has a design akin to that of the stained windows that can be seen in a cathedral.

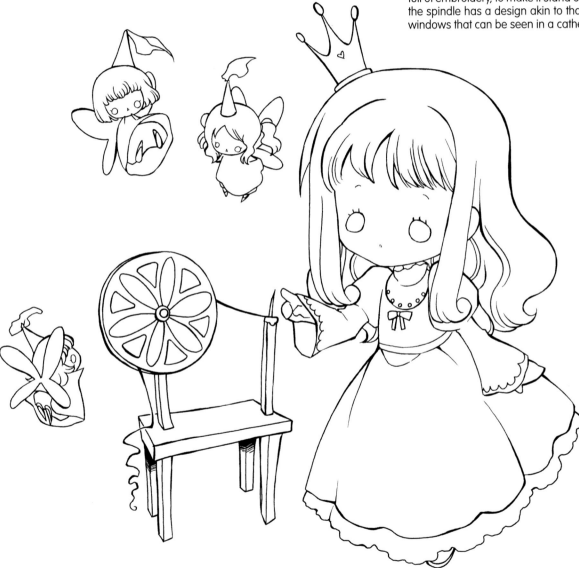

6. Inking and lighting

The white highlights, the blue sparkles in the background, and the light emitted by the fairies all evoke the magic of the moment depicted in the scene. The shadow, which looks much less gentle, foresees the tragic ending to this scene.

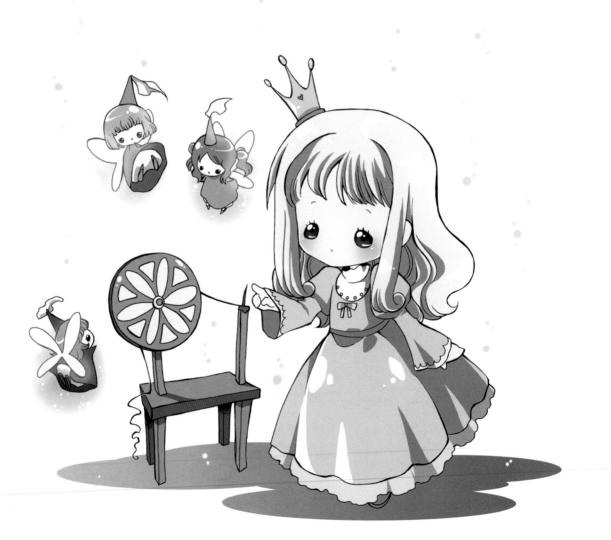

7.1. Color

The coloring of this scene is very simple, with pastel tones and finished with white highlights that make the drawing stand out.

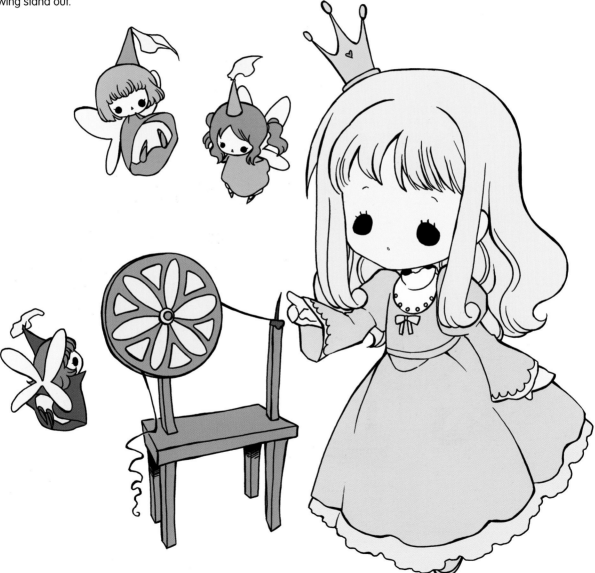

7.2. Color

The fairies closer to the princess have complementary colors to each other; the third fairy is colored using lavender – the complementary color of yellow, which is the prevailing color in the illustration and is the color of the princess' hair.

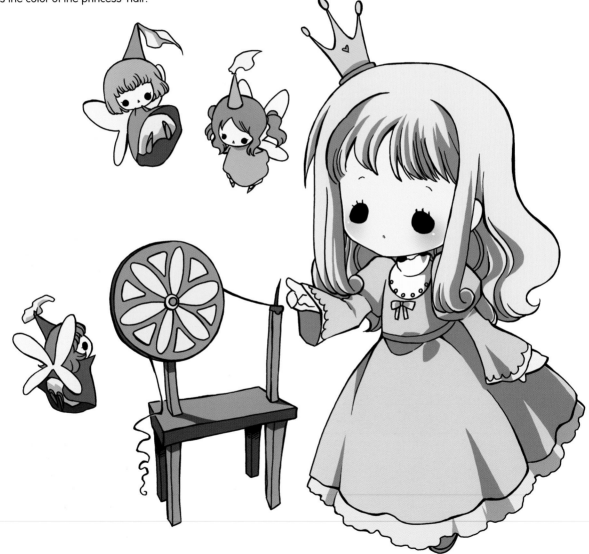

7.3. Color

We add the sheen to the eyes and the hair in the
fairies and the princess.

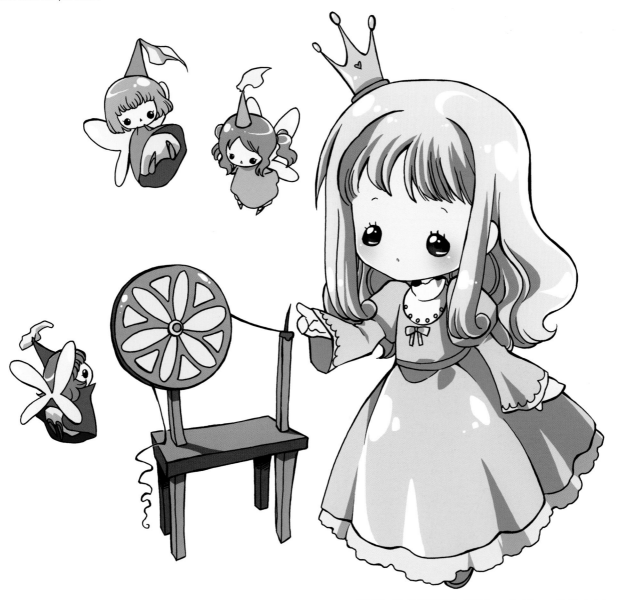

Finishing touches

Tips & tricks

- The eyes are not completely dark; they have a slight blue tint, but the plastic look is really achieved with the highlights we add at the end of the process.

- We create the cheeks with a stroke from the airbrush tool, and we add white highlights over them to prevent the color from looking homogeneous.

- Except for these details and the white highlights, the skin has a flat color, without shadows or half tones, contrary to the rest of the picture.

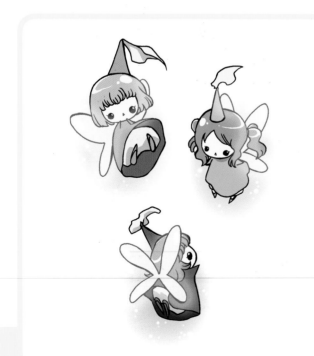

- A stroke with the airbrush tool applied on a layer with low opacity creates the shiny effect on the fairies. To finish it, we create another layer and paint some white spots with the brush.

- The blue sparkles in the background can be blurred slightly using the Smudge tool.

- Lastly, we define the shadow with the Lasso tool and fill it with a color gradient.

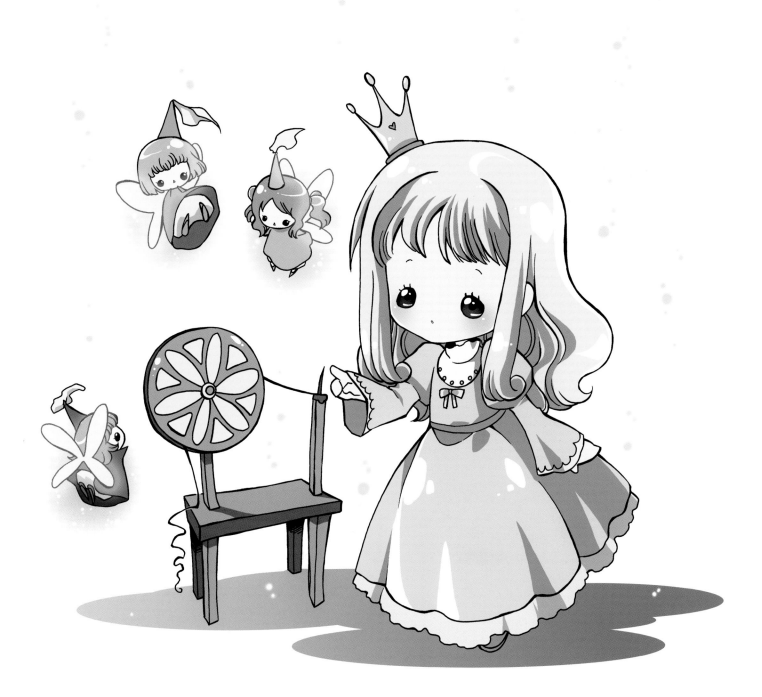

PIRATE OF THE CARIBBEAN

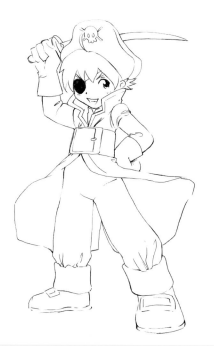

Sailing across the sea is not an easy task, much less so for young sailors. In this exercise we will portray a pirate boy who sails the South Seas in search of treasure and adventure, a young pirate who fears nothing.

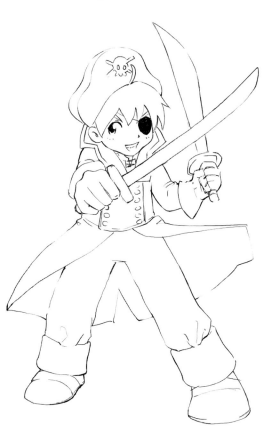

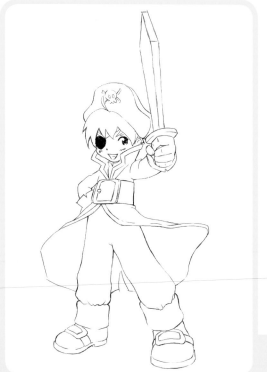

1. Sketches

In this drawing, the small pirate adopts a triumphant pose, with his wooden sword raised as a sign of victory. The other two sketches will be discarded because they were too aggressive and unrelated to the image we wanted to convey.

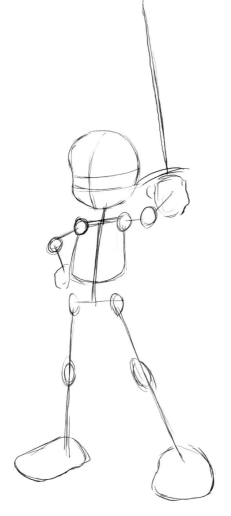

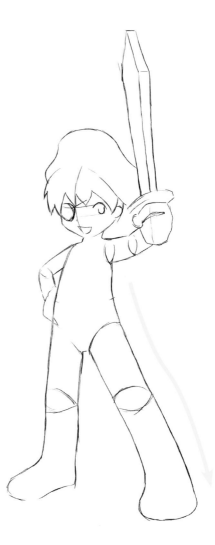

2. Outlining

The character appears standing straight; we add dynamism to the pose, having him raise his fist so it is foreshortened, and place his right foot slightly forward.

3. Volume

We leave a slight curvature on the right side of the torso, just where it meets the leg.

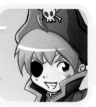

4. Anatomy

We finish refining the body's structure, adding detail to the hands and facial features. The face must have a triumphant look. The body measures five heads in length, and we have made the feet bigger to simulate a low angle shot.

In order to create the hand, we start from an oval, which we divide in four lines to mark the fingers. The foreshortened right arm can prove somewhat difficult for beginners.

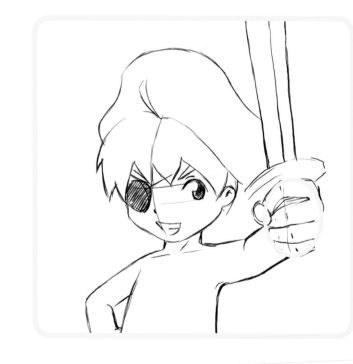

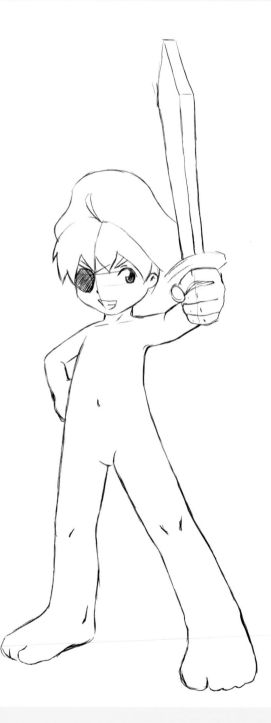

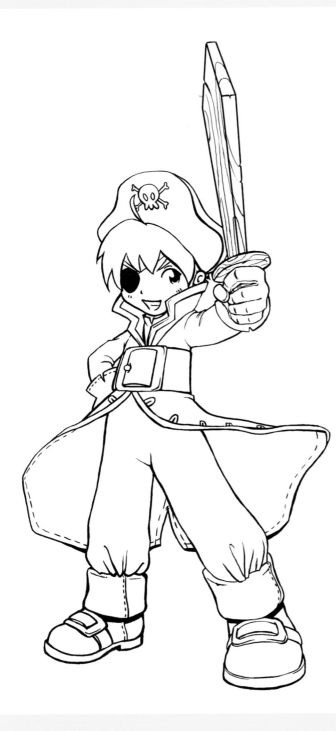

5. Details

The outfit is that of a corsair, albeit slightly exaggerated. We increased the size of the belt and the boots, and the sword is made out of wood. To emphasize the pose, the jacket is open, as if the wind were blowing towards him. To simulate the cracks along the wooden sword, we use curves with different widths.

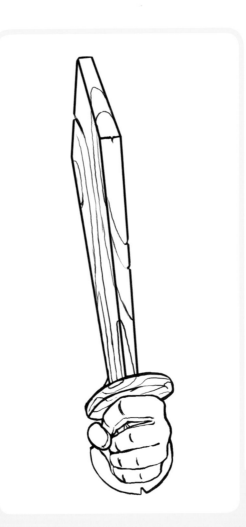

6. Inking and lighting

Lines are tinged thick, with very strong shadows. The sunlight, which lights the pirate's head, creates a strong contrast between tones and casts a shadow behind the character, overlaying the ship's wooden deck.

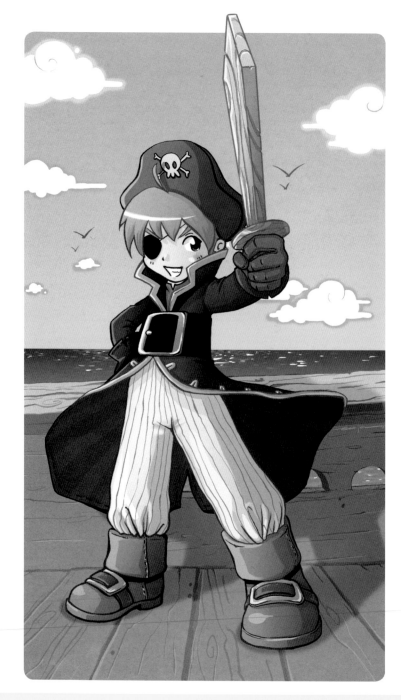

7.1. Color

We use warm gradients as the base for most of the character, with small touches of green and dark blue that complement the figure. We have colored parts of the line drawing, creating a new layer with a Layer Mask so the color only affects the inked line drawing.

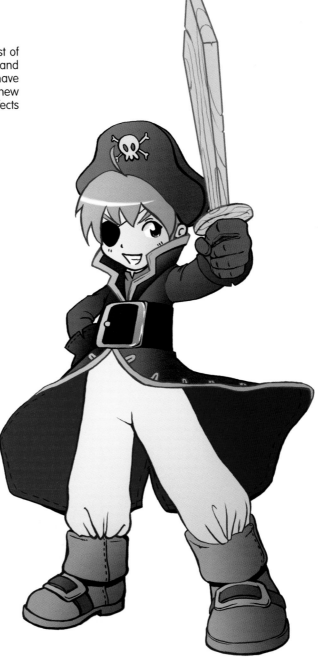

7.2. Color

It is time for the shadows and to finish coloring the sword. Since we had used gradients before, the transition to the darker tones becomes softer and more realistic.

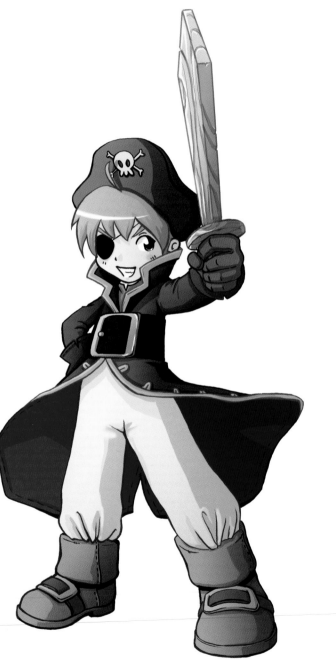

7.3. Color

We finish coloring the character by applying the highlights and some additional details such as the inside of the coat and the stripes on the pantaloons. Now we can start working on the background.

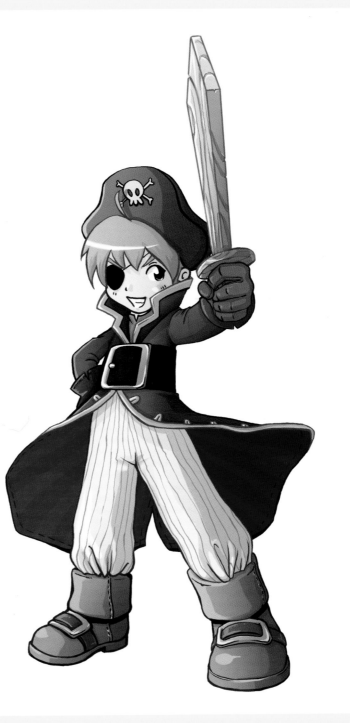

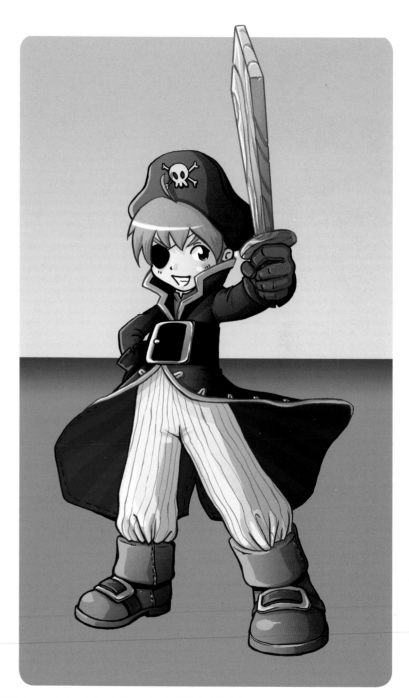

8.1. Background

We emphasize the horizon with two gradients: one for the sky, the other for the sea. The sky gradient is more homogeneous and the sea's is darker near the line that separates both. This way we have a greater sense of depth.

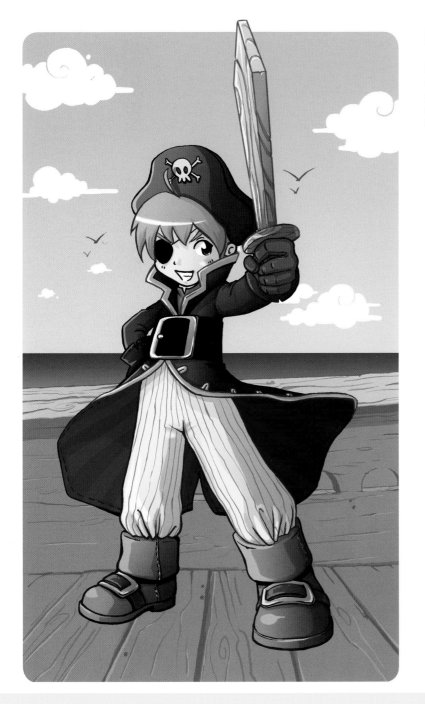

8.2. Background

We add a portion of the deck – completely made of wood – and clouds in the background, which help place the character in the scene. The coloring style and finishes of the wooden deck are the same as the ones used for the sword.

Finishing touches

Tips & tricks

- To depict ancient costumes and items faithfully, it is a good idea to research and create your own version based on real-life images.

- Making the line drawing colored in some areas enhances the realism of the objects in the illustration.

- An easy way of integrating a character with the background is to make use of the shadows cast on him.

- We create the pirate's shadow by adding a layer with its blending mode set to Multiply and paste the deck with a layer mask in the shape of the shadow.

- We give the clouds more definition by creating a bluish outline around them.

- As a last step, we apply some white and blue strokes to depict the waves and sea foam.

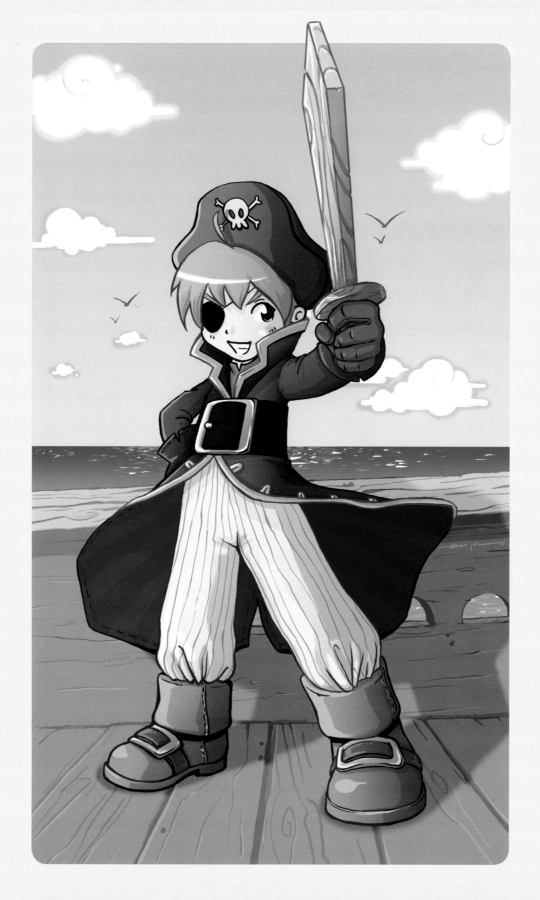

LITTLE RED RIDING HOOD

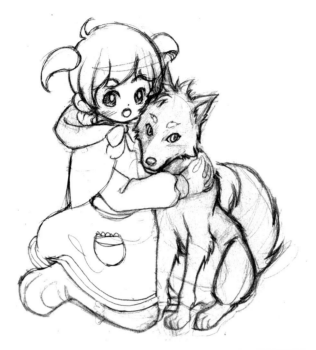

Little Red Riding Hood has turned the Big Bad Wolf into her little pet. Now she has nothing to fear, so she walks happily to her Granny's house carrying her basketful of goodies.

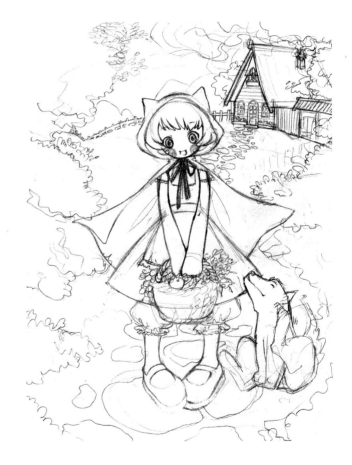

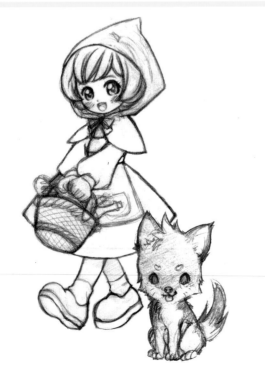

1. Sketches

We use the background of one of the sketches, but the childish look of this Little Red Riding Hood is more convincing.

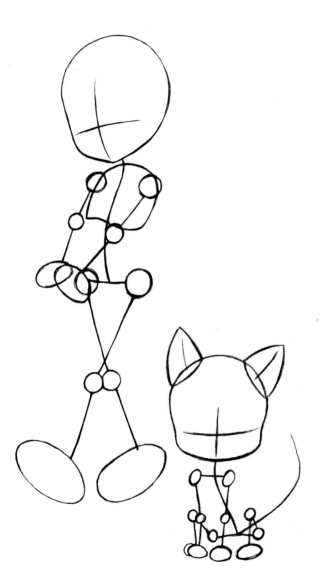

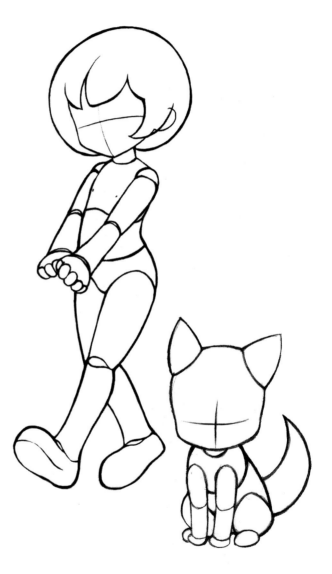

2. Outlining

We tilt the head a bit and curve the spine to stress the idea that she is taking a stroll without the slightest sign of fear.

3. Volume

The pose on the Little Bad Wolf cub can be somewhat complicated if you are not used to drawing animals, but starting with simple shapes will make the process much easier.

4. Anatomy

The look on the eyes and mouth of Little Red Riding Hood are most important in this illustration. They show happiness and innocence. The body is the size of four and a half heads, which makes her look much younger.

As a counterpoint, the Little Bad Wolf has a much more playful and mischievous expression.

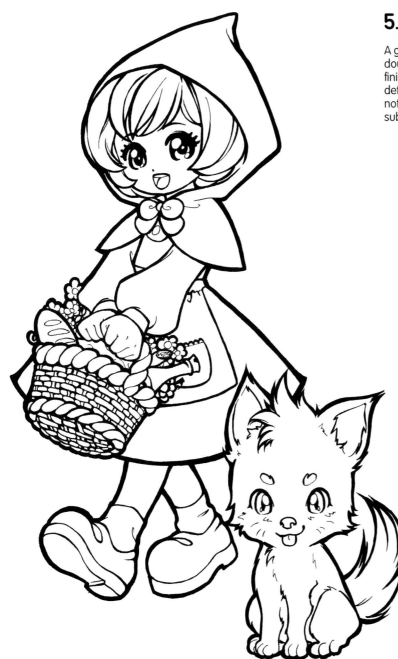

5.1. Details

A gorgeous hood and a rural-looking dress leave no doubt that she really is Little Red Riding Hood. The finishes on the costume are simple, without much detail or wrinkles. We cleaned up the image so it will not look too busy when we add the background in subsequent steps.

5.2. Details

Then we draw an almost finished version of the background and place the characters on it.

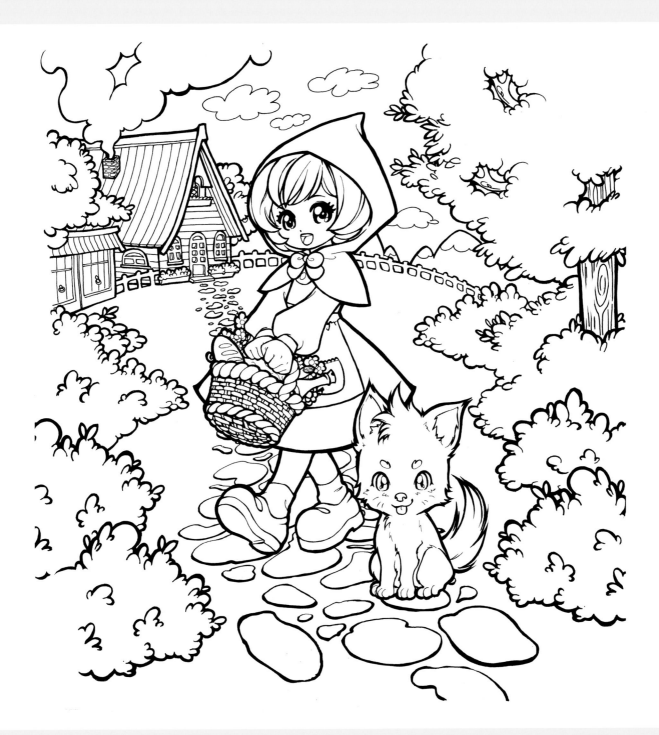

6. Inking and lighting

Although the character is very innocent, we draw it using a thick line, especially for the outer contour. This helps detach the characters from the background. We created several light sources to get a brighter finish.

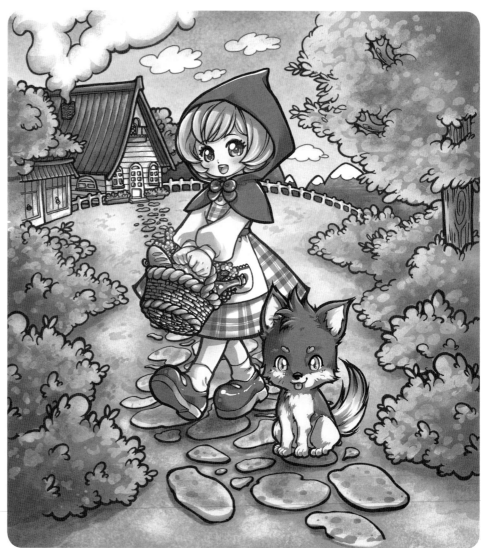

7.1. Color

The base coloring is made up of both flat colors and gradients. The dress has a pattern that imitates cloth.

The Little Bad Wolf has gentle color transitions between different areas; small gradients follow the shapes created by its fur.

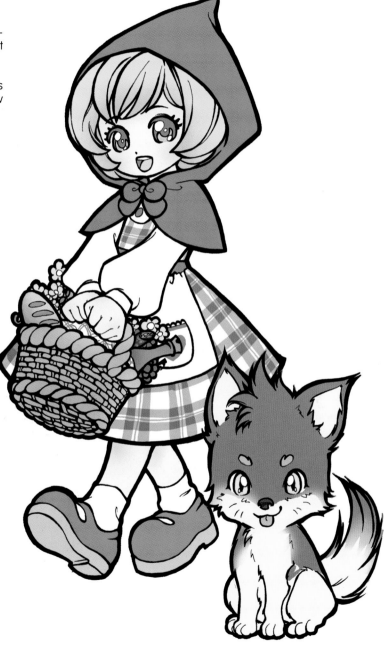

7.2. Color

For the shadows we keep alternating gradients and flat colors, and define lit areas. When applying color to the Wolf, we keep the reference of its fur to add darker shades. We added a black-blue gradient to the pupil.

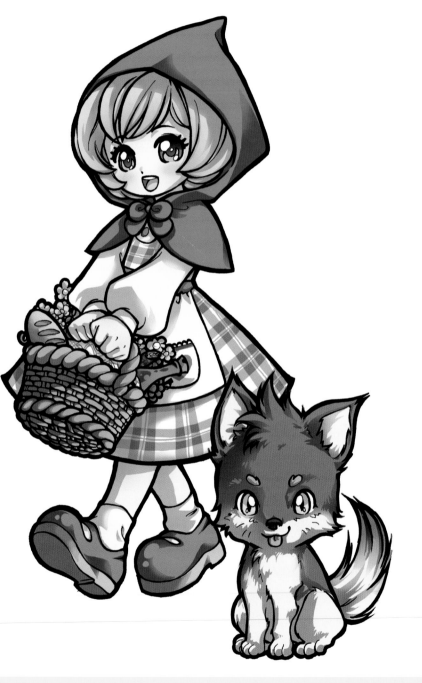

7.3. Color

We include highlights on the costume, the hair and the basket, as we had already defined the color through the use of gradients. The following steps will involve working on the background.

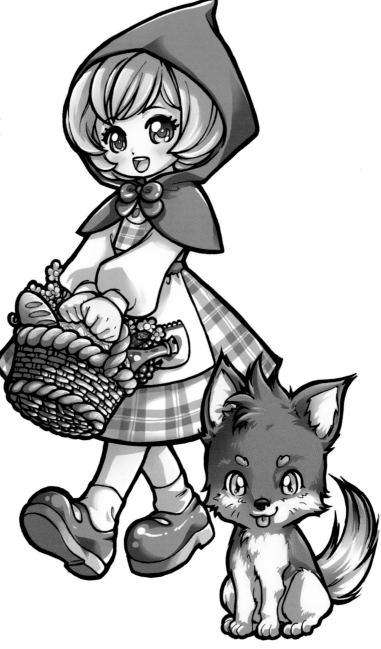

8. Background

Here we highlight the greenish shades in the background and the red roof, a complementary shade to green. Gradually we add the points of light and shade.

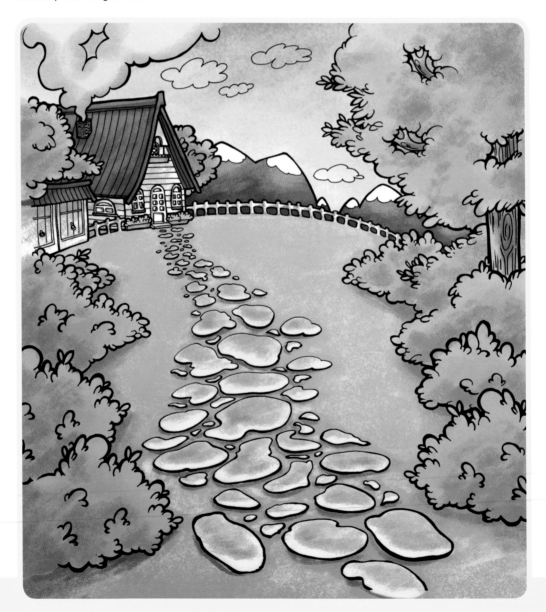

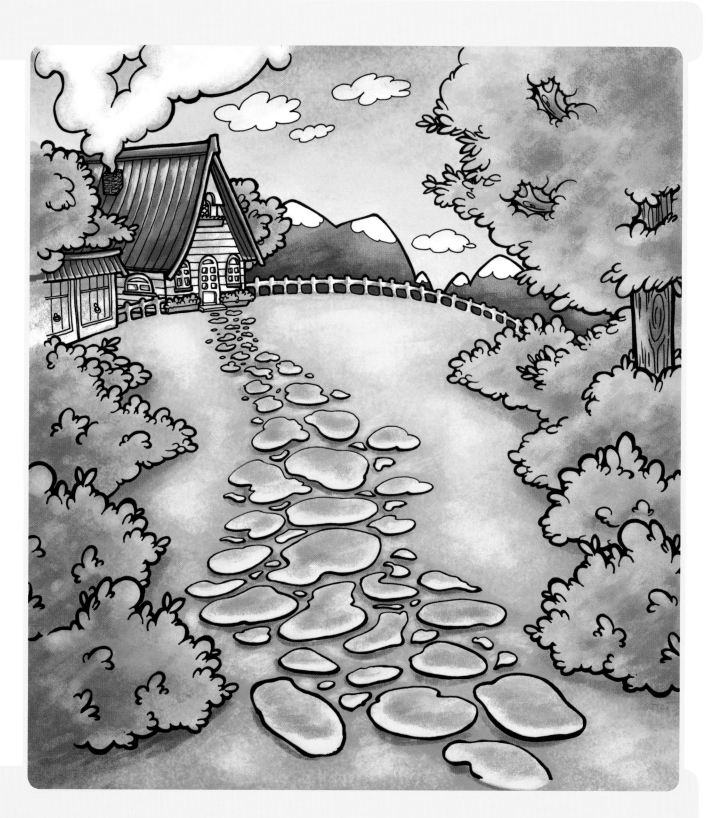

Finishing touches

Tips & tricks

- We have used gradients in this drawing to create a soft transition between areas of light and shadow and to add volume to the objects. The easiest way to create such localized effects is to create selections with the Lasso tool and then fill them in on another layer using the Gradient tool.

- There are many patterns and textures we can use to recreate some elements in a realistic manner. But they have to be well fitted to the object we are working on using the Transform option, if we want the result to be convincing.

- We insert Little Red Riding Hood and Little Bad Wolf over the colored background.

- We add shadows to finish the color details in the background, especially underneath the characters, to make them look perfectly integrated in the illustration.

- The last step is to apply some areas of a colored line drawing to the background using a new layer.

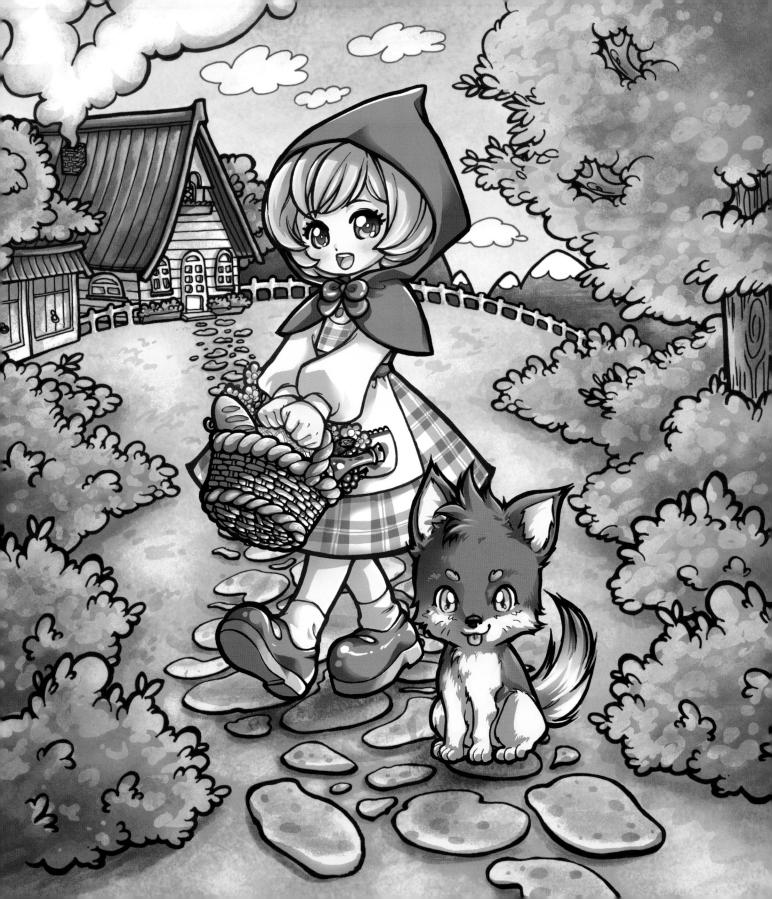

ALICE

Wonderland has many places to play and Alice is willing to have a great time with all of its wacky inhabitants. In this illustration we will use a composition and drawing style similar to that of Japanese stickers.

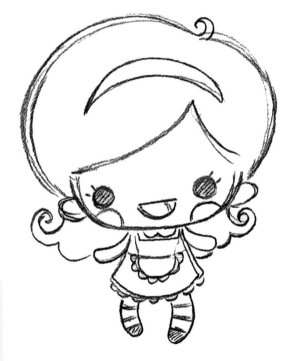

1. Sketches

This teatime scene lets us bring many of the characters in the book, such as the caterpillar (now turned into a butterfly), the cat with the mysterious smile, the mad hatter, and the white rabbit.

2. Outlining

The oval that constitutes the head is flattened to make it easier for us to create the type of head we are drawing.

3. Volume

We still want to go for the puppet-like look, to convey a feeling of innocence.

3. Details

The characters in the book already have very well-defined costumes, so we cannot deviate too much from the original design, although we can simplify or stylize it.

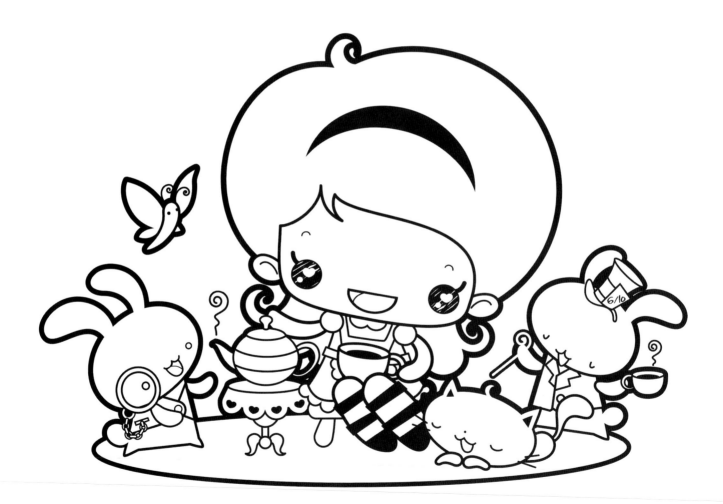

4. Inking and lighting

The line drawing and the subsequent coloring have
been done with a vector drawing program, although
we can still use different line widths.

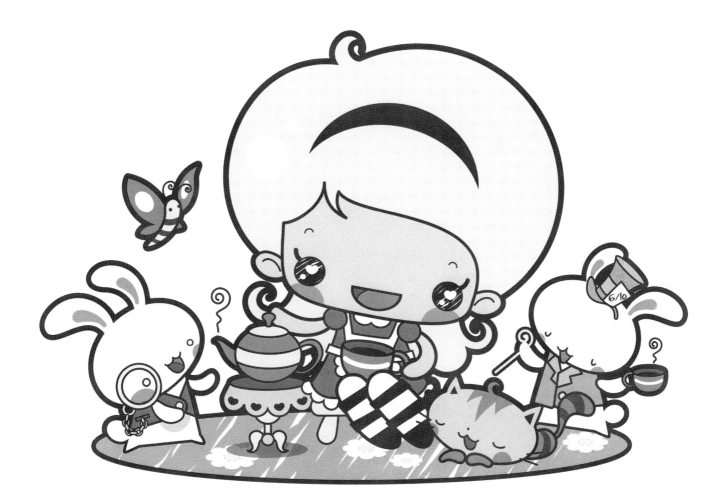

5.1. Color

We use colors with a low saturation and only five basic tones: blue, yellow, pink (light and pure), and green. The coloring is flat, without shadows.

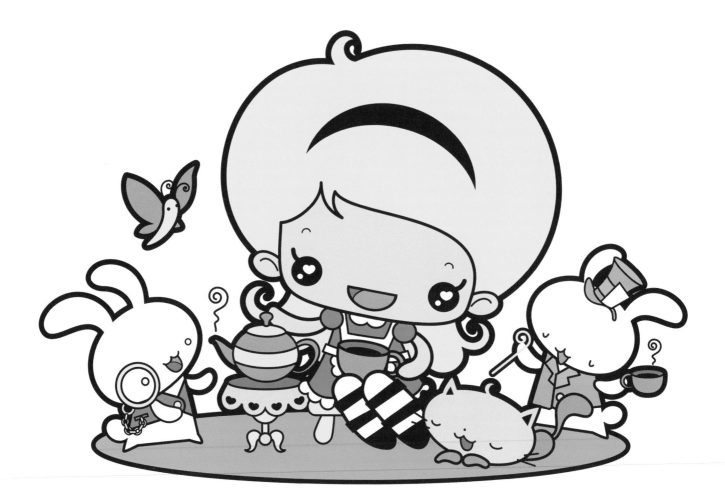

5.2. Color

We add several other details, such as the blush on Alice's cheeks, the white lines on the cups, the cat's stripes, the inside of the bunnies' ears, the flowers on the ground, the wings on the butterfly, etc.

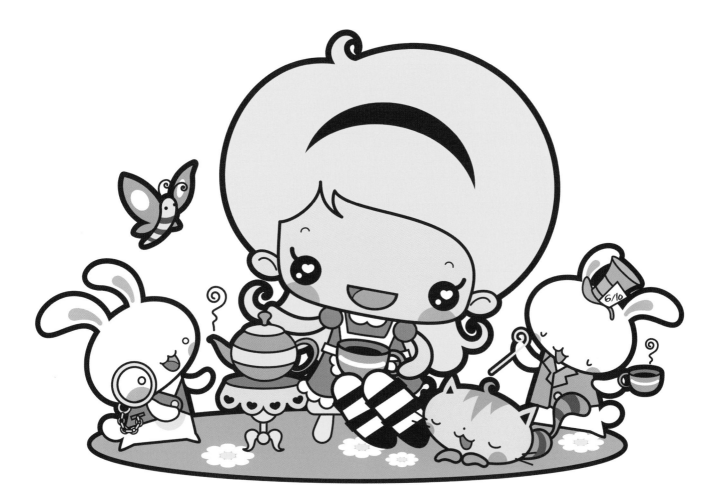

Finishing touches

Tips & tricks

- The inking of the outer contour line is usually thicker than the others.

- We added some detail to the eyes, such as white strokes and hearts, which make Alice look even sweeter.

- Working with a vector drawing program allows us to use more perfect and precise geometric shapes which can be enlarged as much as you want without losing quality.

- As you can see by the diagram below, we employed a triangular composition that groups all the characters as if they were all on a sticker, except for the butterfly.

- We give the line drawing a dark brown color.

- We draw some lines in the grass and a couple of highlights in the hair.

- We then apply several subtle white touches to give the ground and the hair more texture.

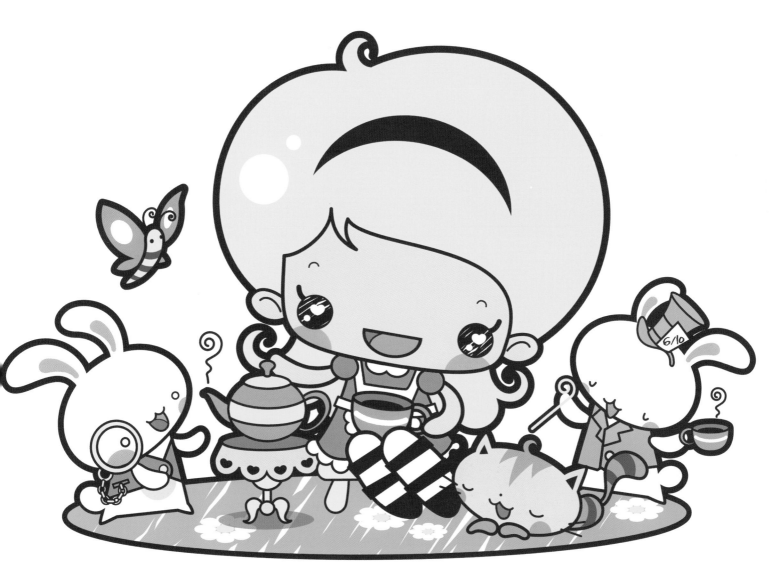

SNOW WHITE

Our first sketches of Snow White just before biting into the poisoned apple had an innocent look to them, but she looked too much like Sleeping Beauty that we had drawn before. That is why, as we did more sketches, the young princess became increasingly Gothic and dark.

1. Sketches

In the end we choose an intermediate look. The drawing style reminds us of the one used by Pop and alternative Japanese artists, without losing the essence of commercial manga. The fawn's design takes us back to the beginnings of manga, having a more classical look.

2. Outlining

What is most complex about this drawing is the fawn's structure and finding the right size for the head. Once this has been solved, the rest of the process will be much easier.

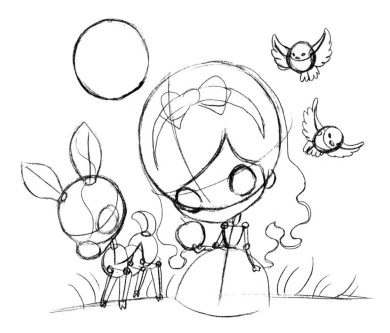

3. Volume

We sketch the hair and add some details in the background. We include the eyes, which will be defined in the next step, and we finish the design for the fawn.

4. Details

As with many popular and classic tales, the general public already has an image of the way fairy tale princesses should look: a small bow in the hair, a corset and a traditional bell-shaped skirt.

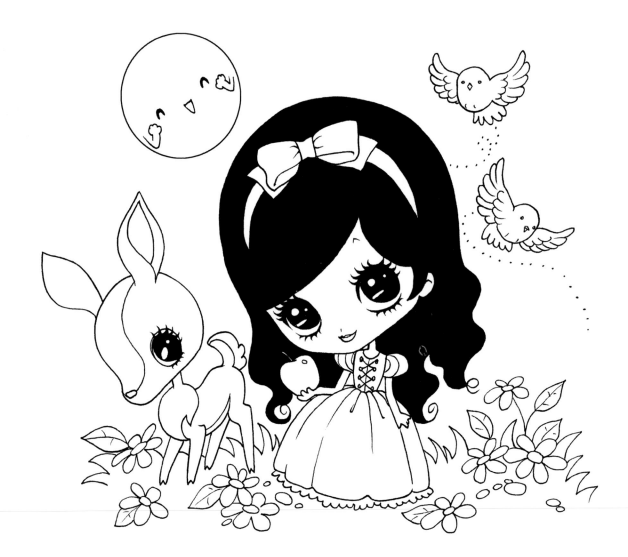

5. Inking and lighting

To prevent ending with a backlit scene because the sun is positioned behind the characters, we imagine that there is a strong light source in front of the scene.

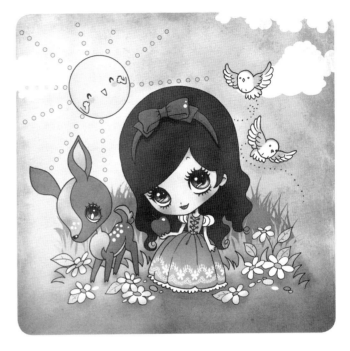

6.1. Color

The prevailing tones are red and blue, but during the illustration process they will evolve and become richer with the addition of shadows, gradients, highlights and textures, so in the end colors will be yellowish.

6.2. Color

Once the light and dark areas have been defined on the basis of the smooth flat colors, texture is then applied to the surface.

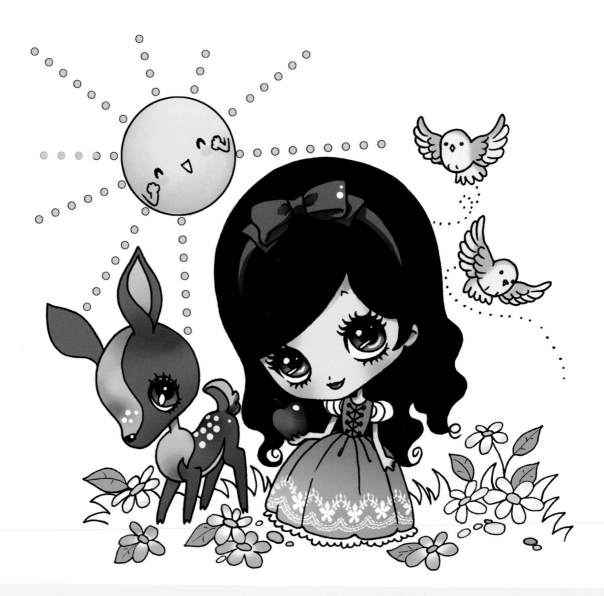

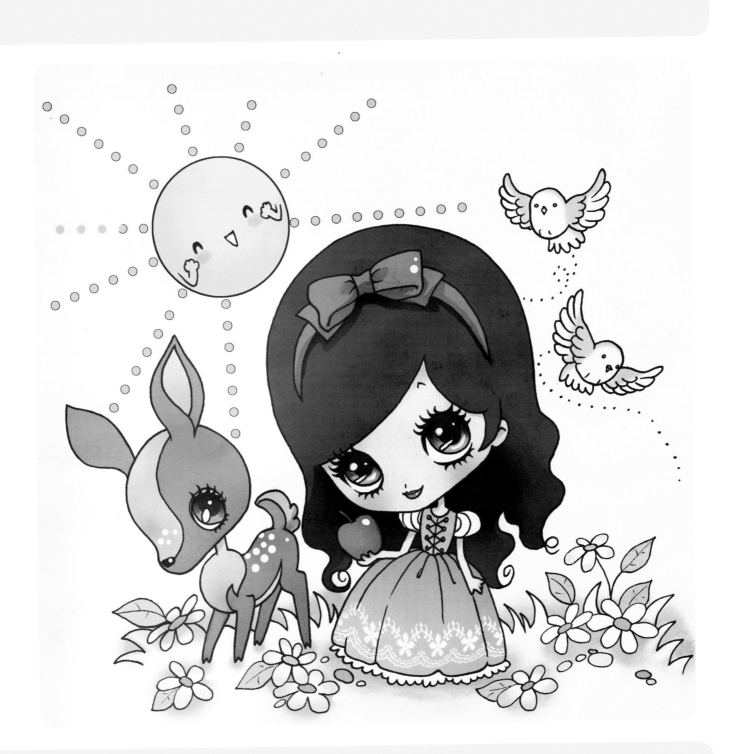

Finishing touches

Tips & tricks

- When applying texture, the whole drawing gains more brightness, volume, detail and nuances; of course we will need to start out with a good color base.

- The upper part of the pupil is a recurring feature of manga illustrations. Since we employed a slightly alternative coloring, we will keep some aspects of Japanese drawings.

- Even though we brighten some areas of her black hair, her eyelashes are kept dark to accentuate the look.

- To achieve the aged paper look, we apply the same duplicated texture using a Linear Light blending mode. One of them maintains all the original stains, and we blur the other one just to use its tones.

- We draw clouds on the background applying white strokes, and the rest of the grass using grass-shaped brushes. We also add some shadows under the characters.

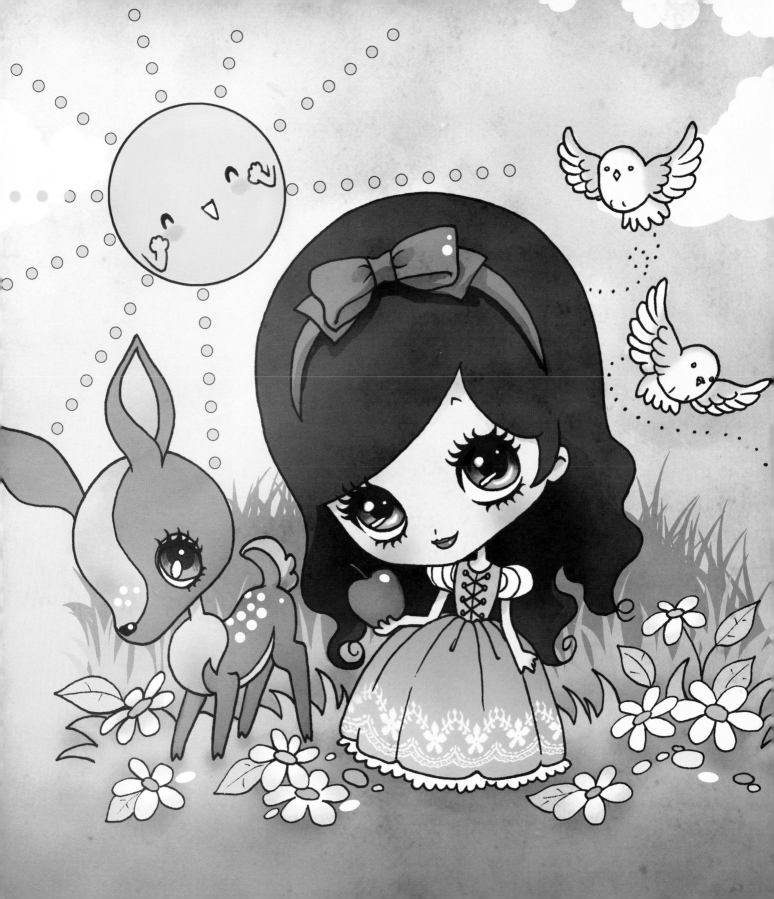

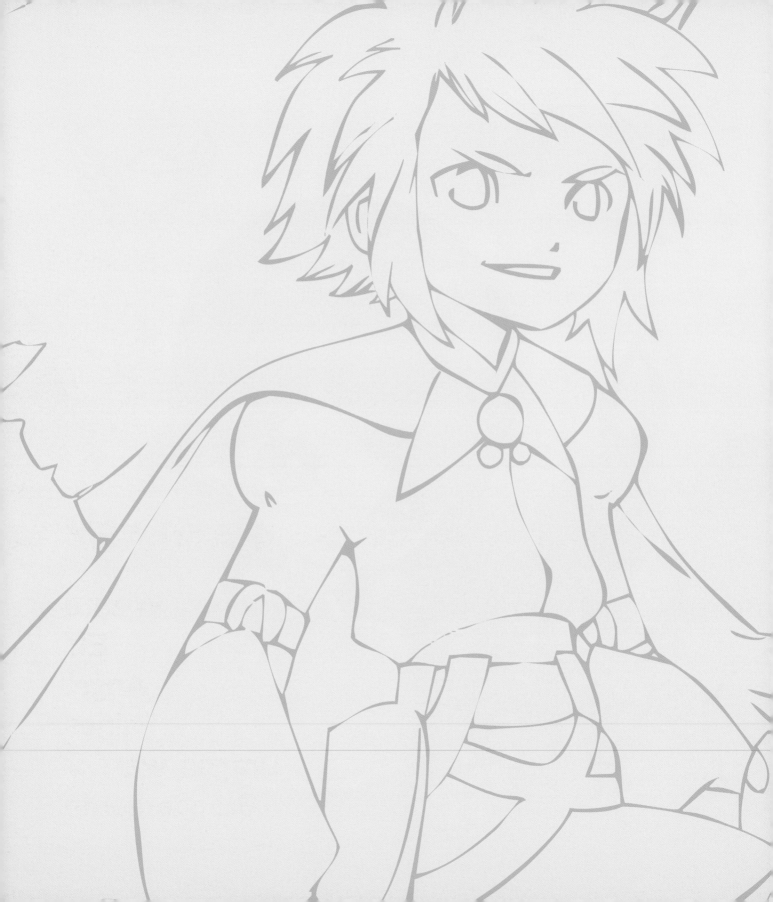

FANTASY

Wizard
Elf
Angel
Fairies
Dragon warrior
Orange sprite

WIZARD

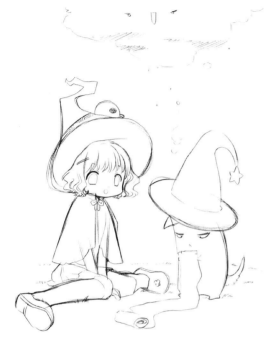

Magic is a constant feature in the Japanese set. Schools for magicians are an inexhaustible source of outlandish personalities, entertaining tales, and fantastic creatures. In this exercise we are going to recreate a scene in which a young apprentice magician is demonstrating her powers, but with a somewhat more Western feel to it.

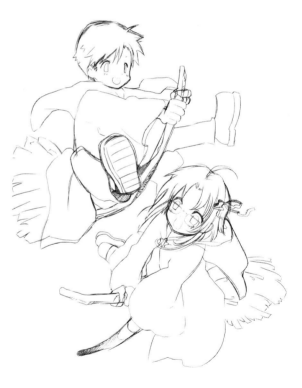

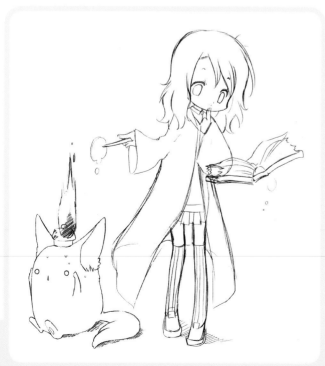

1. Sketches

This is a more entertaining and dynamic scene with the young apprentice trying out her muddled spells while burning her mascot's cap at the same time.

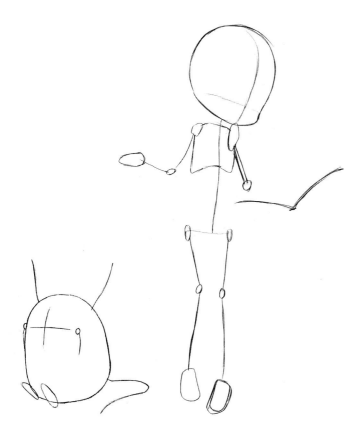

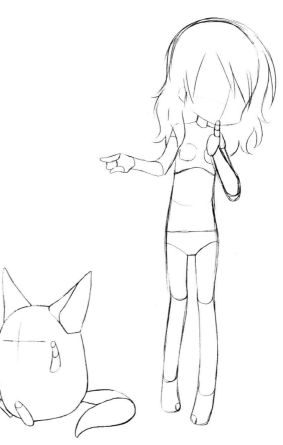

2. Outlining

The girl has a rather sinuous figure.

3. Volume

The female magician's relaxed and curvy shape serves to accentuate her absentminded approach.

4. Anatomy

We have styled the body to be able to coordinate in the next step with the size of the cloak. The expression on the face of the mascot is rather foolish while the girl remains permanently absorbed in a world of her own.

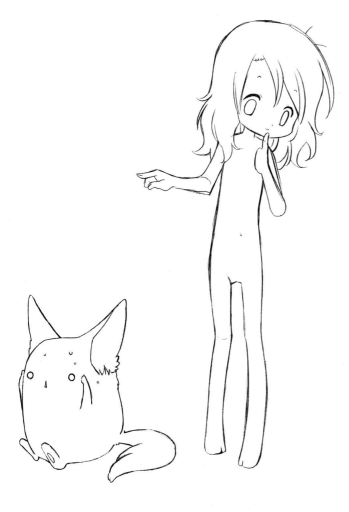

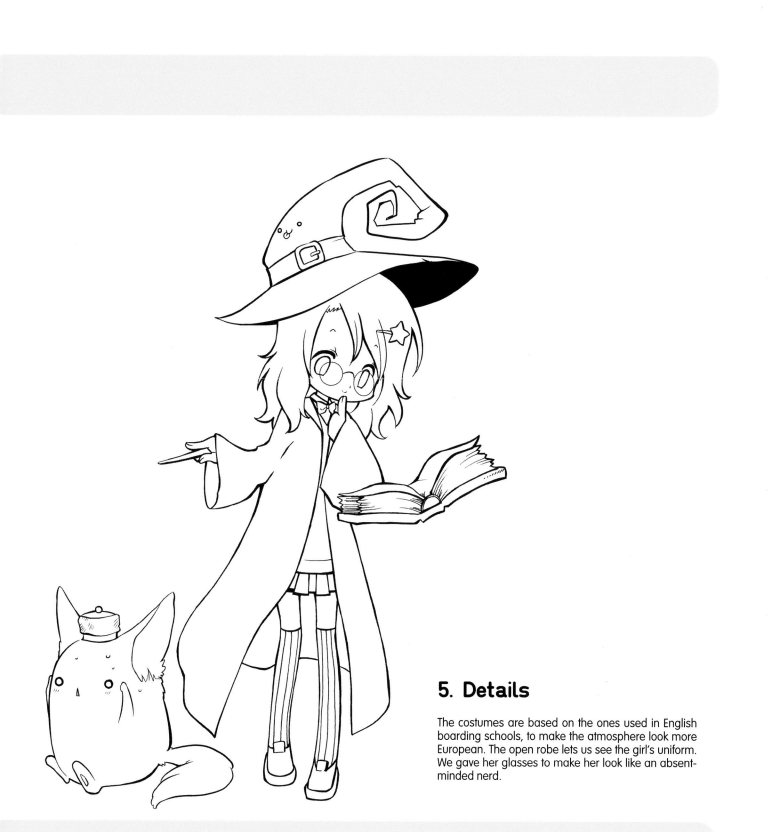

5. Details

The costumes are based on the ones used in English boarding schools, to make the atmosphere look more European. The open robe lets us see the girl's uniform. We gave her glasses to make her look like an absent-minded nerd.

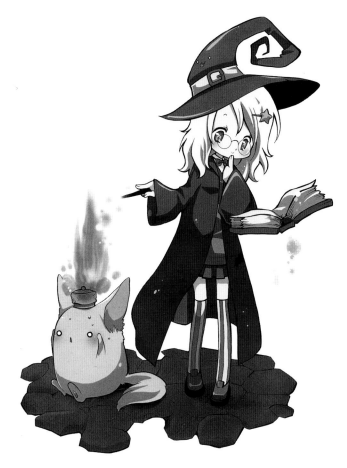

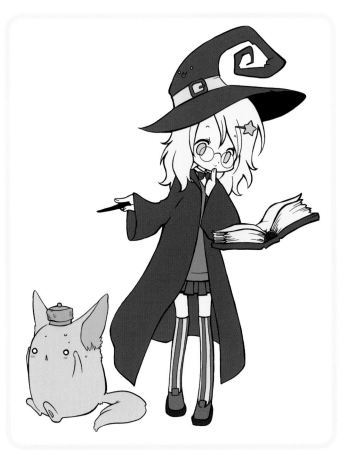

6. Inking and lighting

Black tones are very strong and enhance the brighter tones in the rest of the drawing. The line mimics this with thicker lines in the areas of shadow.

7.1. Color

We start the coloring with the base colors. The most prominent ones are blue, maroon, green, and yellow. Iterating colors allows us to unify the final result and make it look more homogeneous.

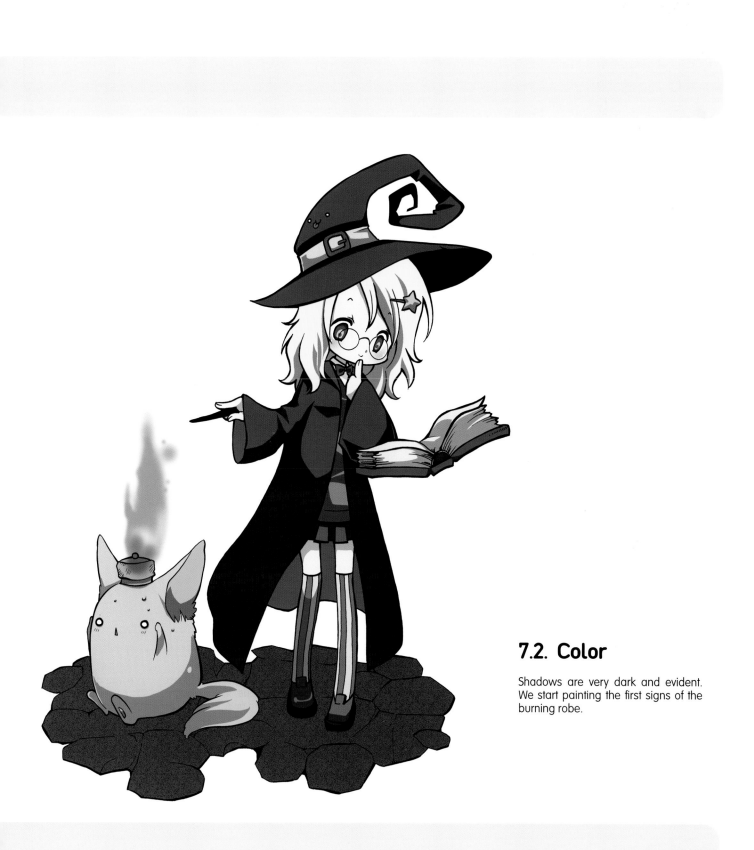

7.2. Color

Shadows are very dark and evident. We start painting the first signs of the burning robe.

7.3. Color

We add the floor, apply the shadow over it and paint more flames.

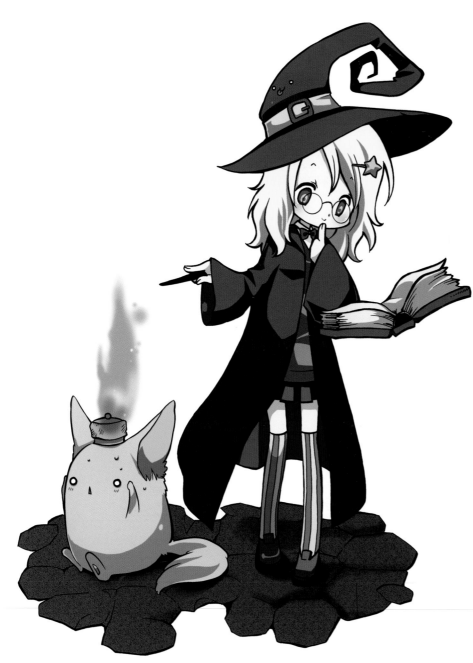

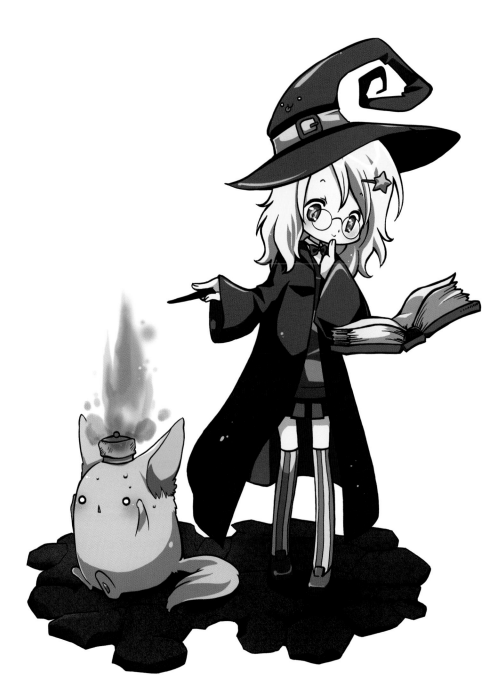

7.4. Color

Now we apply the highlights and gradients and use brighter brush strokes to define the flame.

Finishing touches

Tips & tricks

- Recreating a fire digitally and realistically is a complicated task, so we go for a more magical appearance.

- The contrast of the characters, who were colored with simple and flat tones, and the detailed background – with gradients and textures – is perfect for a balanced illustration.

- Gradients are useful to light precise areas with greater realism.

- We finalize the fire on the cap, adding the last strokes and final tweaks.

- We draw colorful sparkles near the wand and around the book to simulate the effect of the magic spell.

- We make some parts of the floor brighter so that it will not look so dark.

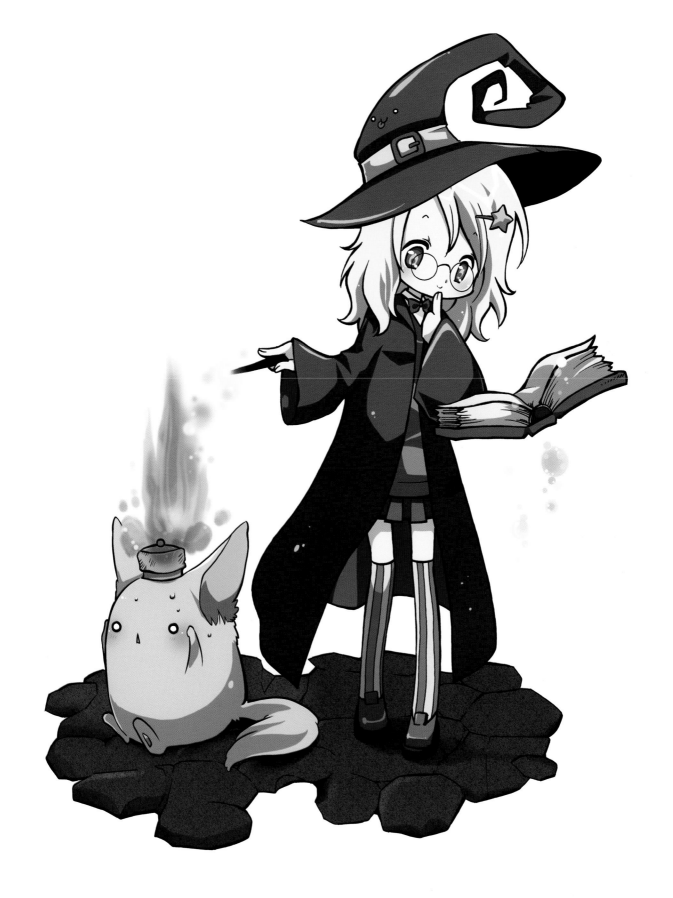

ELF

This little elf tries hard to learn all the secrets of preparing potions, but sometimes things can go wrong. We try different situations in which the elf has trouble with magic potions.

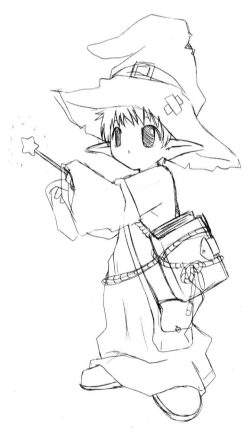

1. Sketches

We thought that an unpleasant surprise would add to the thrill of the scene. Our poor elf does not know what he has gotten into.

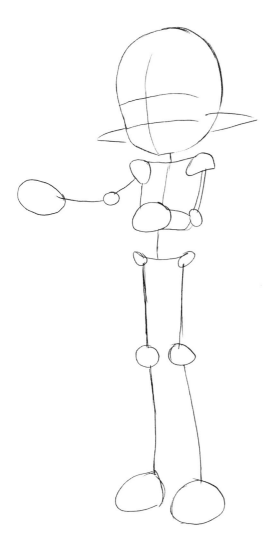

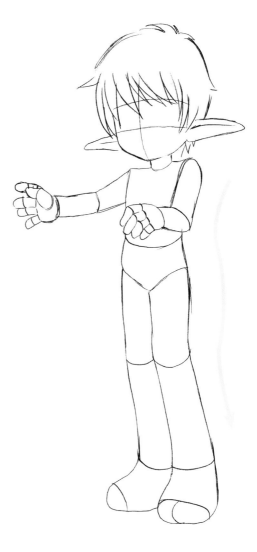

2. Outlining

We define the axis for the hips and mark the foreshortened position for the arms.

3. Volume

The right leg is slightly bent, which means that the outer line of the torso will have a wavy aspect.

4. Anatomy

We add detail to the elf's hands, as well as the hair and ears. We draw the eyes wide open, leaving enough separation between the pupils and the eyelashes, and we add a number of parallel diagonal lines to indicate surprise.

5. Details

The design of his outfit is based on the legends set in a fantastic medieval world, full of stories of heroic fantasy. The untidy look, with some rips and even a patch on the hat, give the elf a clumsy look.

6. Inking and lighting

The illustration has a gloomy atmosphere, as the scene takes place inside a cave. Light comes from the glow produced when the flask was opened.

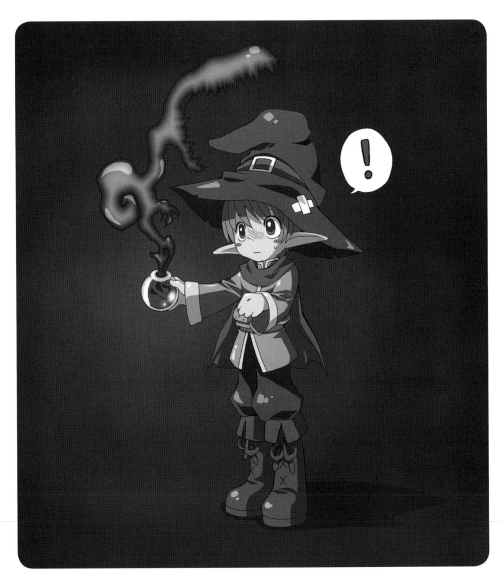

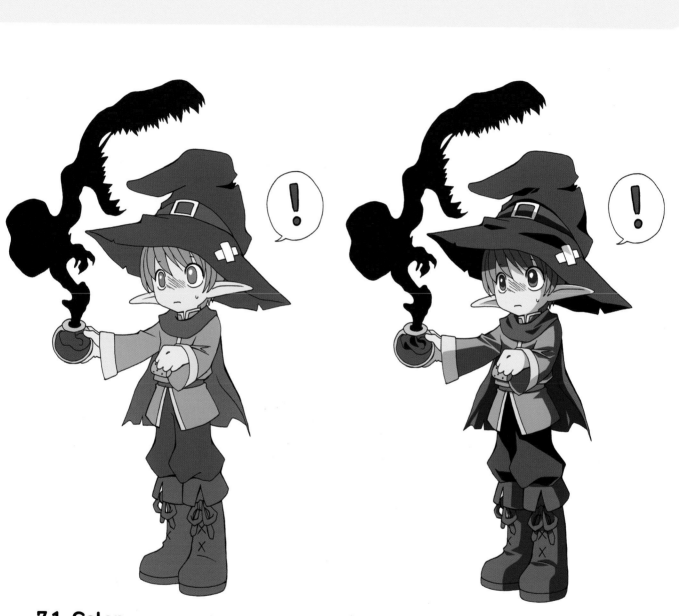

7.1. Color

We begin the coloring process using a flat color base with a predominance of green and earth-like tones.

7.2. Color

The shadows on the character are also painted using flat colors.

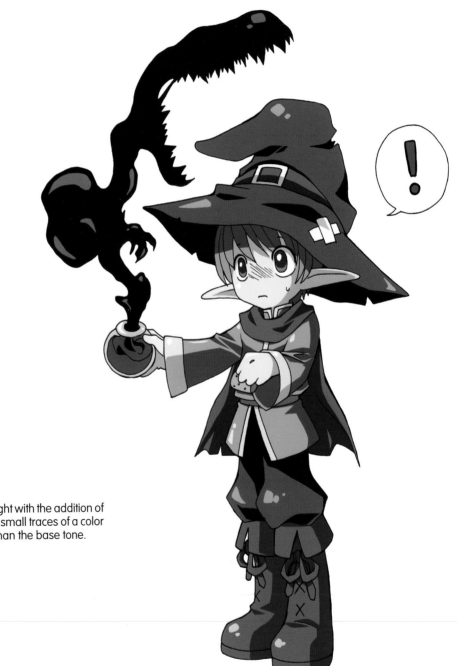

7.3. Color

We bring a touch of light with the addition of highlights, which are small traces of a color somewhat brighter than the base tone.

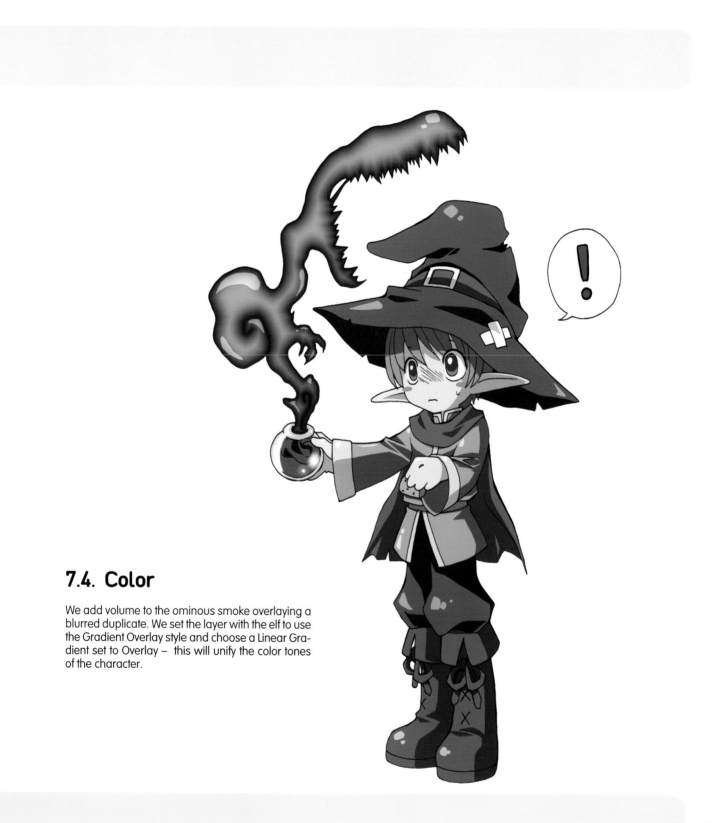

7.4. Color

We add volume to the ominous smoke overlaying a blurred duplicate. We set the layer with the elf to use the Gradient Overlay style and choose a Linear Gradient set to Overlay – this will unify the color tones of the character.

Finishing touches

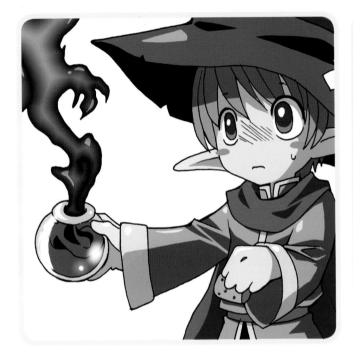

Tips & tricks

- This time we forgo any white highlights, as we are dealing with an indoor scene.

- In order to emphasize the scene's dark atmosphere, we go for the darker tones. Brighter ones are the exception here.

- The look on the elf's face has to convey a sense of concern.

- We finish the illustration with a burgundy-colored background to which we apply a radial gradient centered on the flask to simulate the light source.

- We also add a fiber texture and a Noise filter to the background.

- Finally, we draw the shadow projected by the elf's silhouette on the ground.

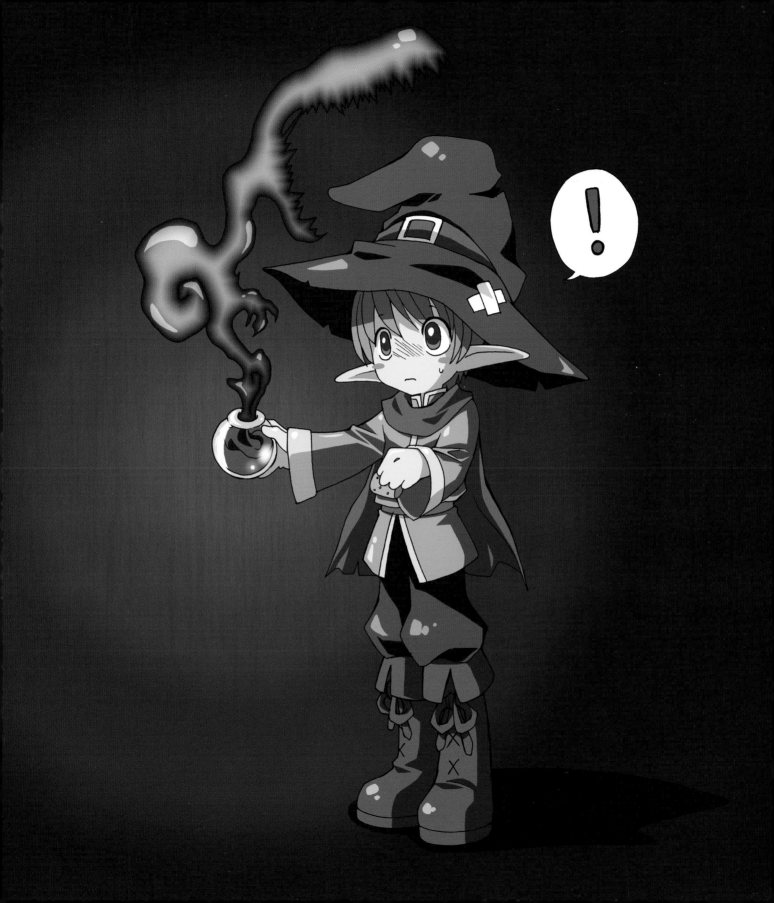

ANGEL

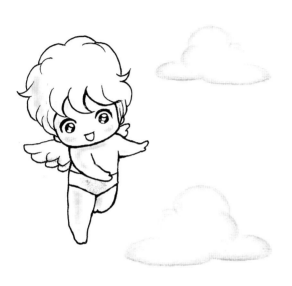

The Western tradition is plagued with stories in which the leading role is played by beautiful celestial beings protecting human beings and guiding their feelings. We have proposed a more infantile version characterized by the classic cherubs created by Renaissance artists.

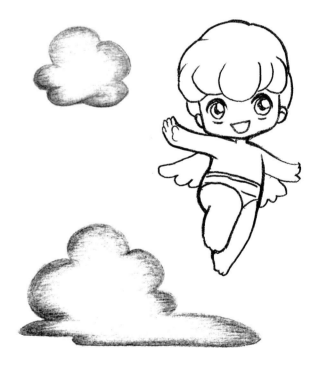

1. Sketches

We have selected this triangular composition in which the cherub is seen to be emerging from between the clouds.

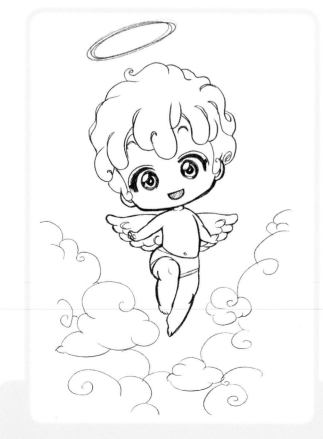

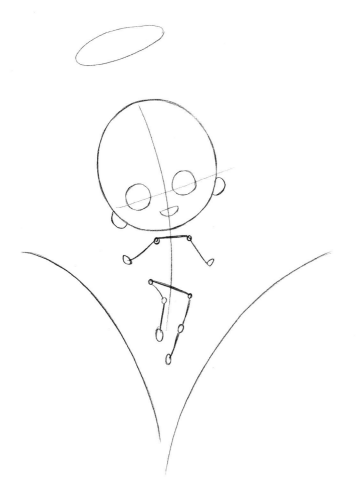

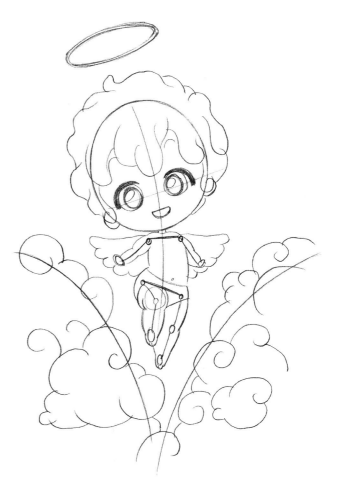

2. Outlining

The central theme is defined by the curve created by the sensation of the cherub leaping with its head slightly inclined to the left.

3. Volume

Once the elements are in place, we can proceed to add the details both to the central character and the surrounding clouds. It's vital for both the wings and the clouds to have a light, fluffy appearance.

4. Details

We clean the line as we buff up and add some final details to the hair, the pants, and the wings. Based on this pencil drawing we will trace the colored version on to a new sheet.

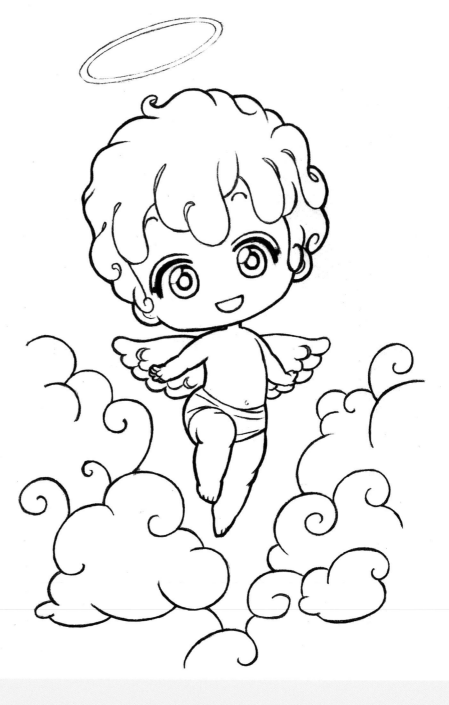

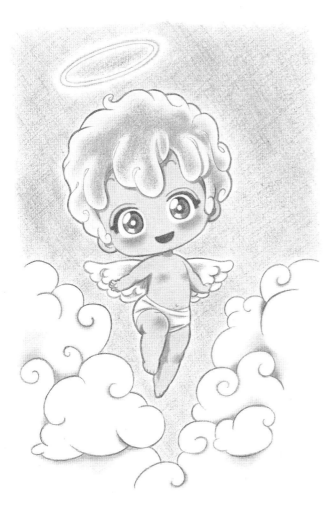

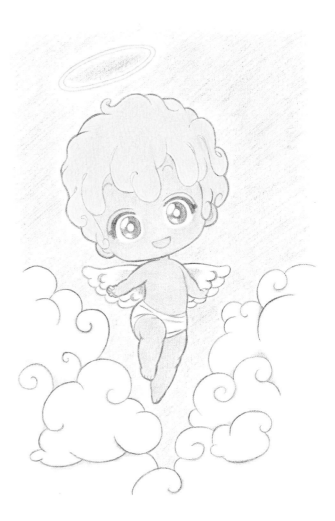

5. Inking and lighting

The slight margin we leave just on the outside border of the hair adds volume to the cherub's curls, simulating the way in which light falls on cylindrical shapes.

6. Color

We go over the contour lines which make up the cherub with a sepia colored pencil and proceed to color the rest with colored pencils. We use pastel shades and a very soft first layer: yellow, blue, and flesh-colored shades. Later we will apply the shadows, facial shades, and fine details with darker shades. We use the same sepia shades for the clouds, but toned down.

Finishing touches

Tips & tricks

- The white areas serve to enhance and balance the final image. When we are coloring, its not necessary to color in absolutely all,, the most fundamental aspect is achieving a fine balance.

- By using the Adjustment options from the Image menu we can correct and make alterations to the colors as we wish. For example, after scanning our cherub it appeared darker, but we managed to recover the original brighter shades digitally.

- Colored pencils are a useful technique for those beginning to color, as these are easy to manage. Also useful for finishes are the pastel shades.

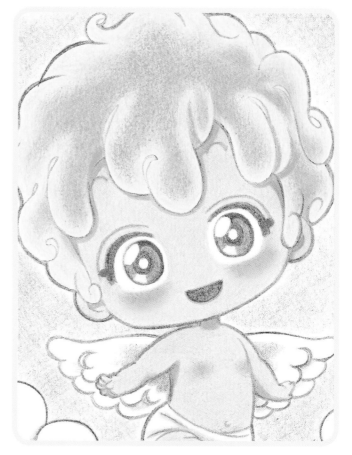

- We slightly soften the sepia shade on the clouds by rubbing with the finger or with the help of a paper blending stump.

- The subtly blended shades give the image a more natural appearance and greater volume, with greater detail, even though we use only a few shades.

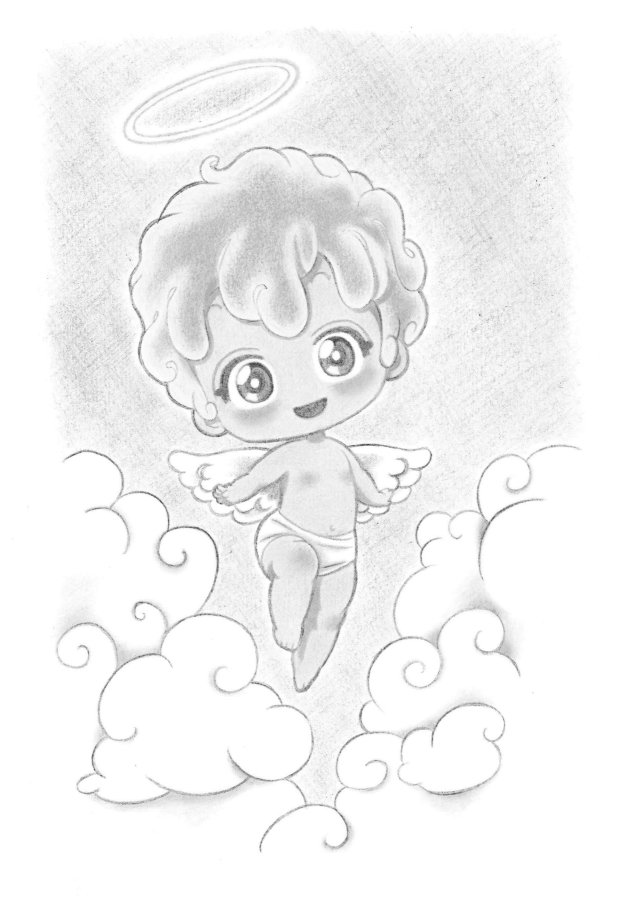

FAIRIES

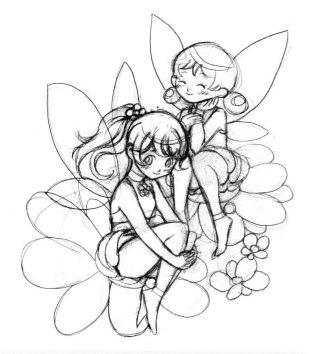

The little flower fairies have fun flying around among the shrubbery in the forest. Happy, they play for hours on end. Only when it gets dark do they rest, placidly hidden among plant stalks.

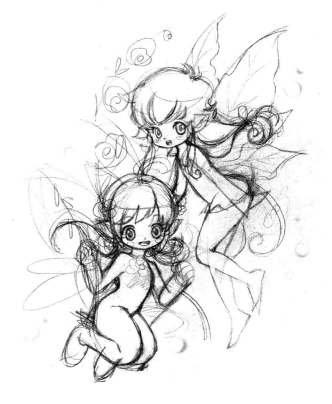

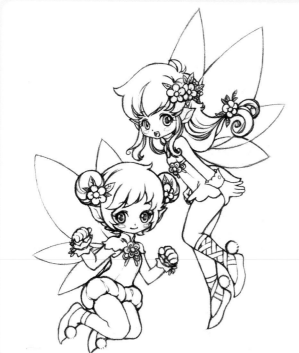

1. Sketches

Once we discard the more adult version, we work on the concept of younger fairies, adding the background later. We differentiate their personalities, making one of them sweeter and the other one more energetic.

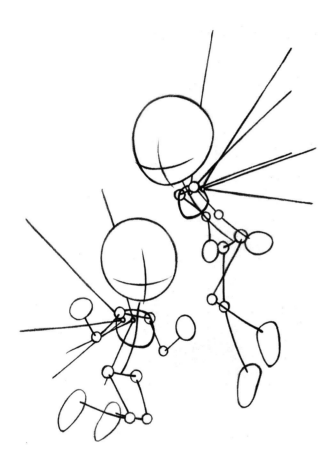

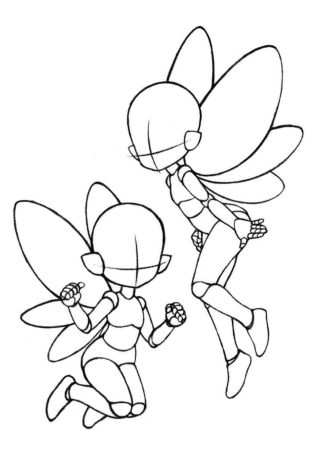

2. Outlining

Although the pose is not really complicated, the structure is somewhat more complex because the style of the drawing is more realistic and detailed.

3. Volume

We develop the structure of the characters with more ovals to try to create a three-dimensional look.

4. Anatomy

We outline the details of their facial features, drawing their pointy ears, hair, and wings. The eyes are big and expressive. The bodies are outlined in a clean yet realistic style, and they measure five heads.

5.1. Details

We create their outfits according to their respective personalities. The fairy on the right, more coquettish and feminine, wears a dress, while the one on the left, more energetic, wears an outfit similar to those of Harlequins. They both have floral ornaments.

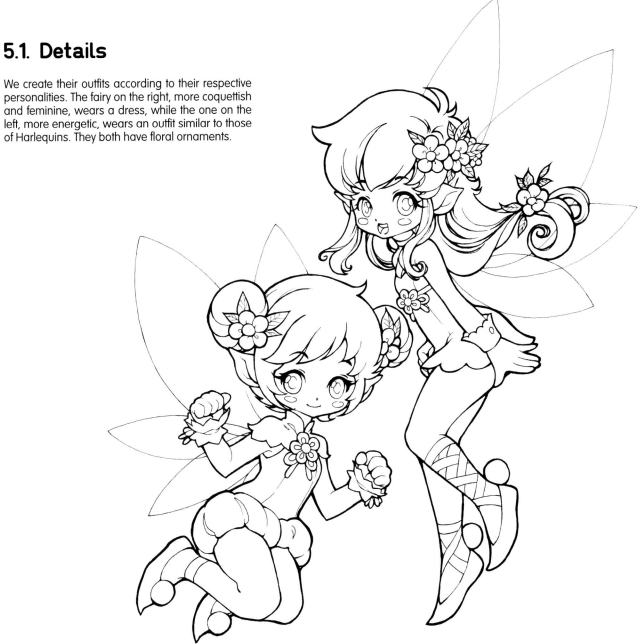

5.2. Details

We draw flowers in the background, which we will add later, before we start coloring. With that we will have completed the final structure for the illustration.

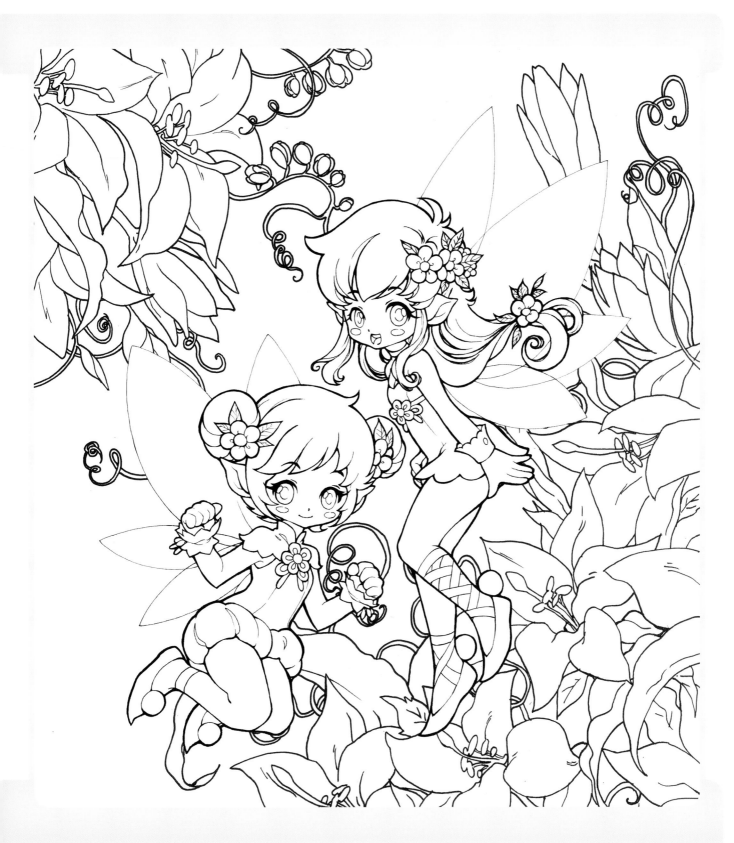

6. Inking and lighting

We employ soft and precise lines. The fairies are lit by a front light, and also by their own glow and sparkles. All of this adds to a crystalline look.

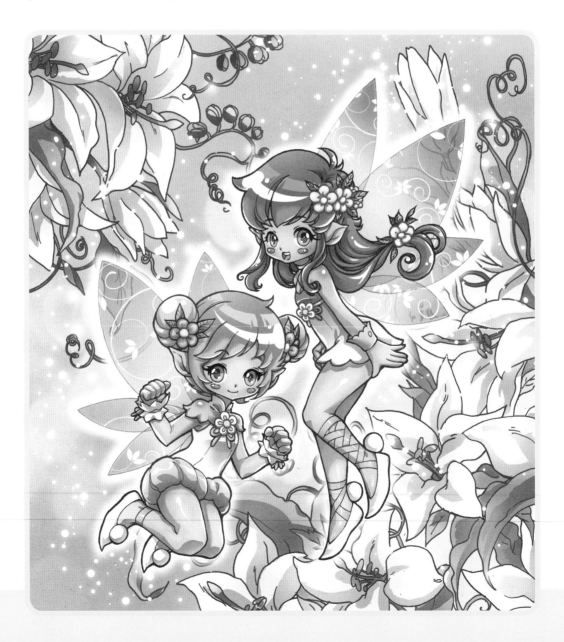

7.1. Color

We decided to use orange and pink tones to differentiate the fairies, while keeping green tones to link them both. The coloring process for this illustration is arduous, so we begin by applying gradients to define areas of light and shade.

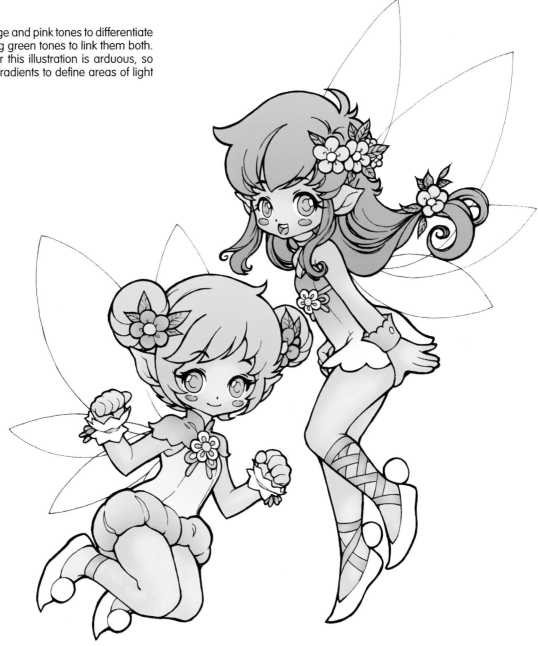

7.2. Color

We continue working on the shadows and creating new details for the wings, all done with gradients; we also define the middle tones in the process. We have to be careful when using gradients, as they tend to create a cold-looking finish.

7.3. Color

When we apply the highlights, the illustration gains more definition, volume, and detail. The wings have floral vector patterns with colored lines.

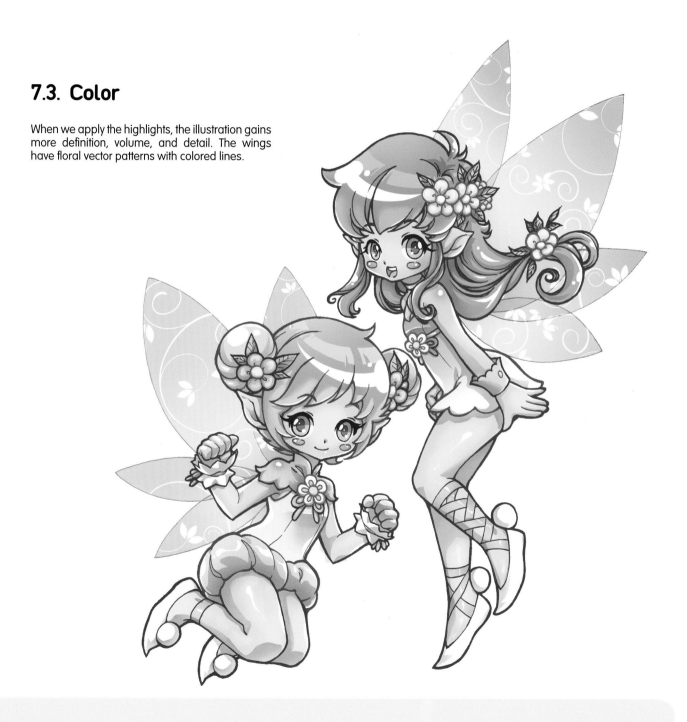

8. Background

In the following steps we will be working on the background which also includes the flowers we designed earlier for the foreground, and a background layer comprised of various slightly blended brushstrokes displaying different degrees of opacity.

Finishing touches

Tips & tricks

- To be able to draw flowers with this level of realism and detail it is necessary to gather documentation beforehand. We start making pencil sketches and then we try to find the right style so they match the overall look of the illustration.

- The coloring and highlights we used give the image a crystalline look.

- The fairies' wings have a tiled vector pattern. This type of graphic resource, common in the design world, allows a much cleaner look.

- We place the fairies in the center of the image, surrounded by a glowing halo that makes them stand out from the background.

- We make the background slightly darker by applying blue with a Color Overlay mode set to Overlay blending. This makes the background colors cooler so the fairies stand out.

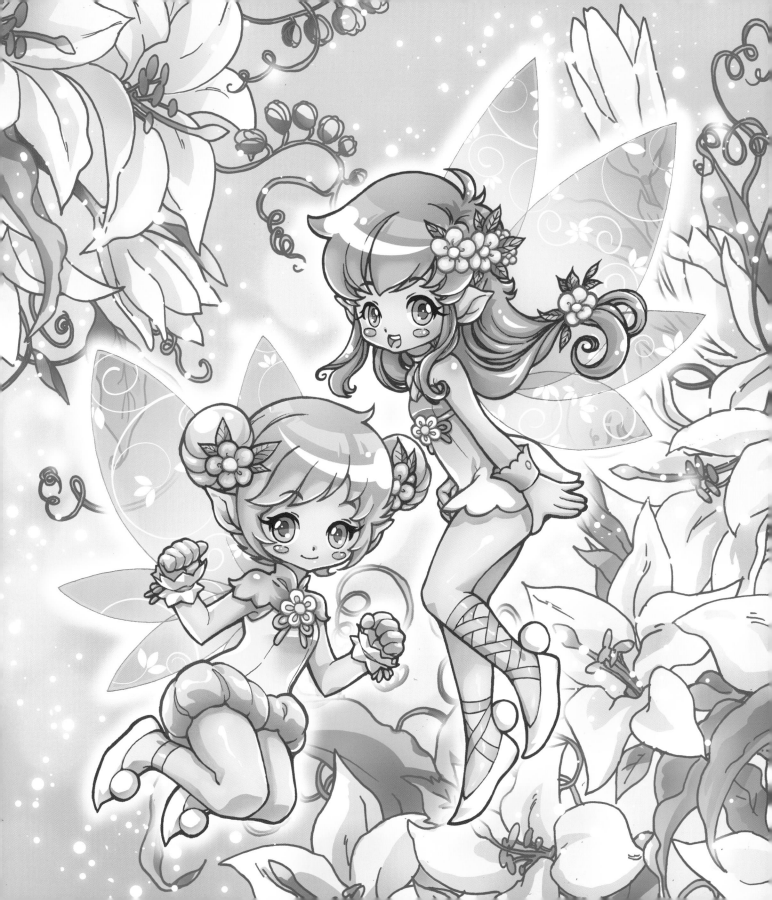

DRAGON WARRIOR

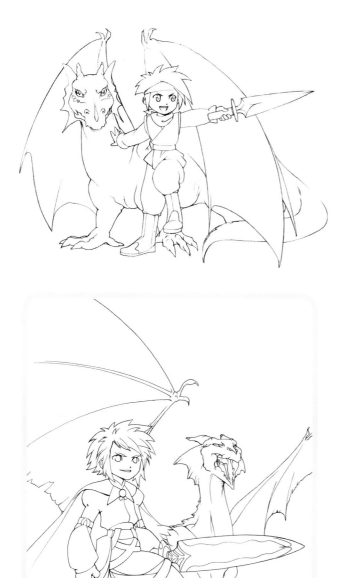

Heroic fantasy is one of the most popular genres in young literature, card games, role-playing games and video games. In this exercise we will draw the ideal lead character of one of these legendary sagas, in which young warriors fight fantastic creatures in a medieval setting.

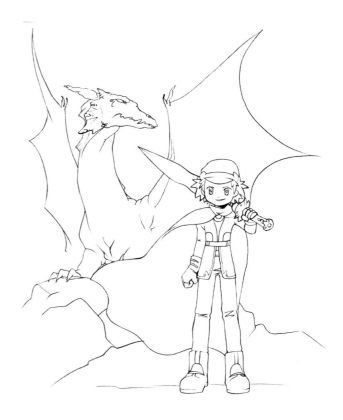

1. Sketches

This pose is the most elegant one; it shows the bravery of our small warrior and at the same time keeps that child-like look essential to engage the younger audiences.

2. Outlining

With a slight curvature of the spine and the left leg lifted, we get a pose that is not static at all. The three-quarter format of this illustration allows us to give more detail to the outfit and the expression, which are the key elements we want to emphasize.

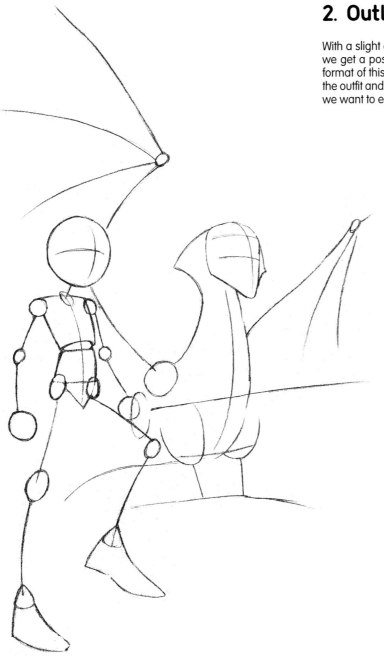

3. Volume

The character wears loose-fitting clothes, but we cannot depict him as being bulky – we must make him look thin. In this step we added detail to the dragon's features, giving it a more classical look, as opposed to a caricature-looking one.

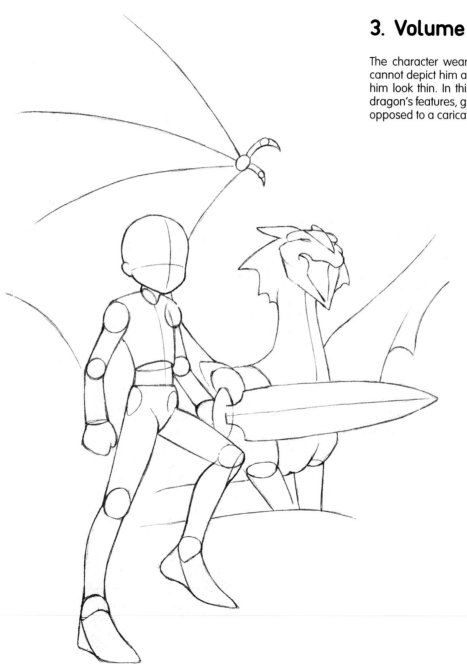

4. Anatomy

The character is more stylized, similar to that of a very young teenager. The height of the body is equal to seven heads, making him look thin yet sturdy.

The dragon in the background, more realistic, contrasts with the character but is perfect for the atmosphere of the illustration.

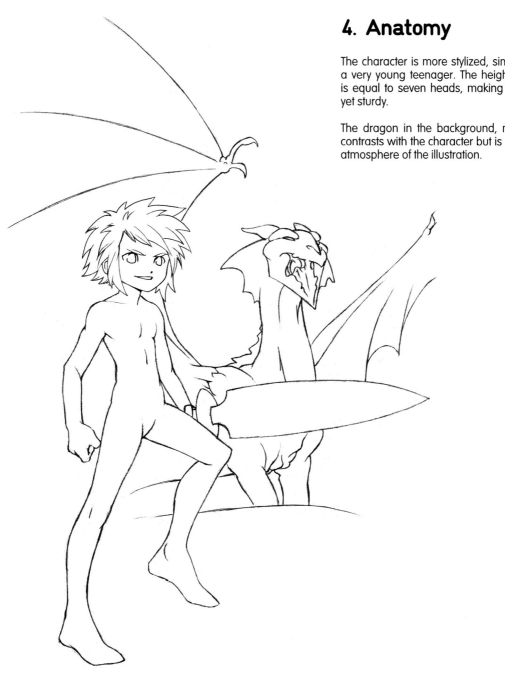

5. Details

We finish the line drawing of the dragon and dress our warrior with an eye-catching outfit, loose-fitting and thick enough to be used in low temperatures.

The sword wielded by the character is somewhat exaggerated, something very typical in Japanese fantasy role-playing games.

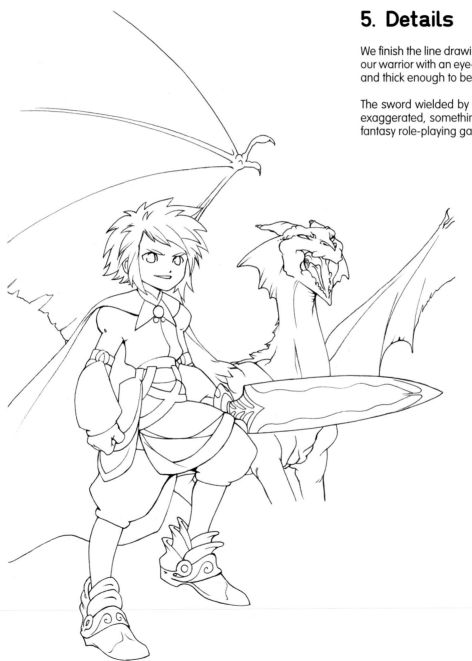

6. Inking and lighting

Thin lines are complemented with thicker ones for shadowy regions. Shadows are softened as they are blended with the base color.

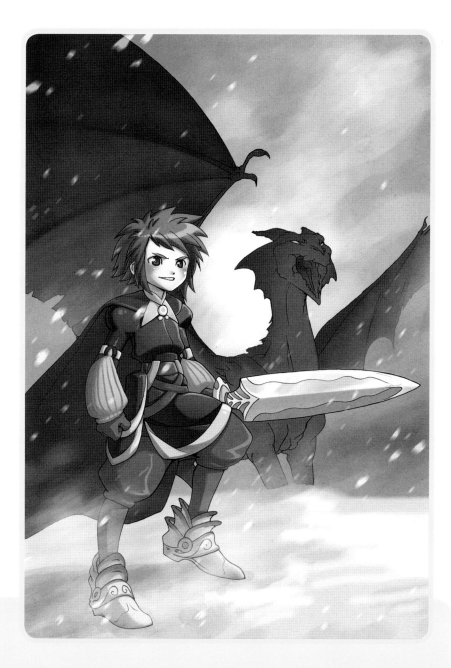

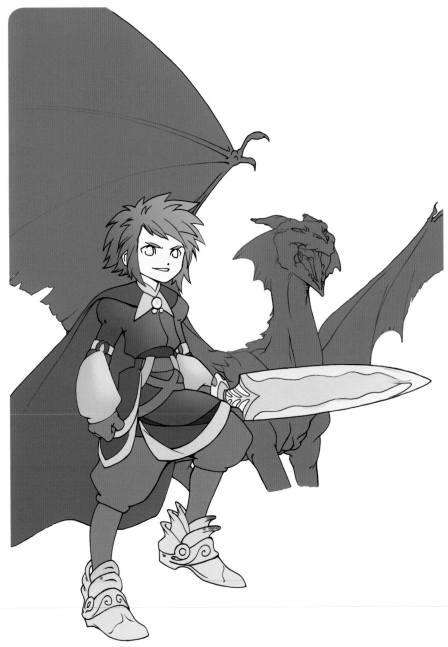

7.1. Color

We start the coloring process with a base color to which we apply some gradients to define the volumes for the rest of the process. The source of the lighting is also noticeable in this first step.

The lower area is not completely finished, as it will be covered later by the snowstorm.

7.2. Color

This illustration uses contrasts as a resource. The warrior and the dragon stand out over a clear background in which the snow prevails. The slightly blurred shadows blend in a softer way than the harsh finishes made with flat colors.

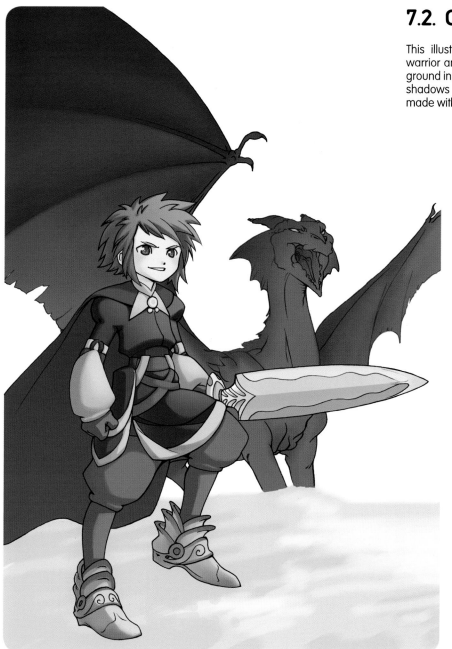

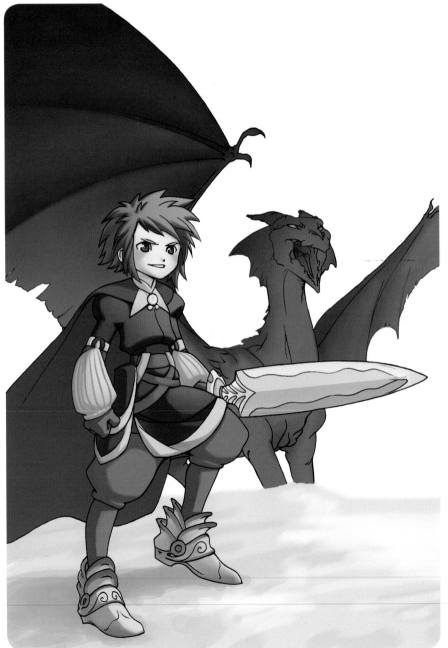

7.3. Color

We add emphasis to the shadows by tweaking them, paying special attention to the upper side of the drawing. We apply color to the character's cheeks to add a touch of rosiness, but use a tone that is consistent with his skin.

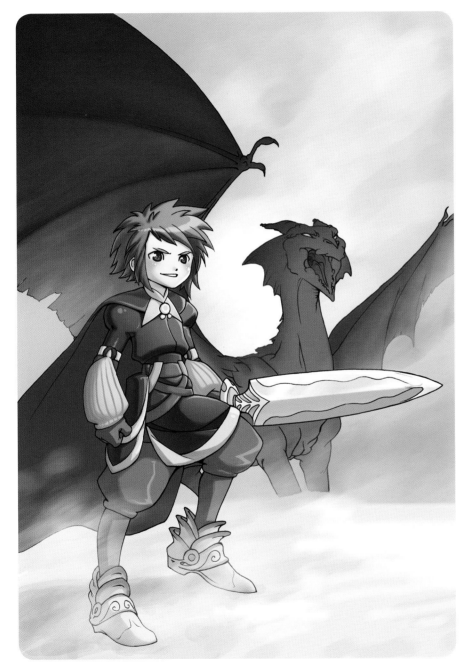

8. Background

We paint the background with strokes of varying opacity, and create a new layer to overlay additional strokes that will simulate the snow being blown by the wind. We include some highlights, keeping them subtle so that they don't stand out too much while adding light to the scene.

Finishing touches

Tips & tricks

- For this exercise we combined different drawing and coloring styles. This allows us to blend different ideas together to achieve a more distinctive finish.

- Although the dragon has remained as a background element and has a decorative purpose, we have detailed its complex anatomy.

- We finish the atmosphere of the illustration adding more snowflakes on a new layer.

- We draw the snowflakes with strokes of varying sizes that we then blur, using a Motion Blur filter.

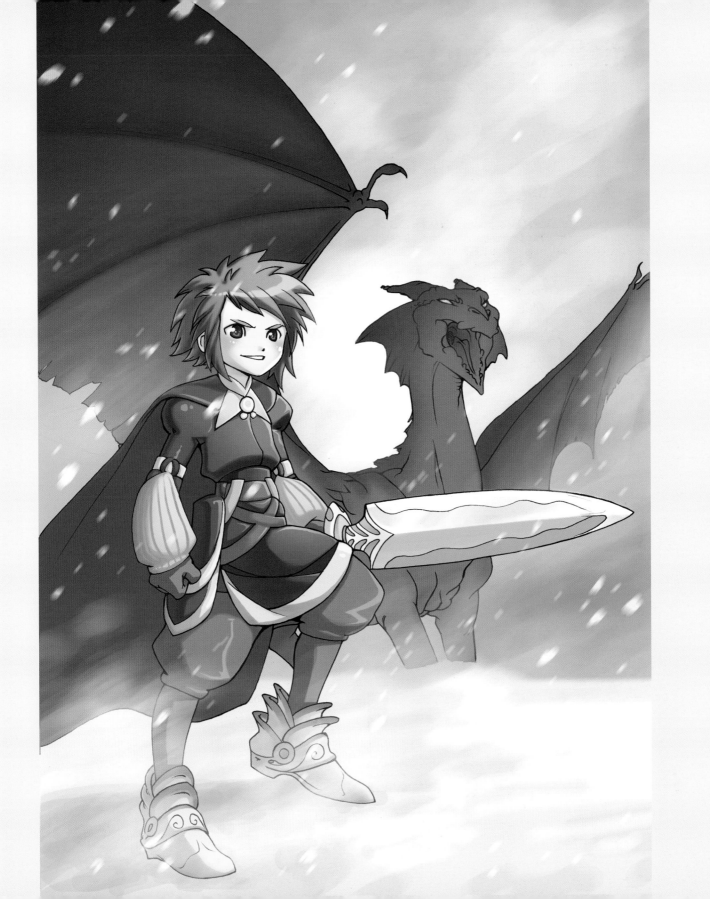

ORANGE SPRITE

Of all the fruit sprites, Orange is always daydreaming. In this exercise we will create a 3D modeling of a previously designed vector character. We used 3D Studio Max to create the model of the character, but the steps we took apply to most 3D modeling software.

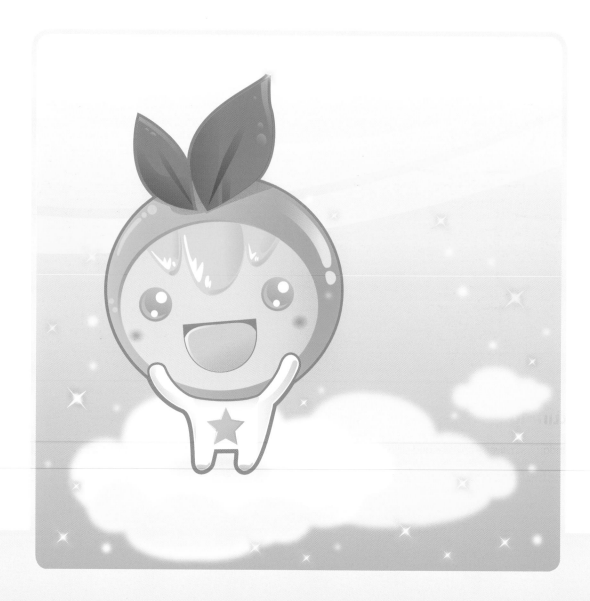

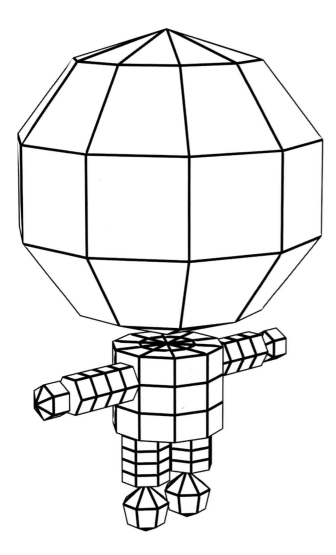

1. Outlining

We use standard primitives – spheres and cylinders – placed in their approximate final positions. We must keep in mind the different sizes and proportions of the original design.

2.1. Volume

We combine all those primitives into a single editable polygonal mesh, welding the appropriate vertices to achieve the desired result.

2.2. Volume

In this step we will modify some of the vertices in the arms to make them more rounded and similar to the original.

2.3. Volume

Now we scale the vertices in the extremities to produce a cone-like shape.

3.1. Anatomy

To create the leaves that we will place on top of the head, we start with two planes whose vertices will be scaled to produce the shape of an oval leaf.

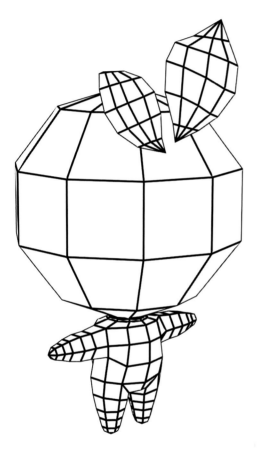

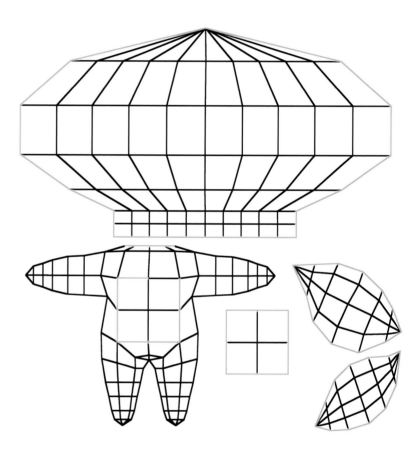

3.2. Anatomy

We place the leaves on the sprite's head, twisting them slightly to make them look wavy.

3.3. Anatomy

We unfold the mesh into a 2D structure that we will use to apply the texture to the 3D model using Adobe Photoshop.

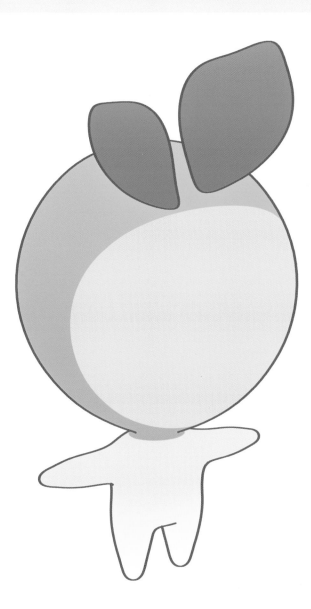

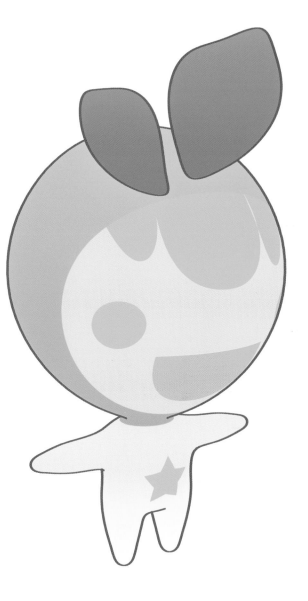

4.1. Color

We create the texture with base colors: green, orange, and a gradient from flesh to white.

4.2. Color

We add new elements to the texture: eyes, hair, mouth, and a star.

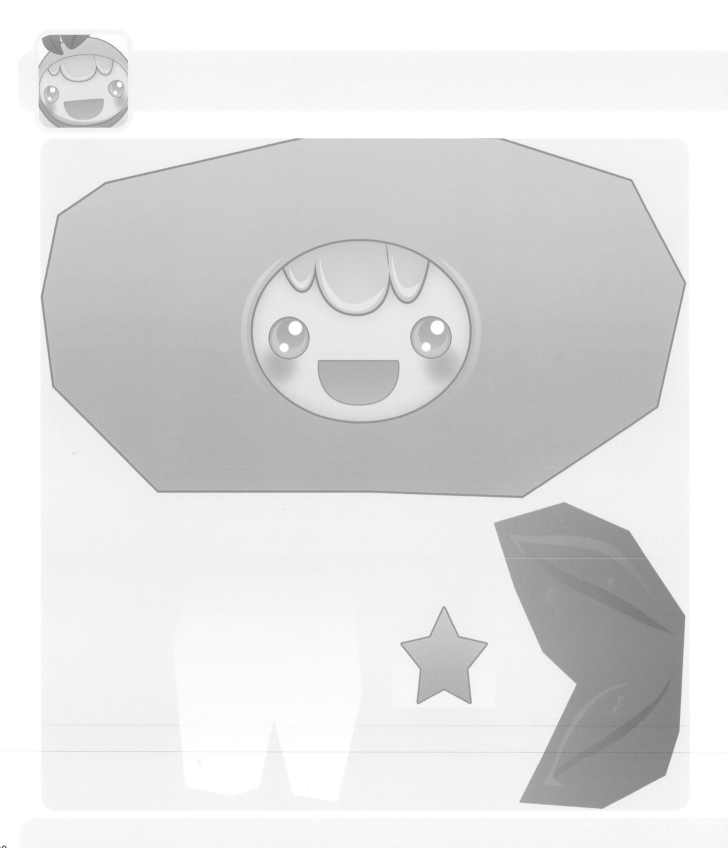

4.3. Color

In previous steps, we unfolded the mesh and painted it using Adobe Photoshop and added detail with gradients and shadows for individual features. We view the final result in the 3D model without bones to confirm that the texture fits correctly on both sides.

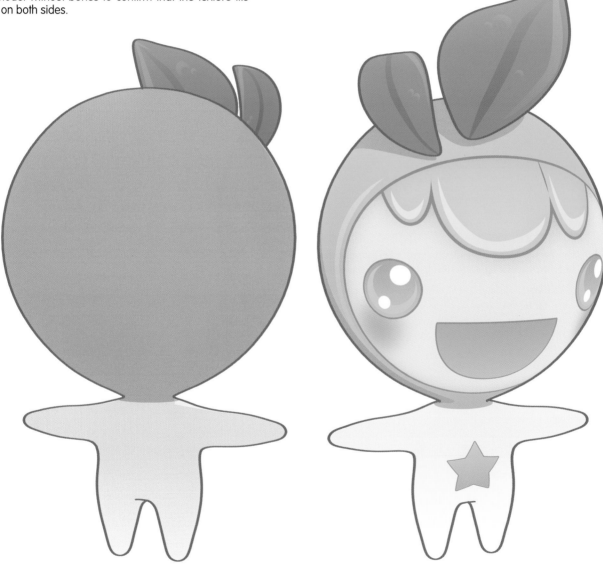

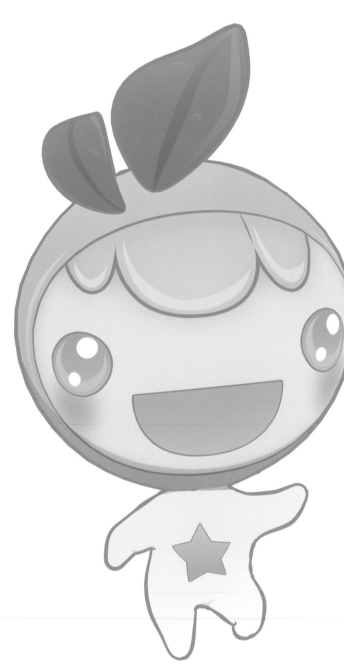

4.4. Color

We create the bones for the model and try different poses and viewpoints until we choose a particular one to which we will add the background with the clouds.

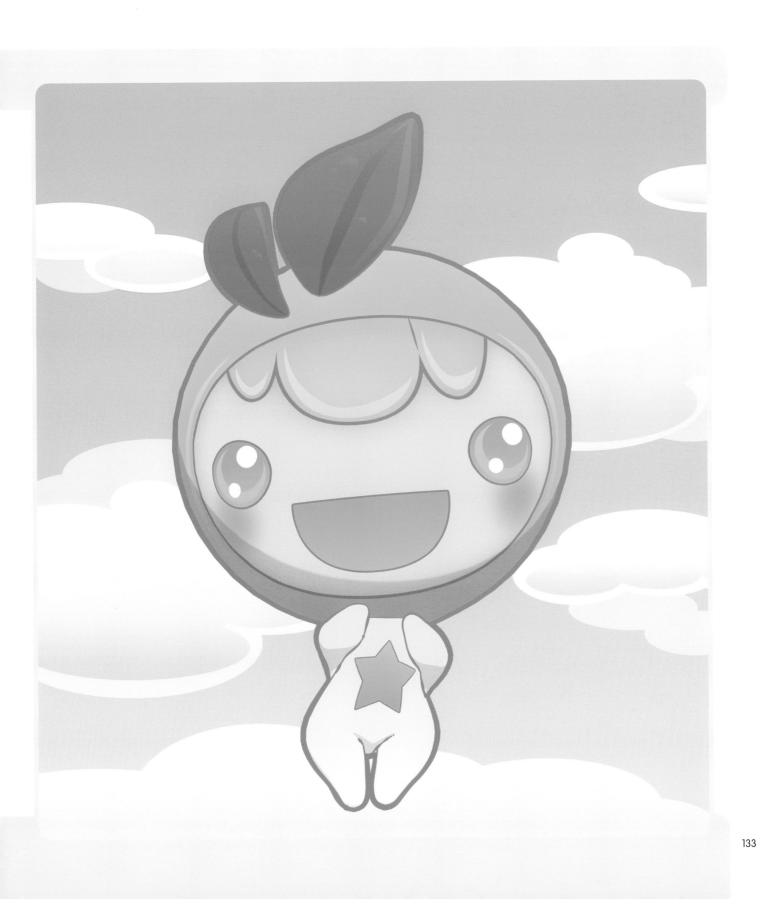

Finishing touches

Tips & tricks

- We did some tweaks to the original design.

- The arms are shorter and the body is shaped like a pear. The eyes have a greater separation and the cheeks are more visible.

- The chosen pose has a low angle viewpoint that makes the character look cuter.

- After trying the previous background we decided to use the original one, a vector drawing created with Adobe Illustrator.

- We place the character on one of the sides of the image to show the rest of the background and break the symmetry of the composition.

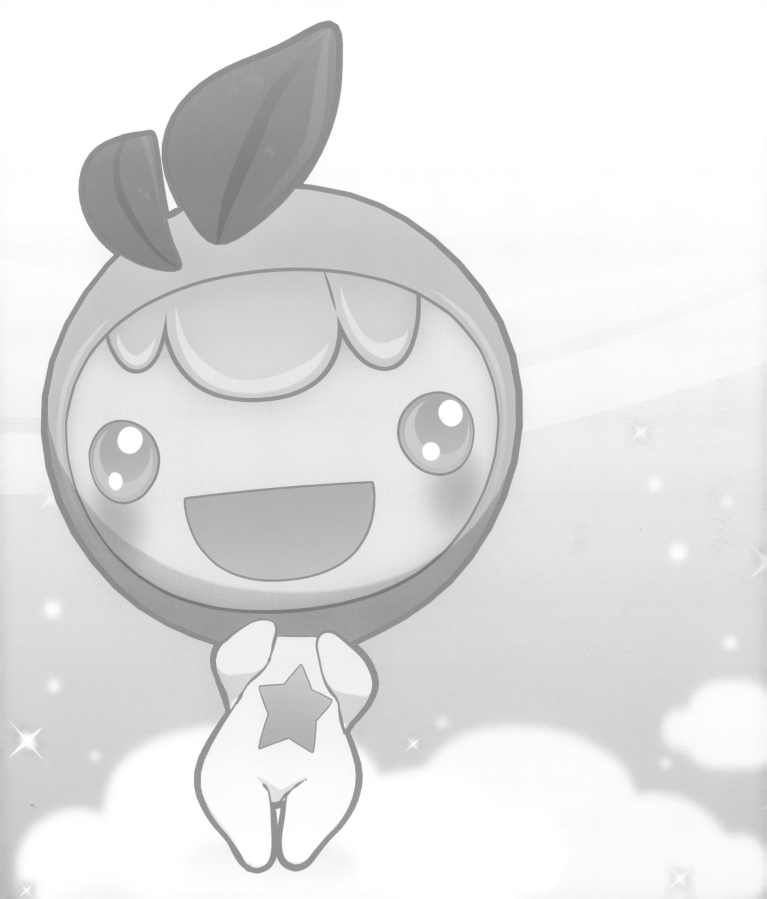

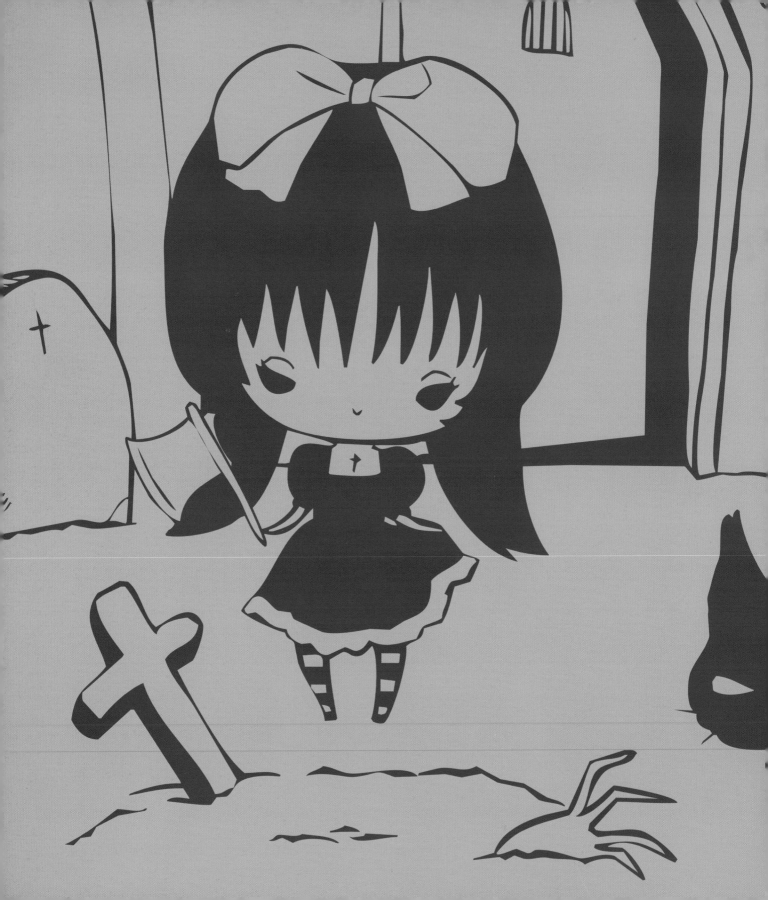

HORROR

Halloween
Vampire
Haunted house
She-devil
Ghost temple

HALLOWEEN

On Halloween, children go out in search of candy and play pranks on anyone who refuses to give them sweets. But, what happens when they are the object of those pranks? Our girl, dressed as a "lolita", is going to find out this very night.

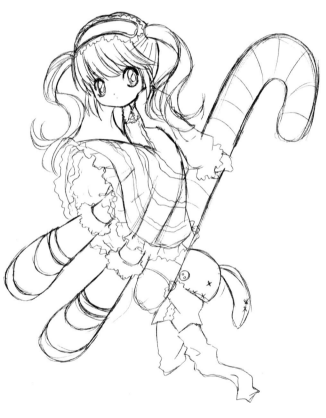

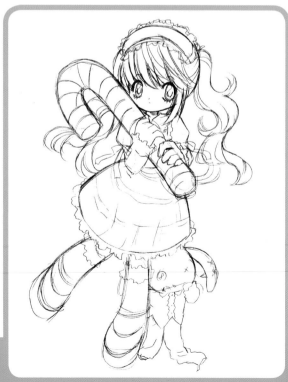

1. Sketches

In this sketch, the "lolita" is more expectant, wielding a giant candy cane just in case any ghost dares to manifest itself before her.

2. Outlining

The character is tilted and rests on her companion. The head is slightly turned to the right and the legs are separated as if she were about to faint.

3. Volume

The extremities are wide and give the girl a caricature -like quality.

4. Anatomy

The girl is floating on air, so the hair must convey that position. The size of the body is four heads. The eyes take up more than half of the face, reinforcing her childish look, typical of manga for girls.

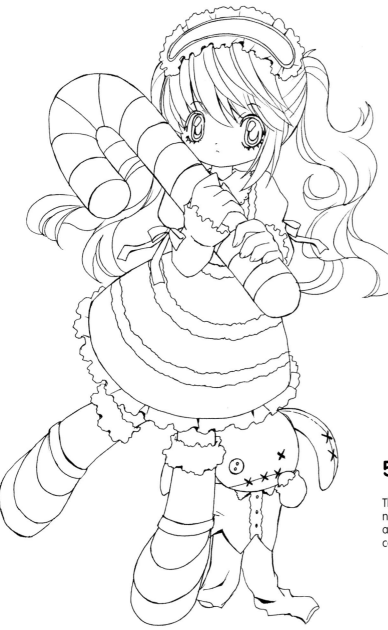

5. Details

The costume design is common among some Japanese urban tribes. That "lolita" style simulates the frills and headbands of French maid outfits, although in this case they are more bombastic and sophisticated.

6. Inking and lighting

We emphasize the lines of the eyes and the dress. The dark background is balanced with a clearer sky.

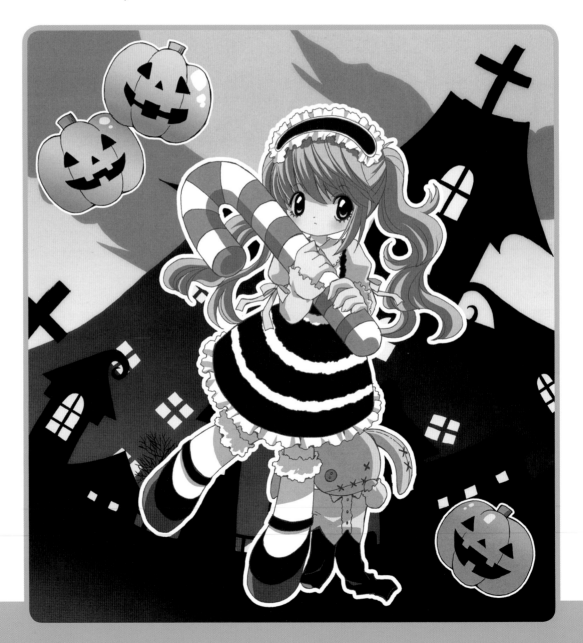

7.1. Color

We only apply some of the base colors, as the rest of the drawing will be defined with shadows and highlights.

7.2. Color

The light comes from the upper right corner of the drawing. The shadow on the hair has a lot of detail because it is very evident in the illustration.

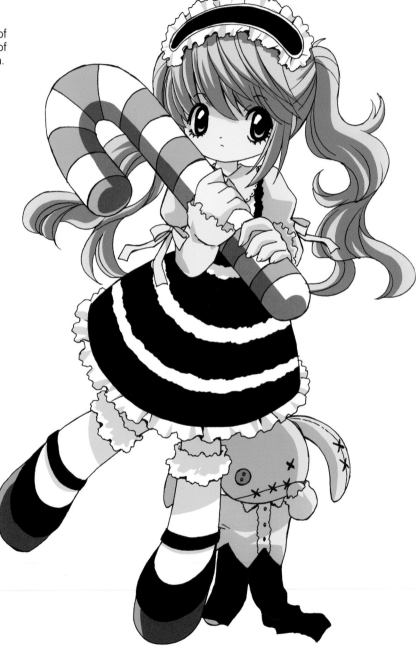

7.3. Color

We have not applied white to the inside of the eye, but the cheeks and shadows around the eyes create a similar visual effect.

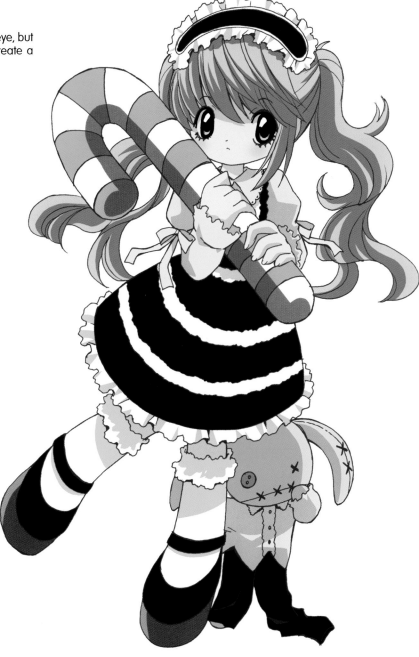

Finishing touches

Tips & tricks

- We can render an attractive and complete illustration with very few tones and a good use of shadows.

- Final touches like these pumpkins help set the mood for the scene and at the same time balance the composition.

- The first version had a skull in the upper right corner, which was replaced with a tower.

- We add the background that we created separately. The aesthetic has a Gothic feel.

- We also add the pumpkins, which now have gradients to suggest volume.

- We detach the characters from the background with a white stroke.

- The line drawing is colored in lavender.

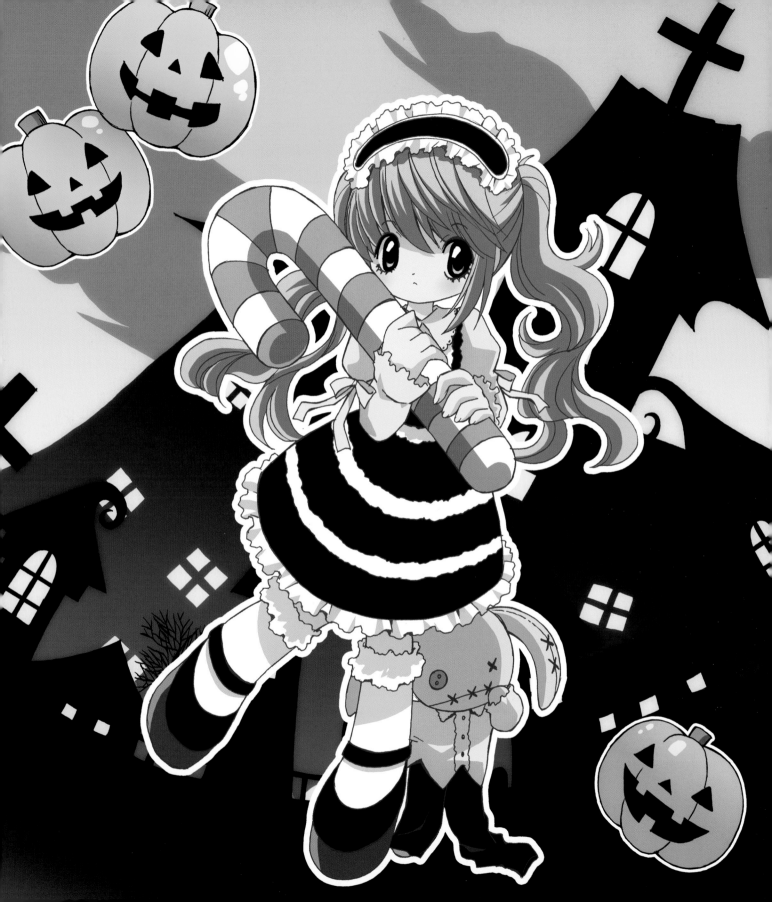

VAMPIRE

Listat, the little vampire, goes out every night to have fun at the graveyard. There, he plays with Batmin, his bat, and dreams of being able to see the sunlight some day, as he is more than familiar with the moonlight.

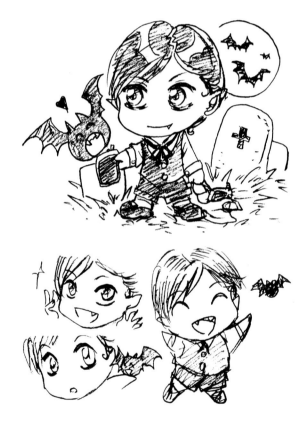

1. Sketches

We choose this version with a much bigger head and more details; it combines a sketch with one of the expressions we already tried out.

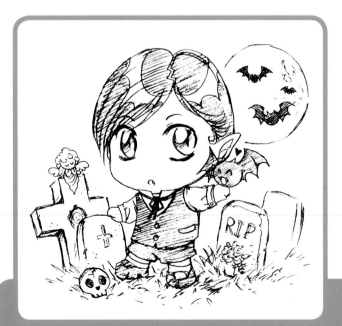

2. Outlining

The structure of this character is quite simple – it only has a subtle curvature for the spine which makes him lean forward just a little.

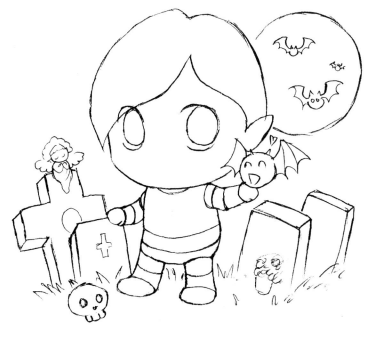

3. Volume

We draw the rest of the body and place the eyes which take up a great part of the face. We also add the background elements.

4. Details

We dress the young vampire like a child from the beginning of the 20th century, with a shirt, string tie, vest, and shorts.

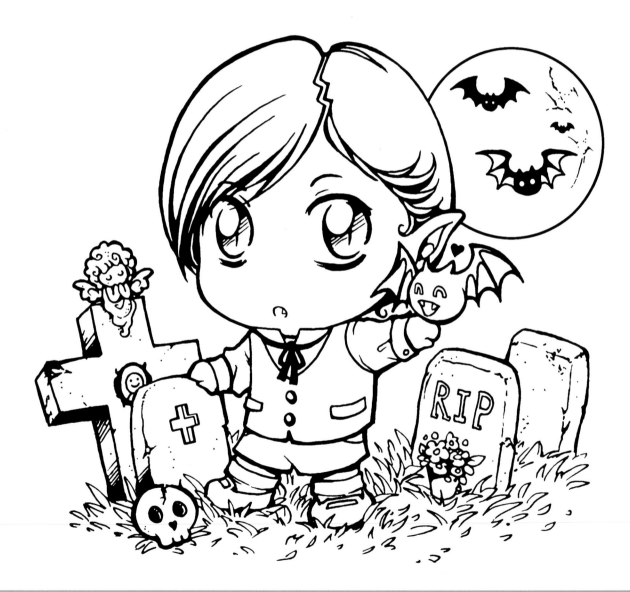

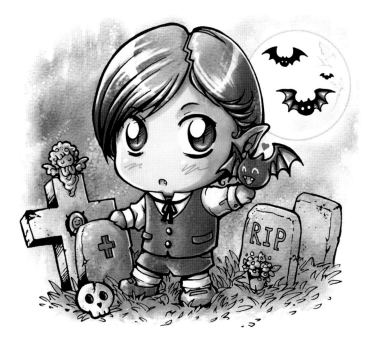

5. Inking and lighting

The inking is done with very thick lines, making the character stand out. The character is backlit, but we simulate an additional light source so that he is not in the shade.

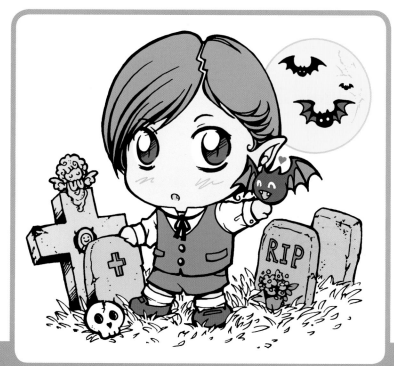

6.1. Color

Lavender is the predominant color in this illustration, as well as cool tones in general. Red eyes make the character look supernatural.

6.2. Color

We add shadows using strokes, giving texture to the image.

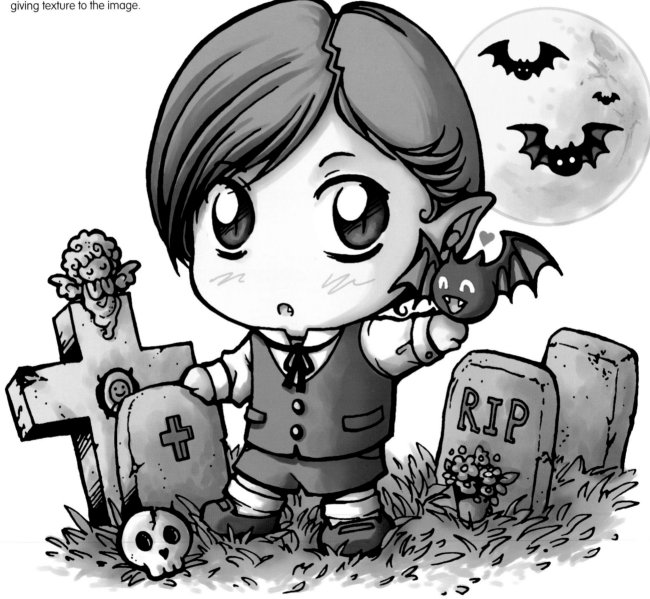

6.3. Color

The image is slightly brightened when we apply the highlights.

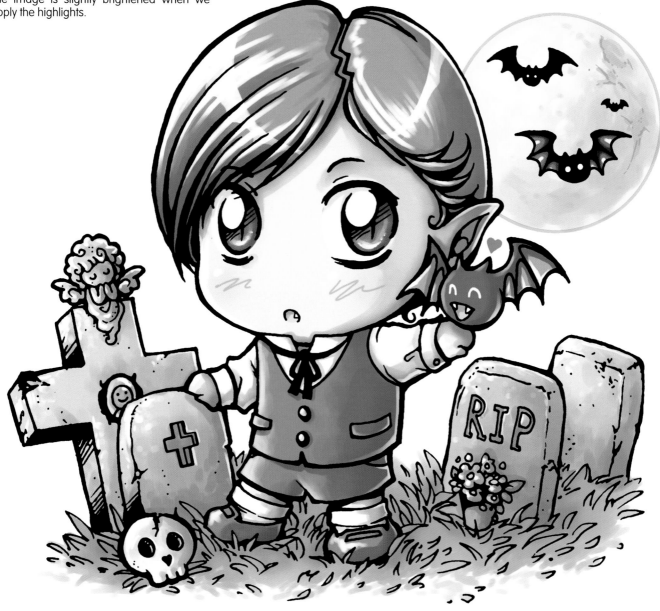

Finishing touches

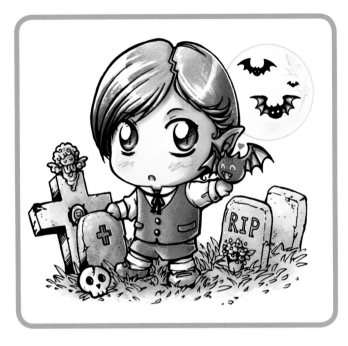

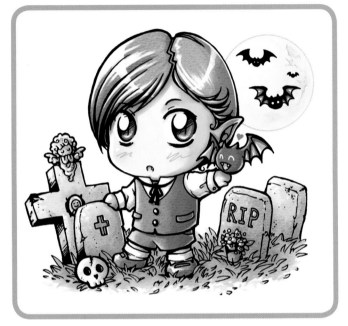

Tips & tricks

- After the coloring has been defined, we apply a watercolor paper texture on a new layer set to Overlay blending mode.

- To prevent this texture from affecting the skin of the vampire; to accomplish this, we create a selection and create a layer Mask, thus leaving the skin areas unaffected.

- We create a new coloring layer set to Overlay and add a slight saturation to the colors in the picture. This simulates the finish of the brushes included in Corel Painter.

- To finish the background of the illustration, we add yet another layer with watercolor paper textures that have been colored previously. We set this new layer to blend using the mode Multiply.

- Although some areas of the illustration are darker now, it keeps its overall brightness, which now has been enhanced by the final color layer.

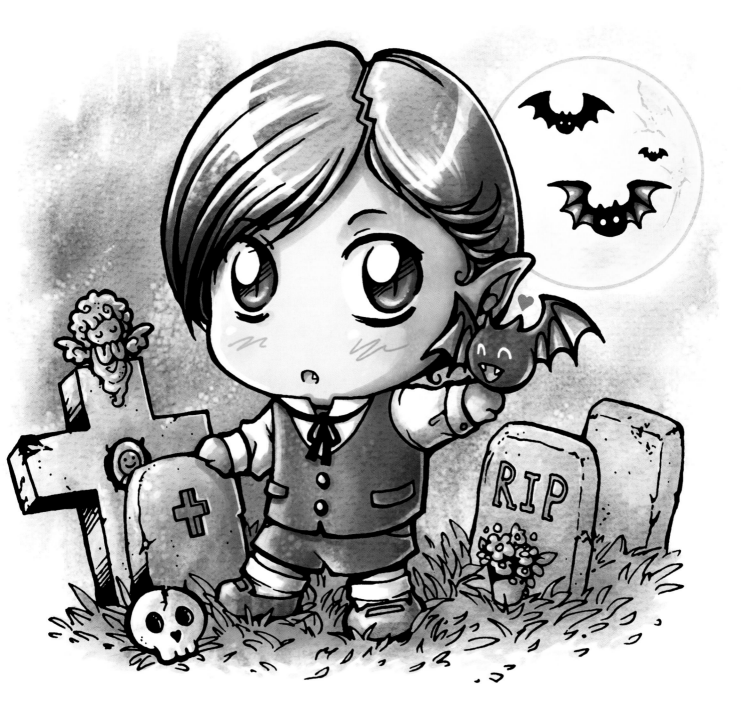

HAUNTED HOUSE

What would a doll house inhabited by monsters and ghosts be like? That is the premise for this illustration. A ghost, tombs, a mysterious Goth girl with her cat, skulls, a mummy, bats, and a zombie – these are the terrifying inhabitants of this peculiar house of horrors.

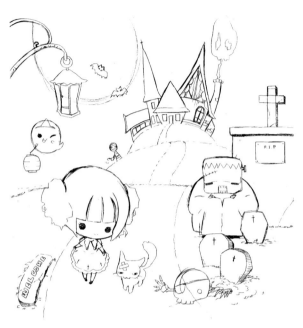

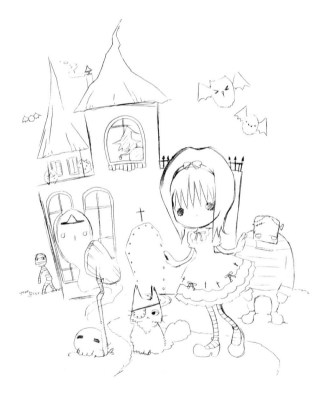

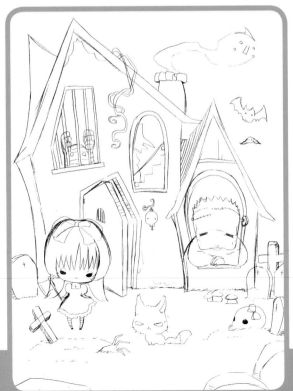

1. Sketches

The house must have as much prominence as its bizarre dwellers. We are also looking for a childlike yet dark look, and although the characters have to look like children, the atmosphere has to be as gloomy as we can make it.

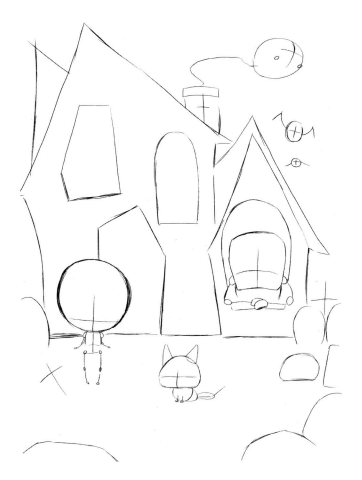

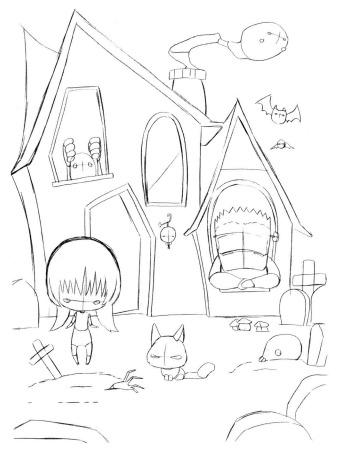

2. Outlining

The house is an important element of the illustration, perfectly integrated with the characters. The ovals that mark each character's head are as big as the rest of their bodies.

3. Volume

The girl's facial features only take one quarter of the total size of the head. This adds to the body proportions to emphasize the childish look. The open front door invites us into the house.

4. Details

The girl has Goth-looking clothes, crowned by a huge bow that acts as a contrast with her threatening aspect. This concept is echoed by the bow that decorates one of the skulls.

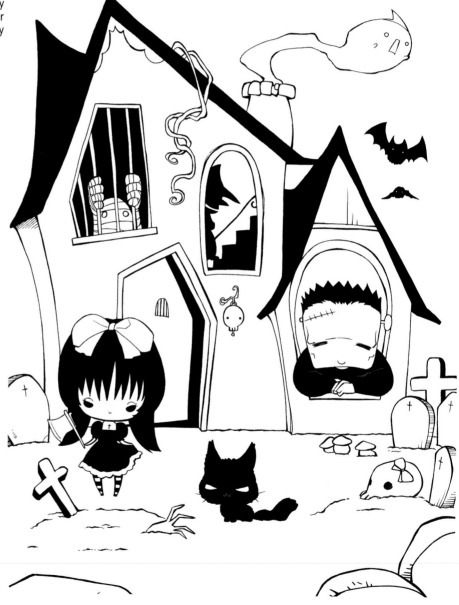

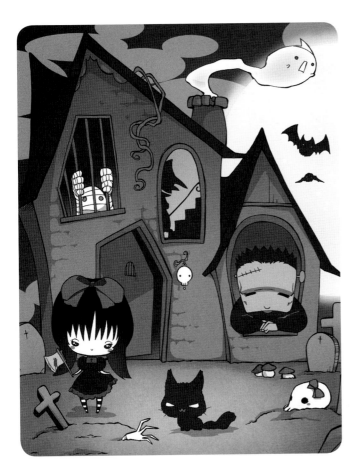

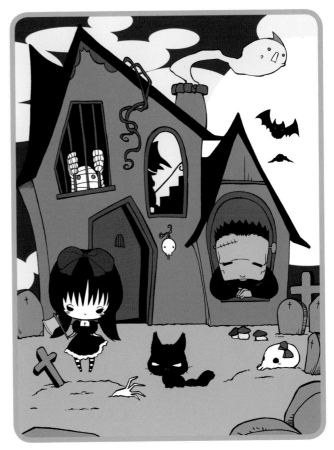

5. Inking and lighting

We balance the dark tones in the illustration with touches of light such as the moon, the ghost, the mummy, the skulls, and the girl's face. We go for an irregular line, with varying widths and abrupt corners.

6.1. Color

We apply some base colors to the image and then we define the general tones of the illustration, which will be refined in the following steps.

6.2. Color

We add shadows, light, gradients and, in the end, textures that will take away some of the coldness conveyed by the use of gradients.

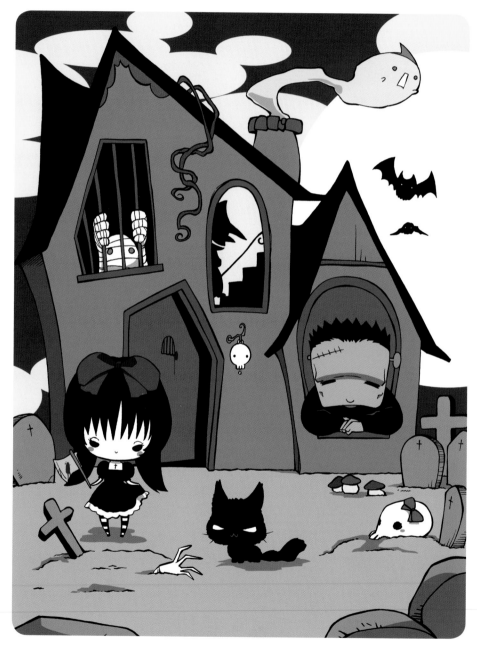

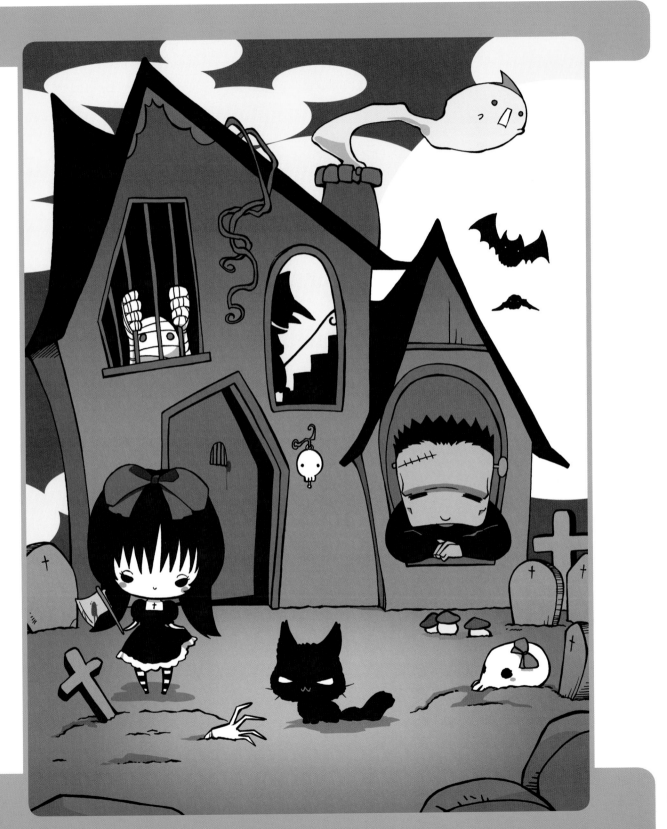

6.3. Color

We darken the sky by giving the clouds a lilac shade and transferring the warm touch to the moon with a yellow shade fading from dark to light. In the same way we fade the color of the ghost from blue to white and make the zombie greener. Lastly, we darken the ground as well as adding new shadows to the house.

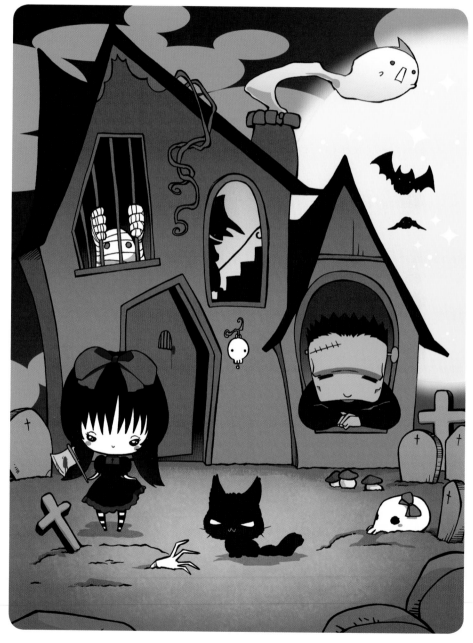

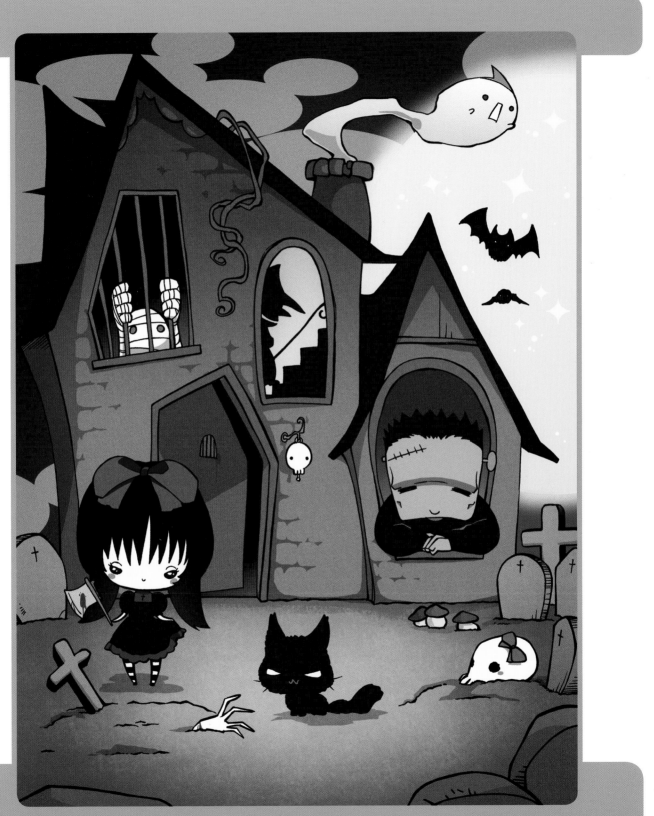

Finishing touches

Tips & tricks

- Badly applied gradients can give the image an unattractive and excessively digital look.

- Textures, which we created with the Add Noise filter, help us give some consistency to the coloring and to the finish of the illustration.

- The colors used by the characters in an illustration can be altered through the coloring process, for best chromatic coherence.

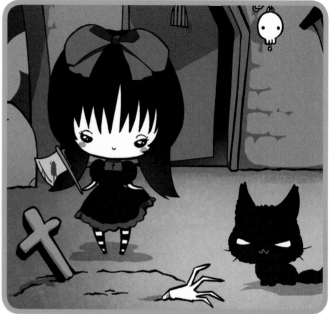

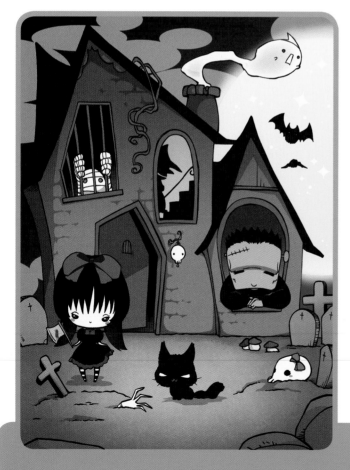

- We crop the illustration slightly to produce a more centered composition that will make the girl stand out.

- We modify the coloring on the ghost, adding an Inner Glow (from the layer blending modes) to make it look more ethereal.

- We create a gradient overlaying the two crosses to enhance the lighting on those spots.

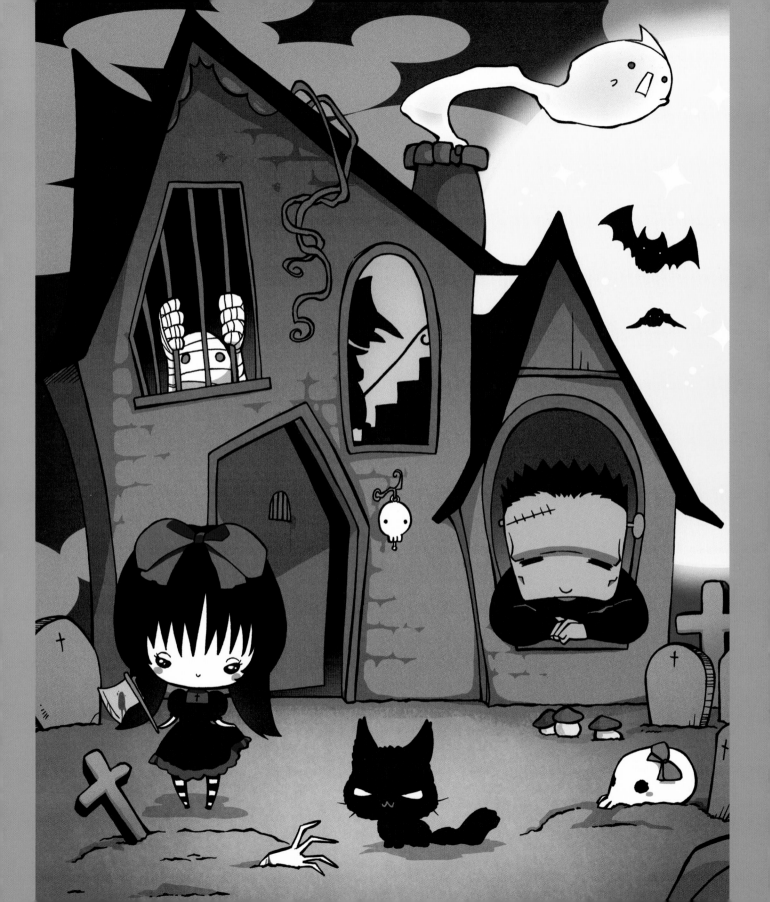

DEVIL GIRL

A sexy, sassy, and mischievous girl, and a really naughty one at that. That's how this little she-devil is described, always surrounded by those tiny succubi; she plays with them and also enjoys tormenting them. Her outfit must be both devilish and casual. The first sketches showed her in a lifeless pose, but we soon changed our minds and decided to go for a look with more attitude.

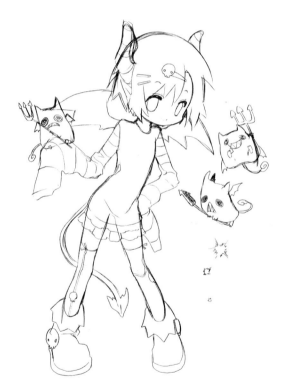

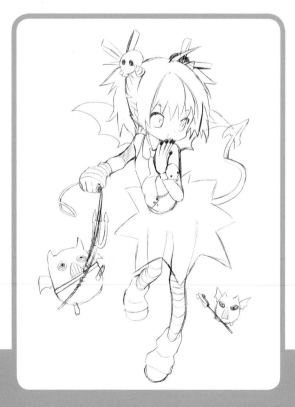

1. Sketches

There were more sketches for this drawing, but we chose this version showing her full of mischief and a touch of cheekiness.

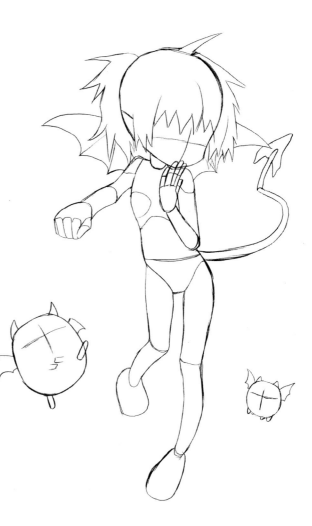

2. Outlining

We use curved shapes and tilted axes. The pose is compli-
cated but has a great dynamism. We must be patient when
building the structure.

3. Volume

The high angle shot makes the thickness of the legs dimin-
ish, as the lower half of her body is farther from the point
of view.

4. Anatomy

Despite the height of the body measuring five heads, the devil girl has a preteen look. Her twisting body keeps its balance using the tail as a counterweight. The left arm, which is in a foreshortened position, may be tricky to draw.

5. Details

We do our best to make her look like a punk rocker. The skulls on both headbands give her outfit an amusing touch. The star-shaped skirt, with its pointy edges, adds to her distinctive look.

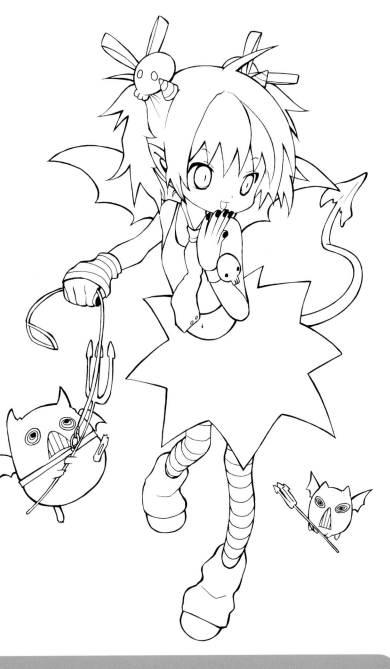

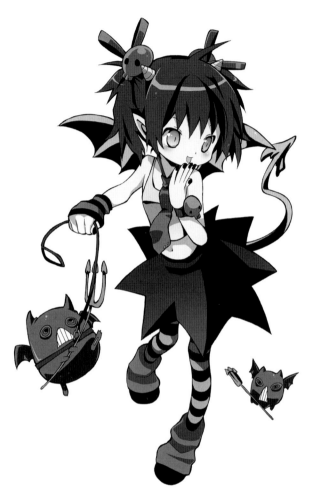

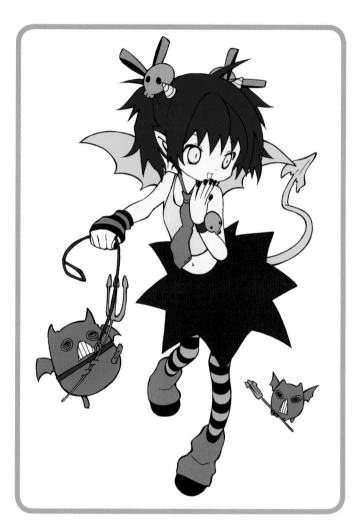

6. Inking and lighting

Inking is an integral part of the coloring process, and we will be using it to apply the darkest shadows, using an irregular and strong line. The light comes from the upper left corner.

7.1. Color

The greenish skirt is combined with orange, yellow, lavender, pink, and brown tones, thus breaking the chromatic harmony of complementary colors.

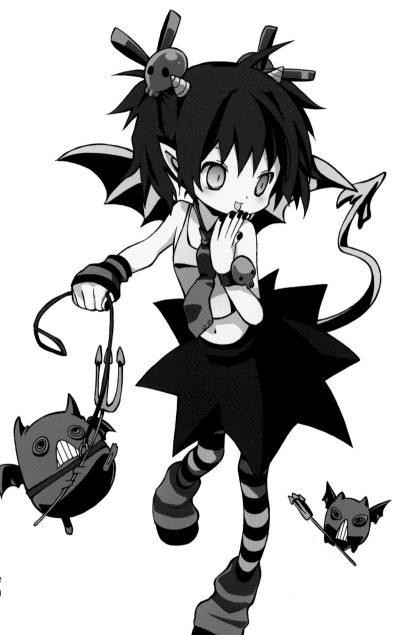

7.2. Color

We add very strong shadows, emphasized by the inking process of the drawing, using them to finish the details and folds on the clothing and wings.

Finishing touches

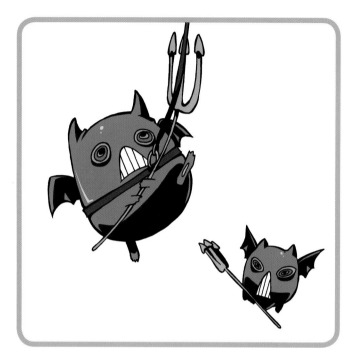

Tips & tricks

- The use of black and thick line drawing in some areas of shadow makes all the difference in this drawing, in contrast to the vivid colors present in the rest of the illustration.

- The eyes have a subtle gradient that creates a sense of volume that is enhanced by the highlight. Tiny pupils help to give her an even more fiendish look.

- The small demons that accompany her greatly enhance the expressiveness of the illustration.

- The highlights soften the final image slightly.

- The gradient on the skirt brightens it and makes all the details visible.

- The contrast between light and shadow is even more evident in the coloring of the small succubi who accompany the character. They were finished with a somewhat plastic look.

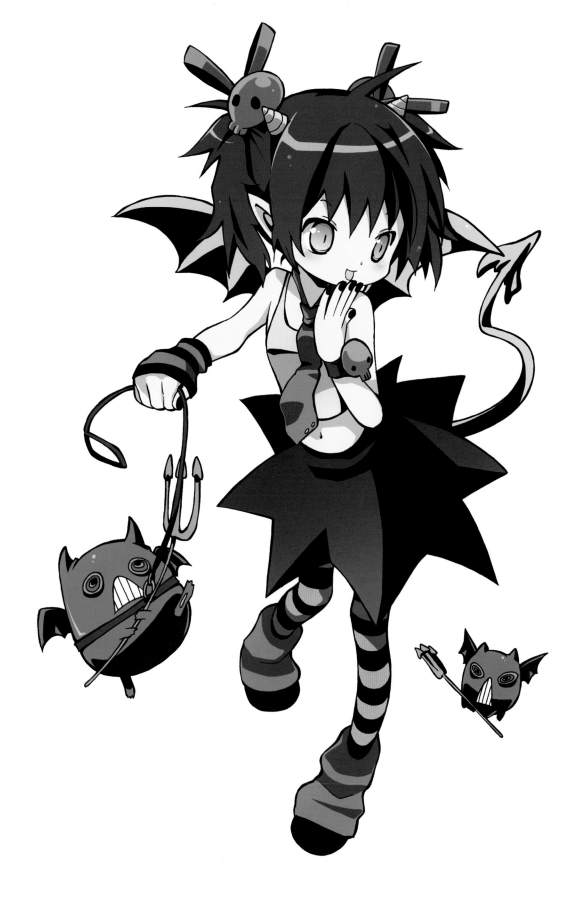

GHOST TEMPLE

Japanese Shintoist temples are havens of peace, but at night the most horrifying creatures can appear in them. To make sure that nothing disturbs the peace at her temple, our young priestess is in charge of controlling and directing whatever creatures come to visit. In this exercise we want to portray some of the usual creatures found in Japanese mythology.

1. Sketches

A fox with nine tails, a swamp kappa, a cat with two tails, will-o'-the-wisps, and a ghost umbrella with a single eye. The priestess is having a great time tonight.

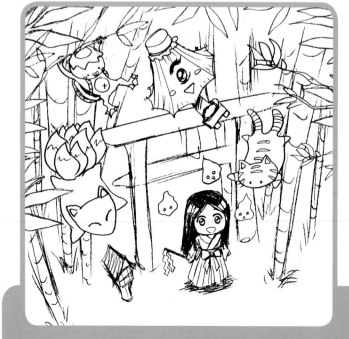

2. Outlining

The lines create a composition in the shape of an inverted triangle, directing the viewer's attention to the lower middle area of the image.

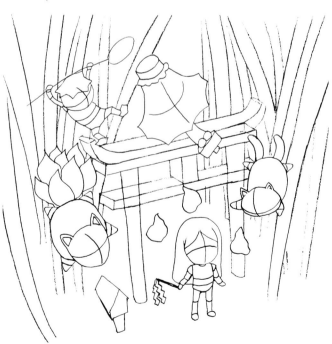

3. Volume

The perspective is extremely important since a high angle shot like this one alters the sizes of objects and characters.

4. Details

The girl is dressed with the typical attire of a Japanese Shintoist priestess and carries a wand called "haraigushi" that has the ability to purify spirits. The structure behind her is an arc called "torii", used to mark the boundaries of a sacred location.

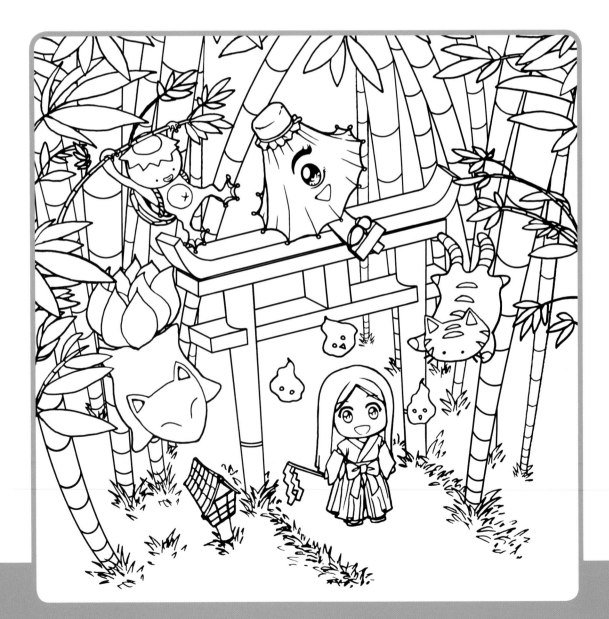

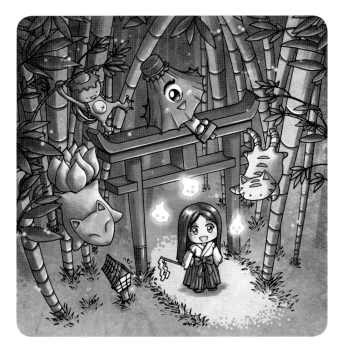

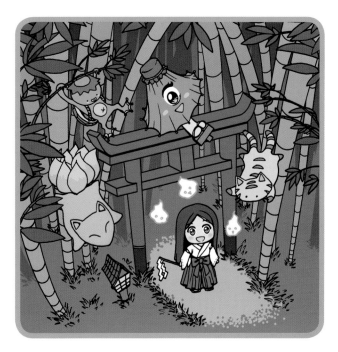

5. Inking and lighting

When coloring this night scene we created some areas of light that counter the image's darkness. The moonlight, fire-flies and will-o'-the-wisps are the elements that help us to set the ambiance and to keep the drawing's detail visible. All of this maintains the mysterious mood needed by an illustration like this one.

6.1. Color

We use cool tones for the background and warm ones for the characters. We almost use the whole range of colors, but balance the coloring, creating a background much more homogeneous. In this first step we tint the line drawing of the will-o'-the-wisps and apply flat color strokes to start adding texture to the grass. For the background, however, we use gradients, with which we can achieve more depth and a more gradual lighting.

6.2. Color

In the following steps we add shadows and highlights with soft brush strokes, using a lighter shade of each base color. We also include a few glowing effects, slightly blurred, for the will-o'-the-wisps, and fireflies.

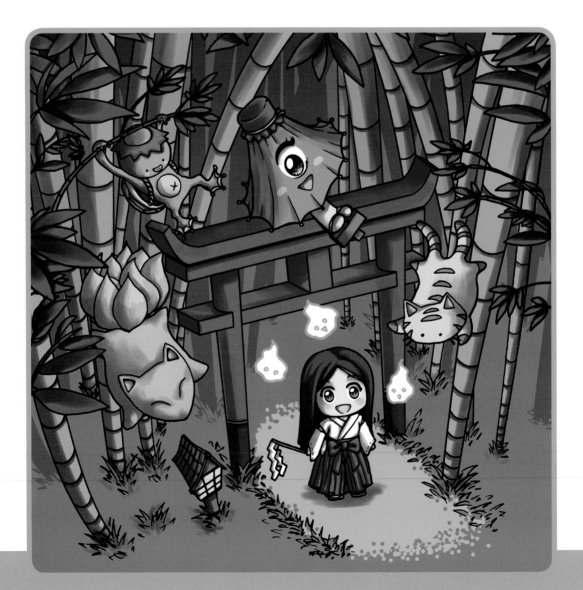

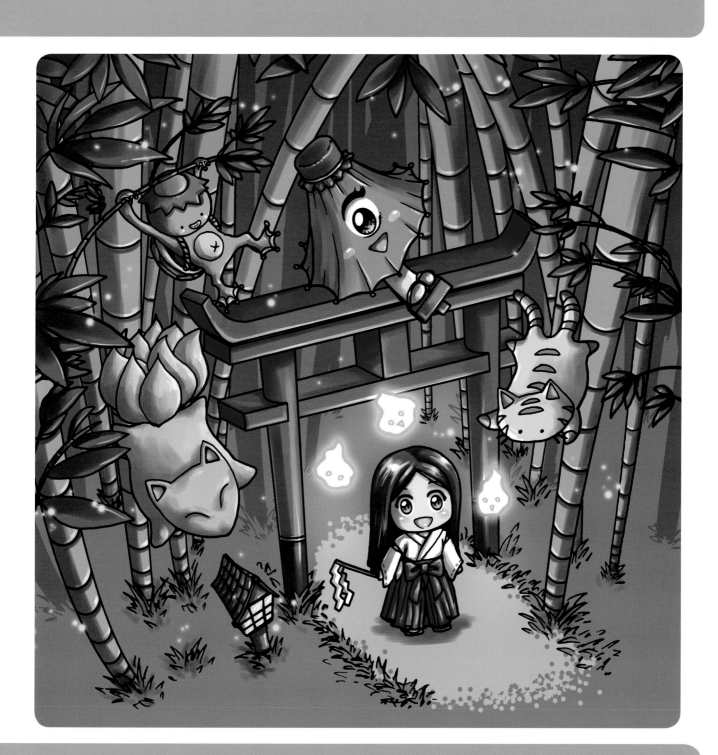

Finishing touches

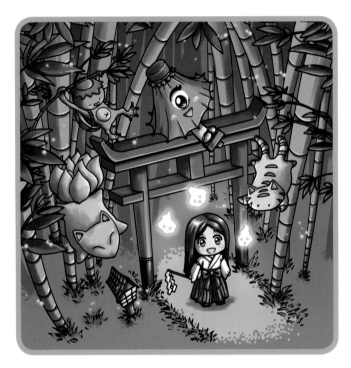

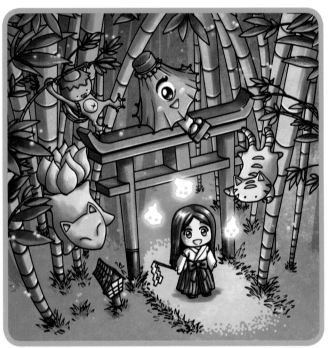

Tips & tricks

- Japanese folklore is full of mysterious characters and terrifying stories, so studying it can help us to create our own manga stories.

- Shinto is a religion that has its roots in Japan; it is based on the worship of "kamis", the spirits of nature.

- We add a first texture to a layer set to Lineal Burn blending, having previously removed the parts that overlap the line drawing.

- We finish with a second texture layer (paper fibers) set to Overlay blending and 80% opacity, giving the final touch to the illustration.

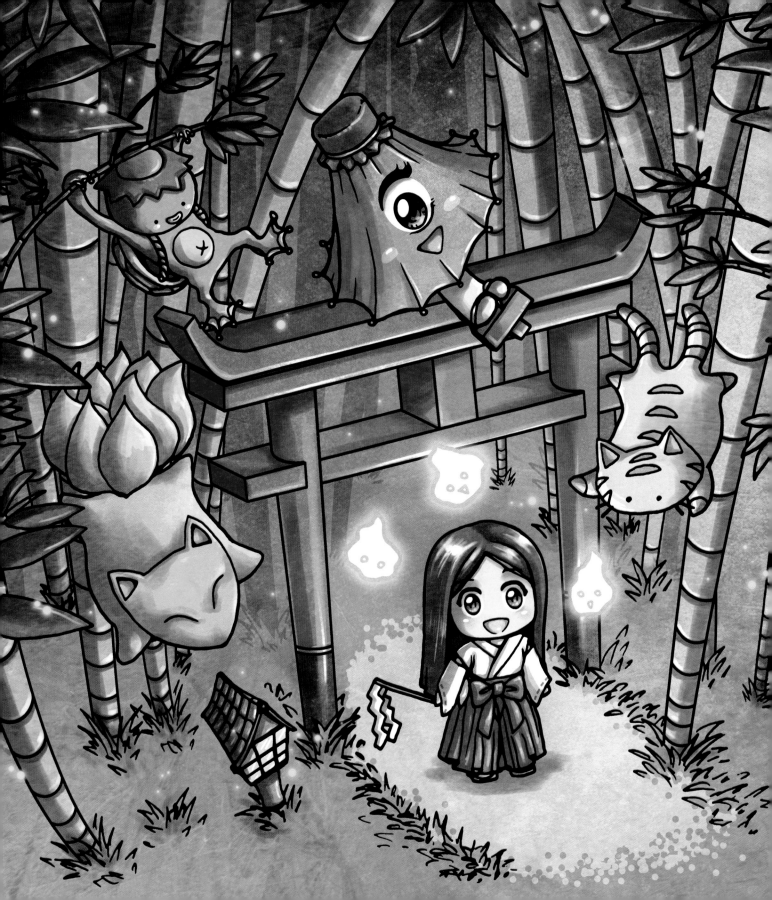

STARS

Batter
Adventurer
Ninja and Samurai
Kodomo Island
Master of cards
Dino-hunter
Super Cowboys

BATTER

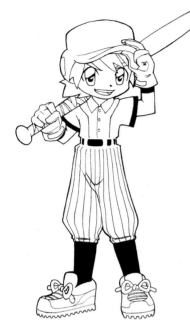

TV series with sports themes are very successful in Japan; baseball is the absolute king of sports there. That is why a batter can be the perfect star for a successful anime. The facial features of the kid are practically decided from the start – now we're testing different poses to find the most appropriate one.

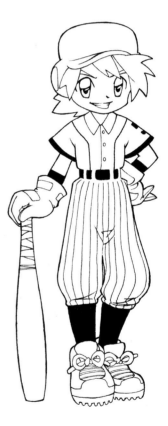

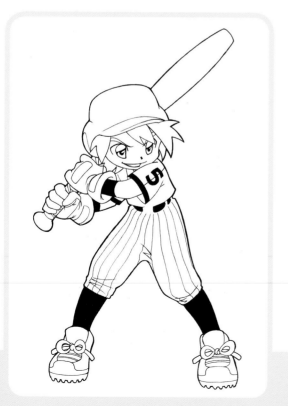

1. Sketches

What better way to depict a young baseball star than showing him in action, ready to hit the hardest ball.

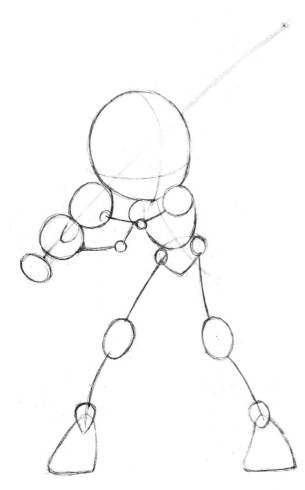

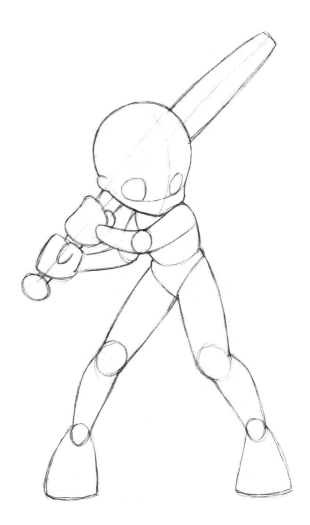

2. Outlining

The weight of the body rests on the left leg, placed further ahead, so we bend the left leg to compensate the weight.

3. Volume

We include the bat at this stage to wrap the hands around it. The right shoulder is slightly in front of the batter's face.

4. Anatomy

Hands clenching the bat, a slightly bent pose and the look on his face, all give the impression that the player is expectant, waiting to bat with all his might. The body measures five heads, and the hands and feet are unusually large.

5. Details

We include a helmet, big padded gloves, sneakers, and the comfy team uniform. He is ready to run himself into the ground.

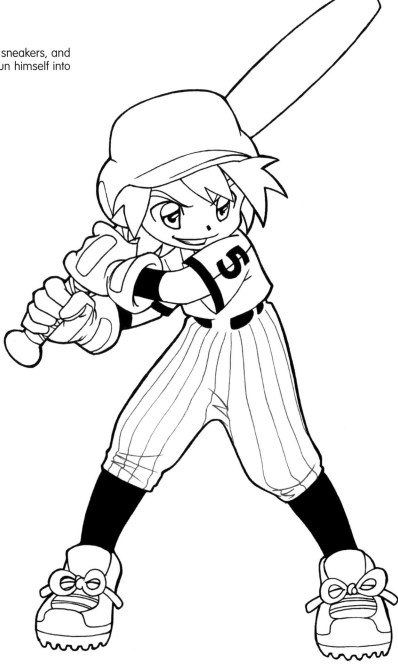

6. Inking and lighting

The inking for the outer lines is thicker than the inner ones and, in general, the line drawing is angular. Whites are predominant, and colors have a high contrast.

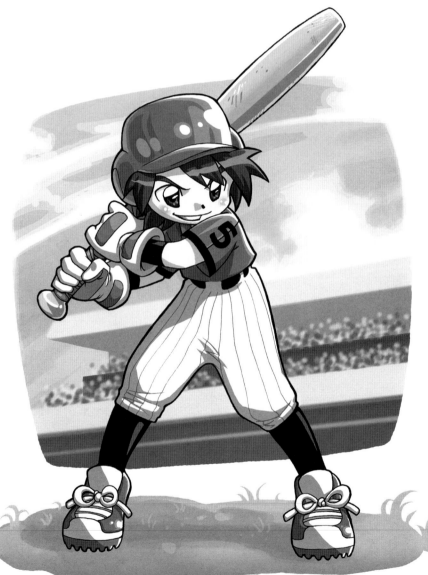

7.1. Color

We apply red, brown, gray and flesh colors. We also give the stripes on the trousers a blue tint.

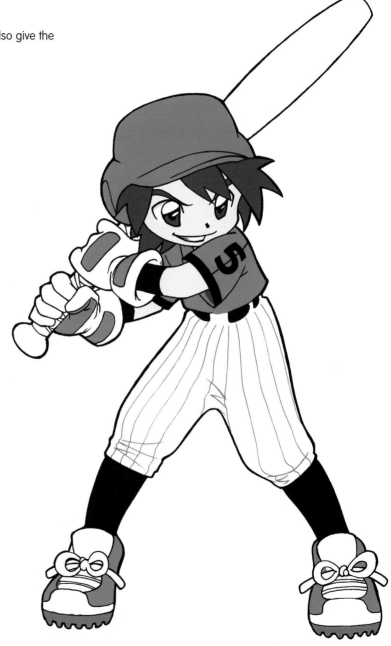

7.2. Color

The dark shadows emphasize the feeling of a strong ambient light.

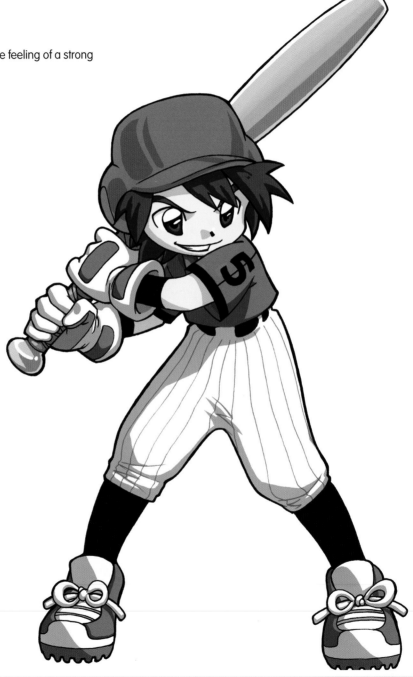

7.3. Color

We color the highlights and reflections, mainly with white to match the high contrast of the rest of the image.

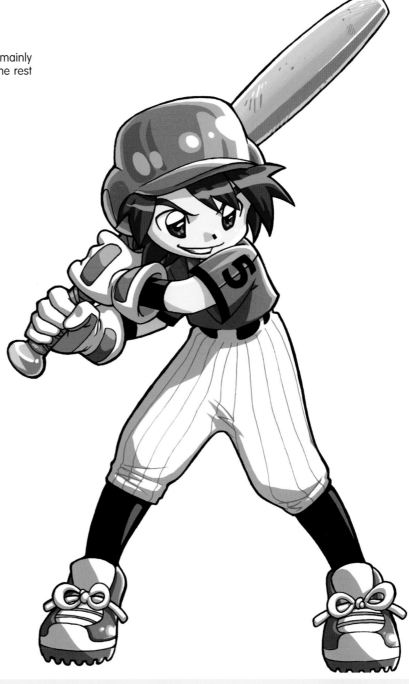

Finishing touches

Tips & tricks

- Thanks to the good use of light and shadow, the coloring of the character stands out despite its apparent simplicity. The key is to use white as just another color.

- The red strokes applied to the pupil increase the intensity in his eyes.

- By adding a blue tint to the stripes on the pants, we enhance its realism and detail.

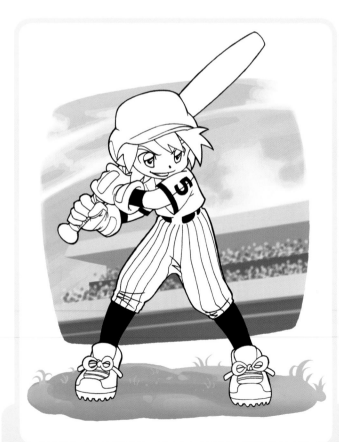

- We color the cheeks on his face, adding a highlight.

- We finally place the background we did separately as a completely digital illustration.

- To give the grass more volume, we applied a Gradient Overlay with a gradient consisting of yellow, lavender, and pink, setting it to Overlay blending.

- We simulate the spectators with a series of spots created with color strokes.

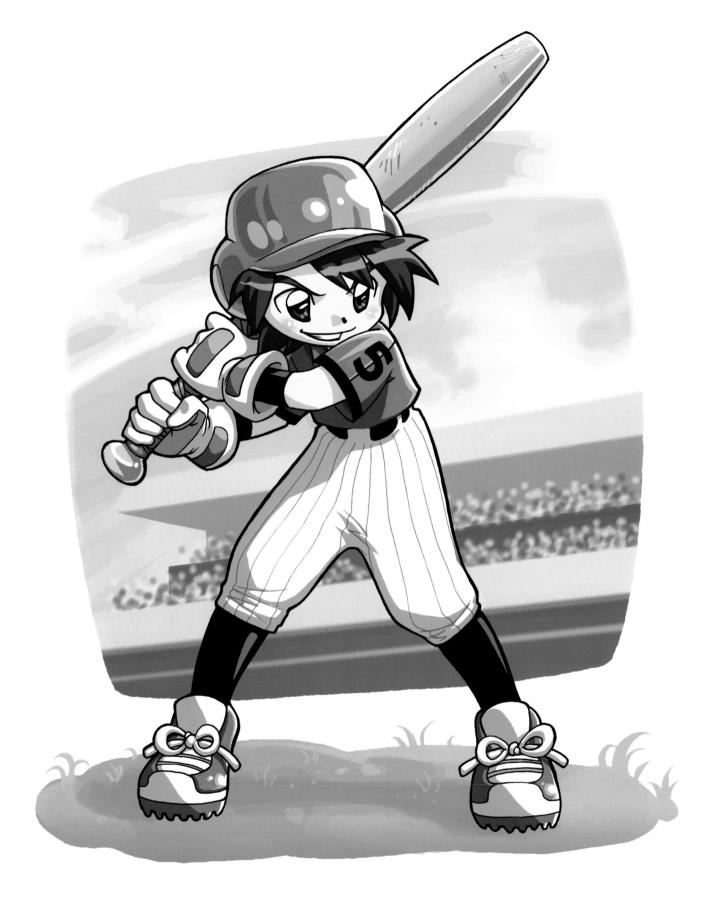

ADVENTURER

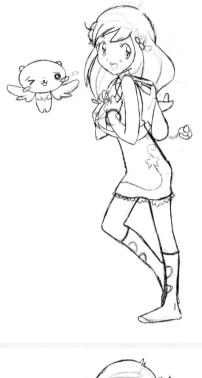

Girls who appear on Japanese series for children have a strong personality, and are lively and energetic. They are usually accompanied by cute little animals that can speak and behave as their confidantes. That said, in this exercise we will depict a young girl ready to travel the world alongside her pet.

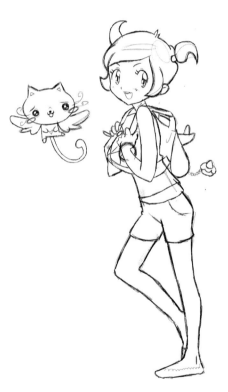

1. Sketches

With her hair in a bob, she looks stronger and more determined, plus it is also more comfortable to travel around the world. We cannot help but feel the winged bunny is super-cute.

2. Outlining

We laid out the image to show the girl just about to start running, so her weight rests on the right heel.

3. Volume

We outline the contour of the hair and include the backpack to help us to define the shape of the arms. The shape of the torso has to maintain that slight curvature, with the head slightly tilted.

4. Anatomy

She is a young sportswoman, so her figure is thin and stylized. We include the winged bunny, whose basic outline can be seen below.

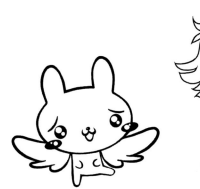

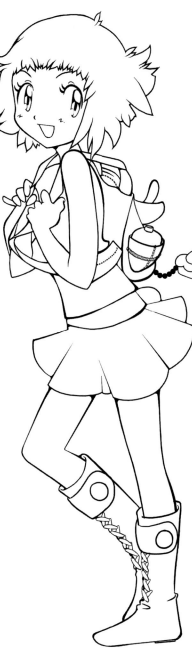

5. Details

The boots and backpack convey the adventurous charac-
ter of this globe-trotting girl, but we remember to give her a
flirtatious touch by drawing a miniskirt instead of the typical
pair of shorts.

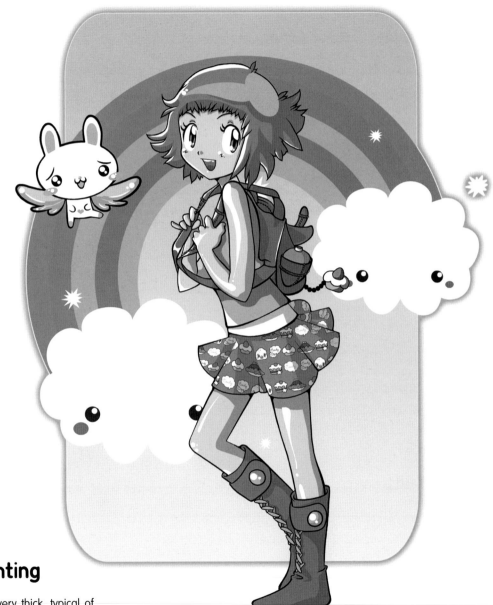

6. Inking and lighting

The outer line for the bunny is very thick, typical of kodomo vector illustrations.

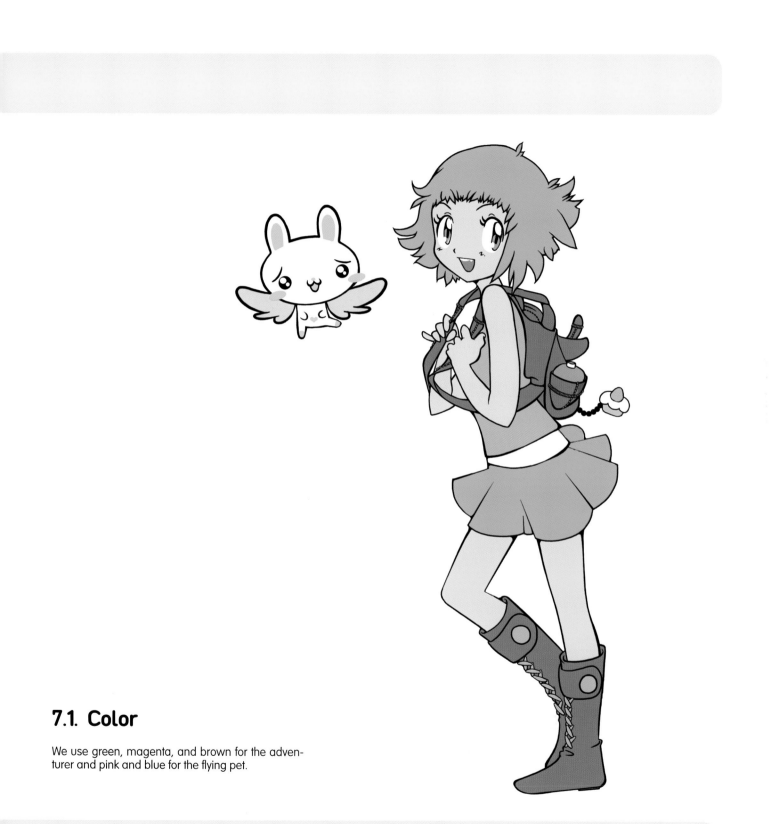

7.1. Color

We use green, magenta, and brown for the adventurer and pink and blue for the flying pet.

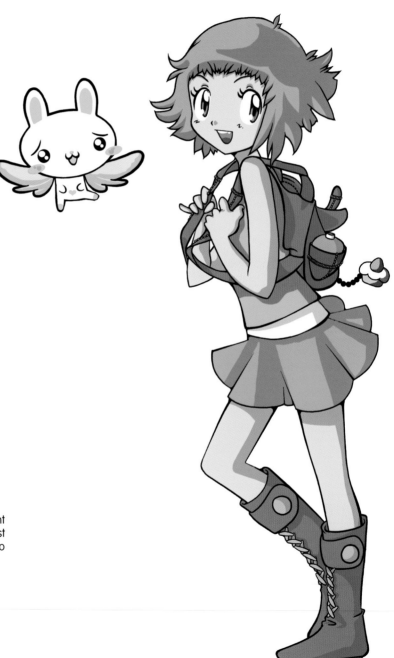

7.2. Color

Pay attention to the shadows' placement. Light comes from the upper left corner, but we must take the shapes for the body and clothes into account to achieve a realistic finish.

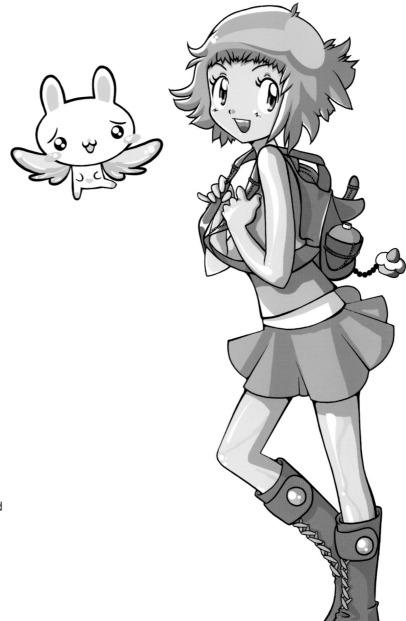

7.3. Color

In this step we add the white highlights and
a brighter tone for the hair.

Finishing touches

Tips & tricks

- Pets are a fundamental part of successful series for kids, as their puppet counterparts mean a great source of merchandising revenue.

- When combining colors it is better to start with very few tones and, once they have been balanced, we add the next ones.

- The adventurer has the build of a teenager, since a younger girl could not travel the world by herself.

- We add a pattern to the skirt, consisting of sweets and cakes, which we had designed previously.

- We create a colorful background for the illustration. It consists of a gradient, a rainbow, clouds, and stars, framed by a blurred pink border.

- We place the adventurer and her pet over the background, placing the girl in the center of the composition.

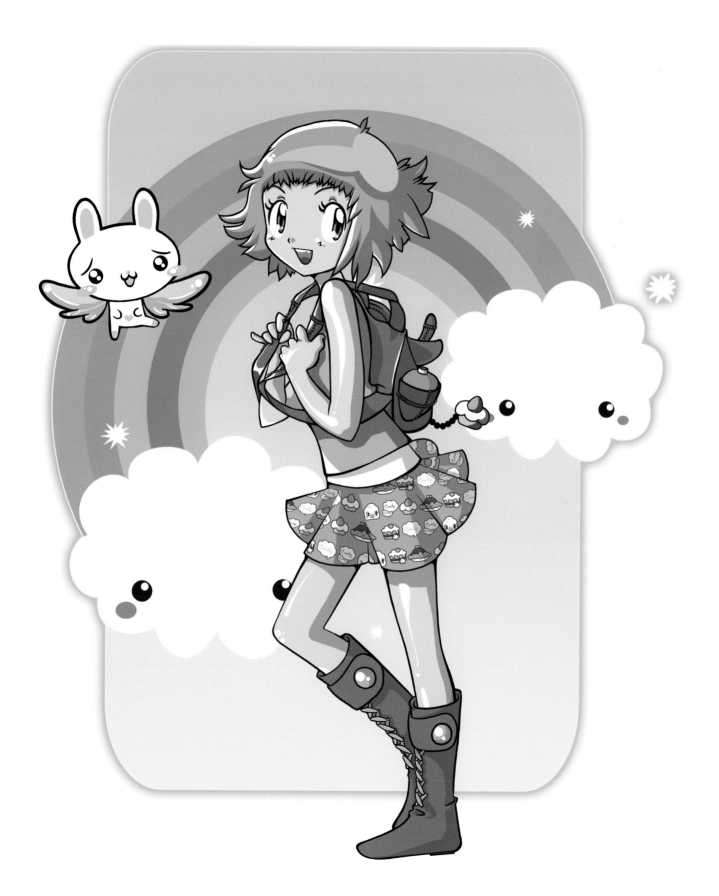

NINJA & SAMURAI

We go back to traditional Japan, home of unbeatable swordsmen and legendary warriors. The Japanese Middle Ages have been the subject of many scripts for TV or cinema. In this exercise, we will recreate a children's version of these classical heroes of the Land of the Rising Sun.

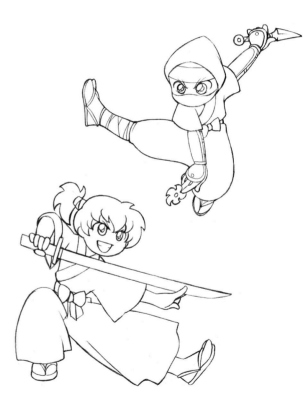

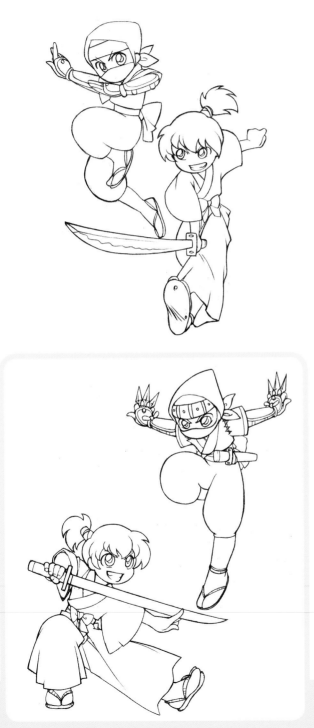

1. Sketches

This version shows a much more aggressive combat, although it maintains the touch of innocence that an illustration for children must have.

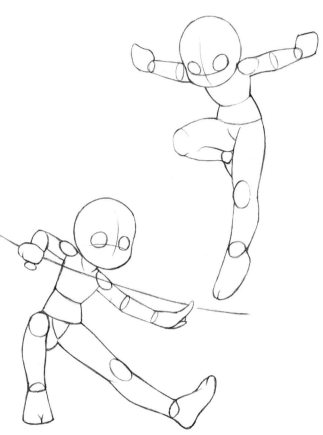

2. Outlining

We create the movements as if we were setting up a choreography, using curved lines and foreshortened angles that add perspective to the scene.

3. Volume

We pay special attention to the size of the extremities so the poses do not seem static and have sufficient dynamism.

4. Anatomy

Foreshortened elements are always difficult to draw, but after all the previous exercises we have had enough practice to know how to deal with them. To check that the size of the legs is correct when they are bent, we draw a line from one knee to the other.

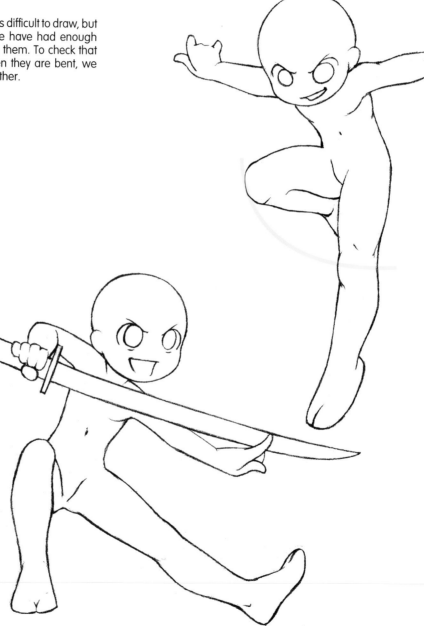

5. Details

The samurai wears a spacious kimono and wields a sword. The ninja, much more mysterious, is almost covering his entire body. He carries a short sword or dagger and short knives he can throw with strength and precision. They both wear sandals. The ninja's pants take on a baggy shape from the knee up, making the leg seem wider.

6. Inking and lighting

We emphasize the elements in the foreground and the folds on the clothes with thicker lines. The contrast between the ninja, whose colors are darker, and the brightly colored samurai makes their differences more evident.

7.1. Color

Graded base colors will allow us to explore a coloring model that is more profuse in brightness and shadows. For the samurai we picked mauvish, greenish and yellowish tones, most of them warm, whereas the ninja's tones vary between lavender and dark blue, with some details in brown, gray, and yellow. We use complementary colors throughout the whole process.

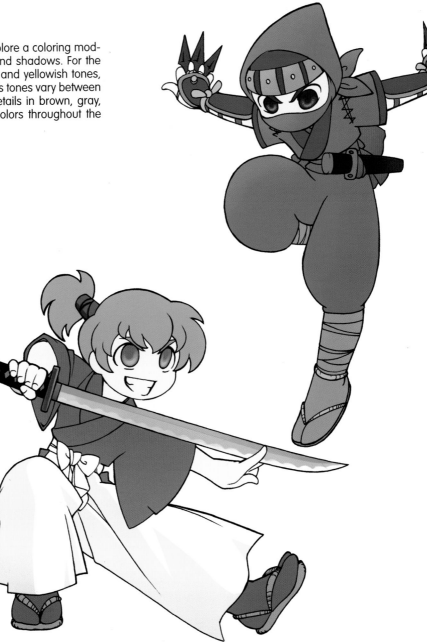

7.2. Color

We paint shadows with brush strokes and more gradients in order to achieve greater detail.

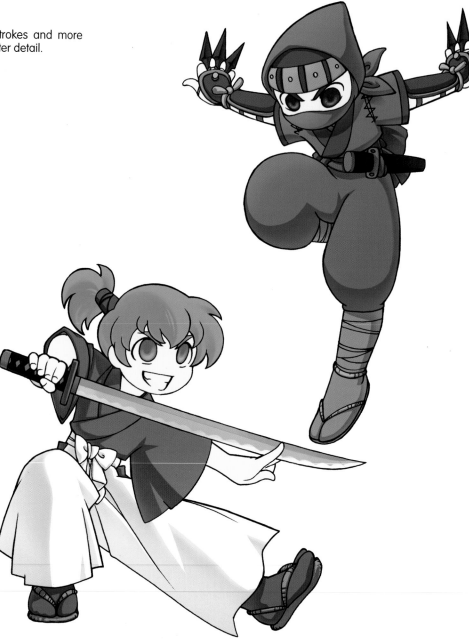

7.3. Color

We finish the coloring for the skin by adding detail to the cheeks and shadows for a greater depth and sense of volume. We can create the cheeks by applying a stroke which we blur using the Smudge tool in Photoshop.

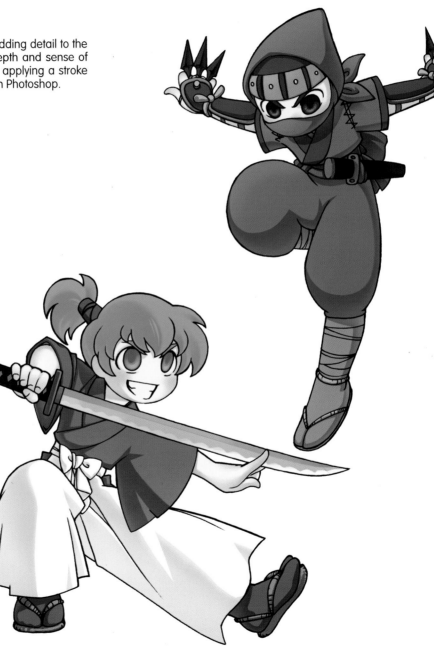

7.4. Color

The flat highlights act as a counterpoint to the complex coloring we have applied. It is a good practice to balance a complex finish like this one so the illustration is not too busy.

7.5. Color

White tones are the last touch for the drawing, increasing the brightness and finishing the coloring.

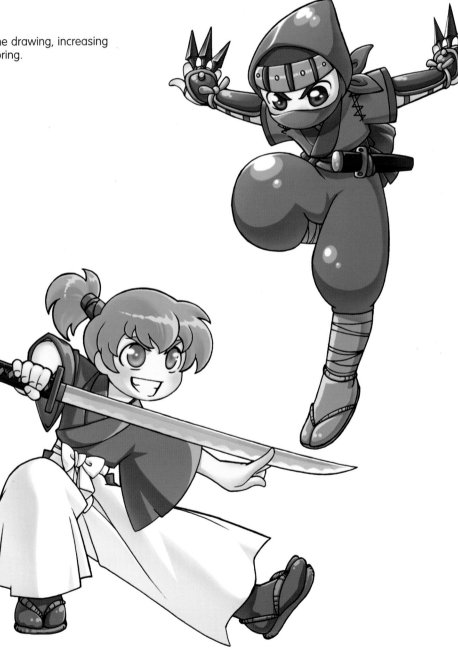

Finishing touches

Tips & tricks

- Using different coloring styles (flat colors, gradients, brush strokes, and smudges) enriches the illustration.

- We can use the coloring to define some details that were not present in the line drawing, such as highlights or cheeks.

- The last details of light were applied on a layer placed over the line drawing and the rest of the color layers, set to Multiply blending so that it makes the white paper visible.

- We check that all the colors match perfectly.

- We add a shadow to help us finally to place the characters in the illustration. The shadow is filled in with a maroon to lavender gradient, further emphasizing the distinction of bright and dark tones between both characters.

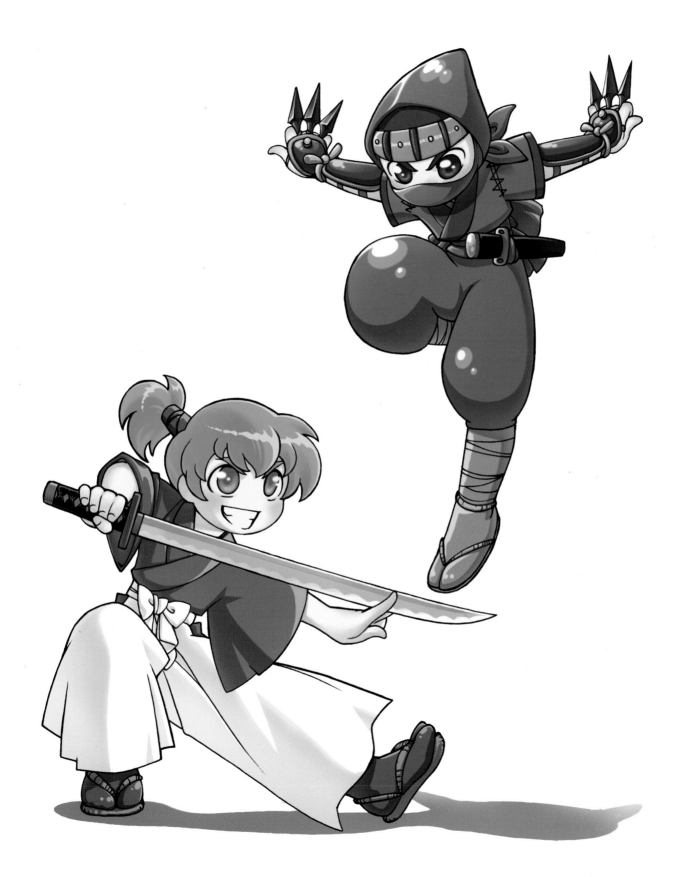

KODOMO ISLAND

Kodomo Island is the island of children. A magical place, full of light and color, lost in the middle of the ocean. Prince Kodomo, the only human there, looks after the living creatures.

1. Sketches

We try different designs for Prince Kodomo: one of them resembling the attire of an African tribe, another one inspired by Tarzan. In the end we choose a more fantastic and less common style, yet keeping the elements one would expect of an islander from the Pacific.

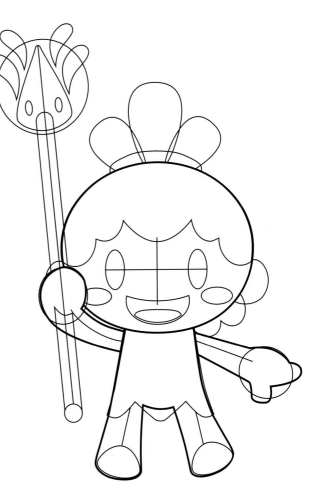

2. Outlining

Since this is a vector drawing, and therefore made completely in the digital realm, we also use the ovals we drew during the sketching phase to define the rest of the drawing in the following steps.

3. Volume

This type of illustration plays with the symmetry of the elements, so it would be helpful to draw a central axis as a reference, as it will help to duplicate many of the shapes we draw by flipping them, thus speeding up the character's creation.

4.1. Details

To simulate the look of a native of a magical island, besides the skimpy fur outfit, we give his spear human features, adding eyes and a mouth.

We differentiate one monkey from the other by adding eyelashes for her and a typical flower from the Caribbean.

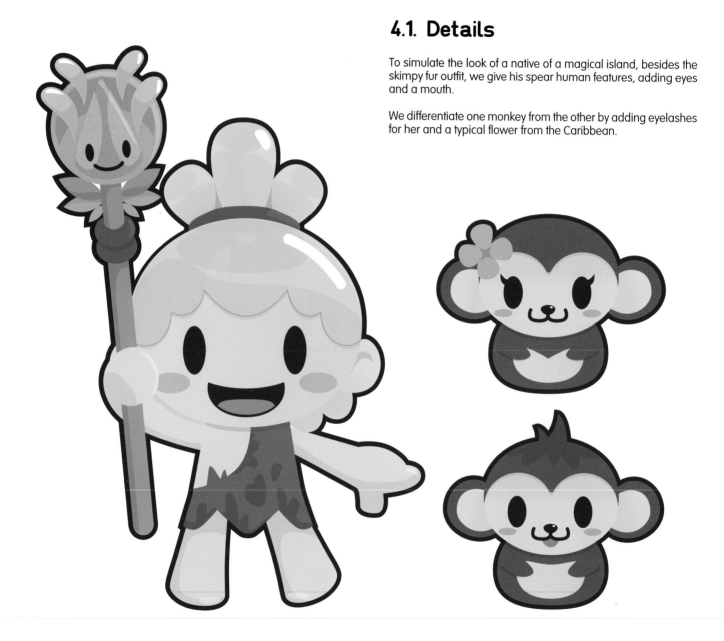

4.2. Details

To give the prince of Kodomo Island some company, we create a group of animals that could very well live on any lost island. To maintain style unity we use the same type of eyes, mouths, highlights, and coloring.

5.1. Background

The next step is designing the island where the characters are going to appear. In the next image we create the shades and the surrounding sea.

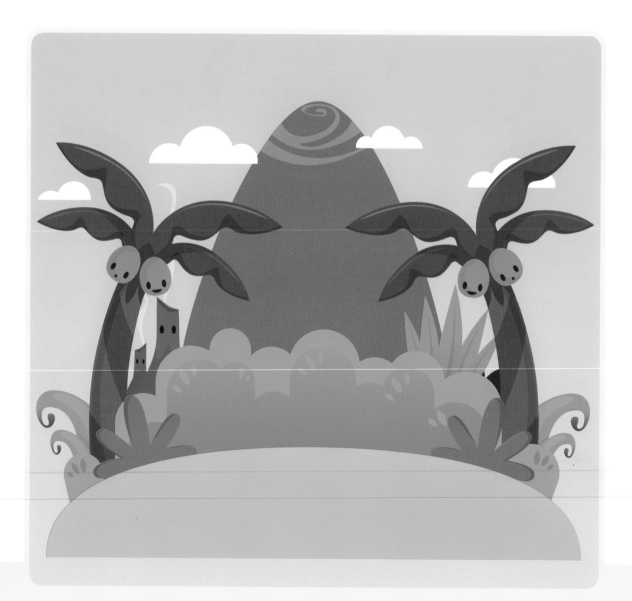

5.2. Background

After this, we place the characters. Lastly, we add several details such as fruits, stars, and colored stones.

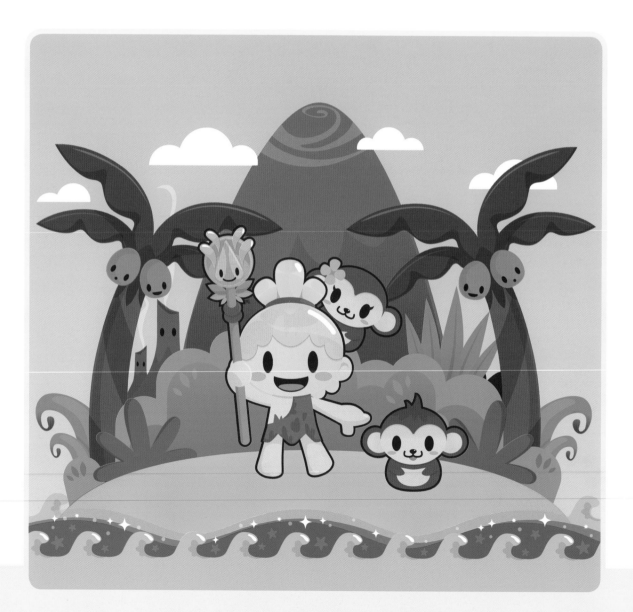

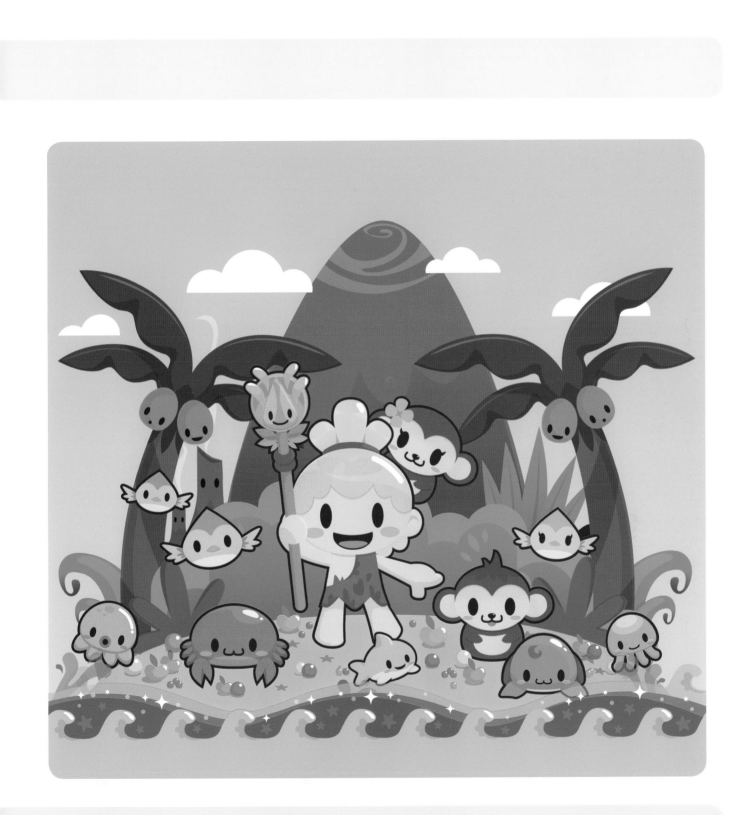

Finishing touches

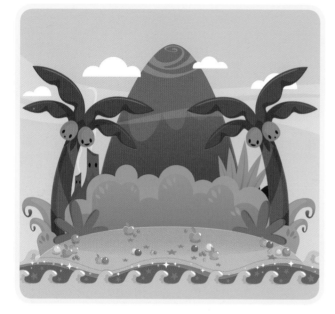

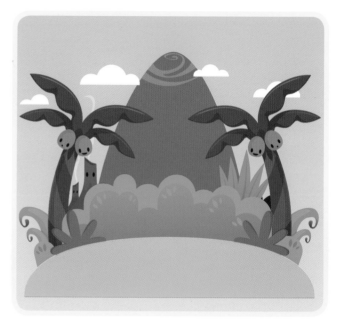

Tips & tricks

- To achieve this level of finish, one has to be really skillful with the Pen tool, as we are not starting just from basic geometric shapes.

- The different levels of color and gradients are achieved with separate layers, on which we mark off independent color areas that will act as a whole.

- To manage the characters once they are drawn, we group and lock them to avoid moving any of their parts.

- We apply a subtle gradient to the background and add various types of fruits and colored stones.

- Surrounding the mountain there is a semi-transparent wavy mist that we have created on different layers.

- We add ellipses under the characters to serve as shadows, making them almost transparent.

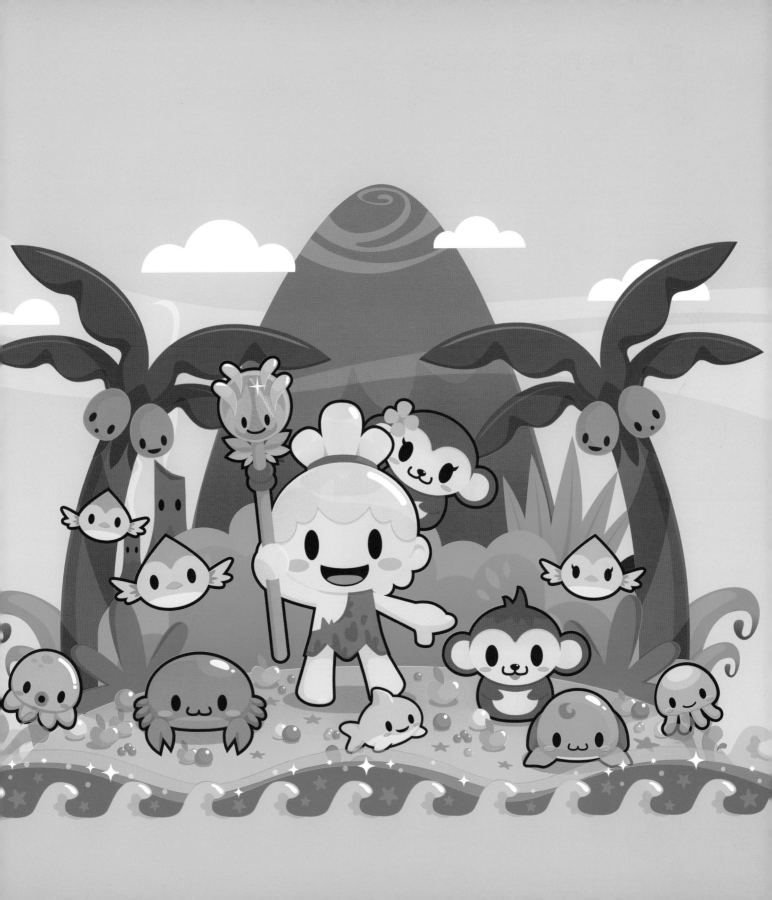

MASTER OF CARDS

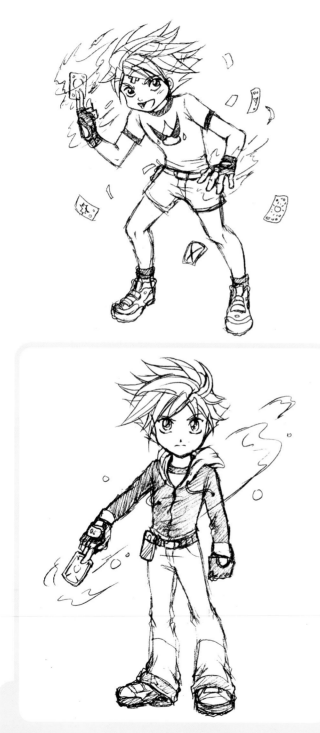

A master of cards must be brave, strong, and quick. Thus, when designing him we tried out several poses for the character interacting with his magic cards. The key is to make him look as masculine as the concept demands, without losing a childlike aspect typical of kodomo aesthetics.

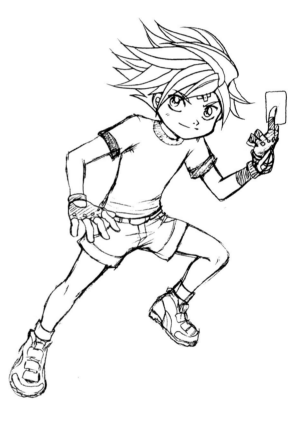

1. Sketches

In the end we chose this more serious version, with a sturdier pose, but nevertheless convincing.

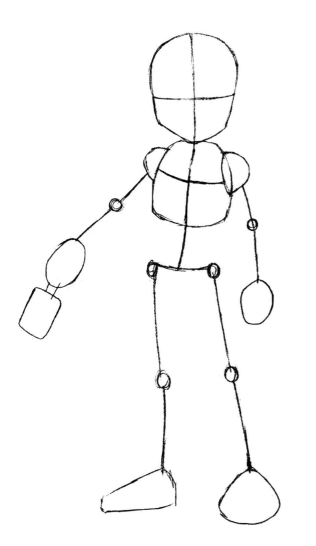

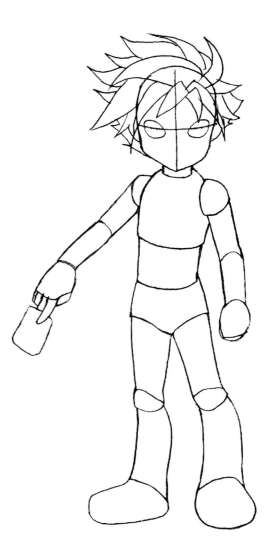

2. Outlining

The subtle displacement of the spine and hip take away some of the solemnity of the image and compensate for the arm movement. The size of the body is five times that of the head.

3. Volume

We draw the hair as if it were made up of small pointy flames, and outline the position of the almond-shaped eyes, marking them at an early stage.

4. Anatomy

Since we are drawing a child, there is no need to make him look too muscular, although it is advisable to consider the breadth of his back at the shoulder so as not to make his waistline too evident. What we will emphasize is the other features – the jaw and facial features in general, with angular shapes.

The diagonal eyebrows over his eyes give him a serious look, even slightly angry, but the neutral position of his mouth counteracts his sullen expression, softening it. The pointy eyelashes give him an exotic look.

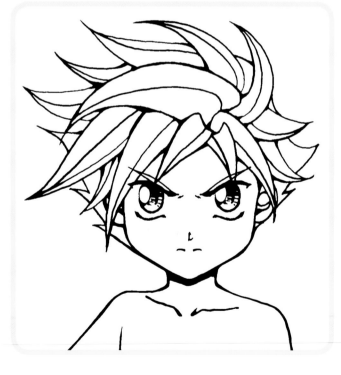

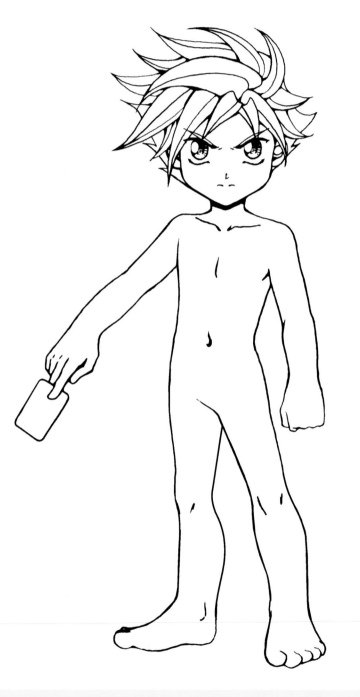

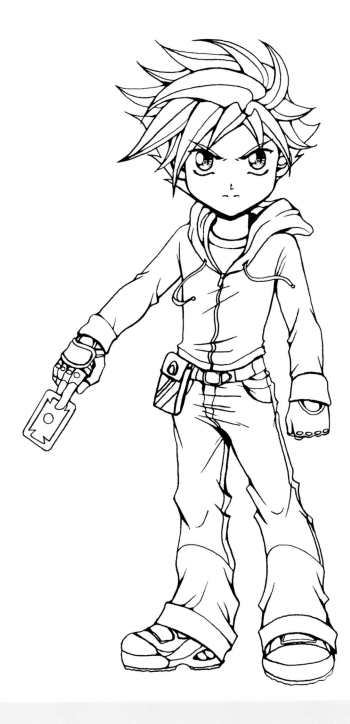

5. Details

The most appropriate thing for this kind of characters is an urban, loose-fitting and casual style. On top of that we add gloves, which give him a hint of being a tough guy, and a small card holder on his belt.

6. Inking and lighting

We emphasize the line drawing of the clothes and the areas of shadow with thicker lines. We chose very dark tones for the background, so we will compensate using white highlights on the character and glowing elements behind him that will make him stand out.

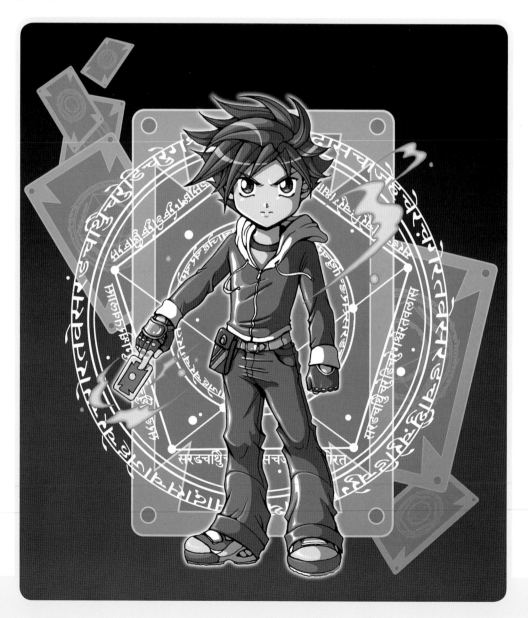

7.1. Color

The predominant color palette for the child is comprised of earth-like tones as well as blue and lavender. Once these base colors have been defined, it is much easier to apply the rest of the shadows and highlights effectively.

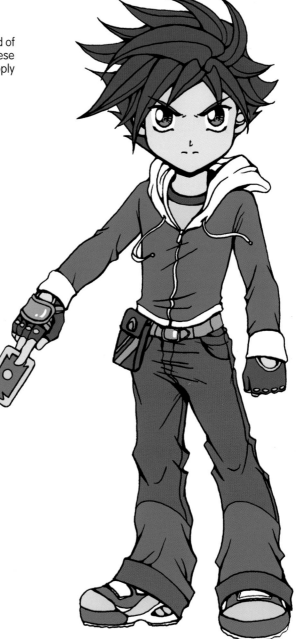

7.2. Color

Light comes from the upper left corner, so we will add emphasis to the shadows on the right side of the image. To achieve more realism it is necessary to recreate the folds and shapes made by the clothes. The shadow affects the whole character and is marked by a lavender gradient.

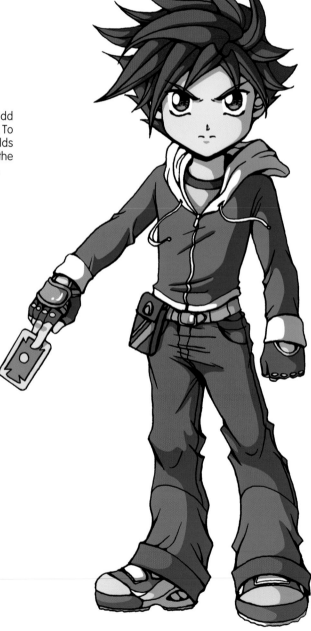

7.3. Color

Using brighter tones, we apply the highlights to the rest of the drawing. The outcome is a slightly plastic texture.

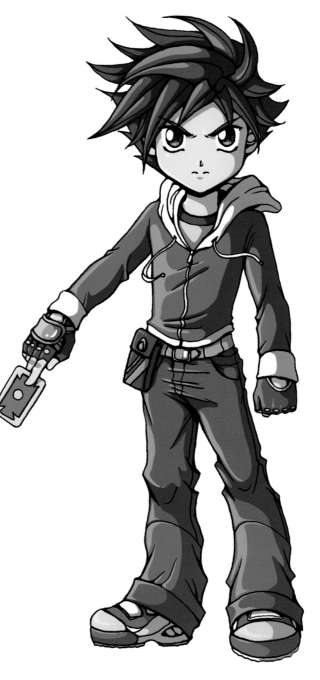

7.4. Color

To increase the character's strength and energy, we add more dabs of light and some flames that appear when he moves his magic card. In the next step we add brightly colored cards to underscore that he is indeed a master of cards.

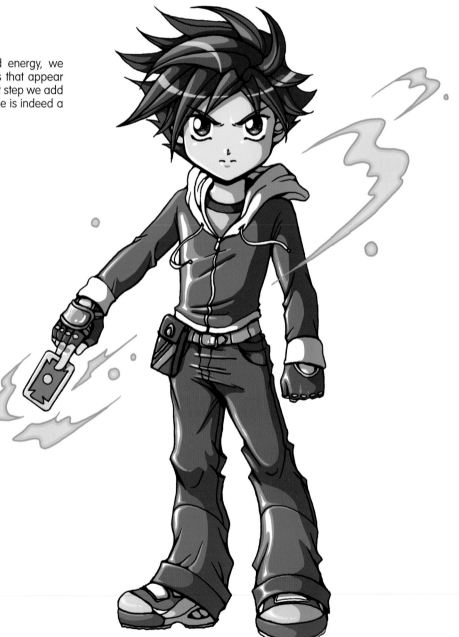

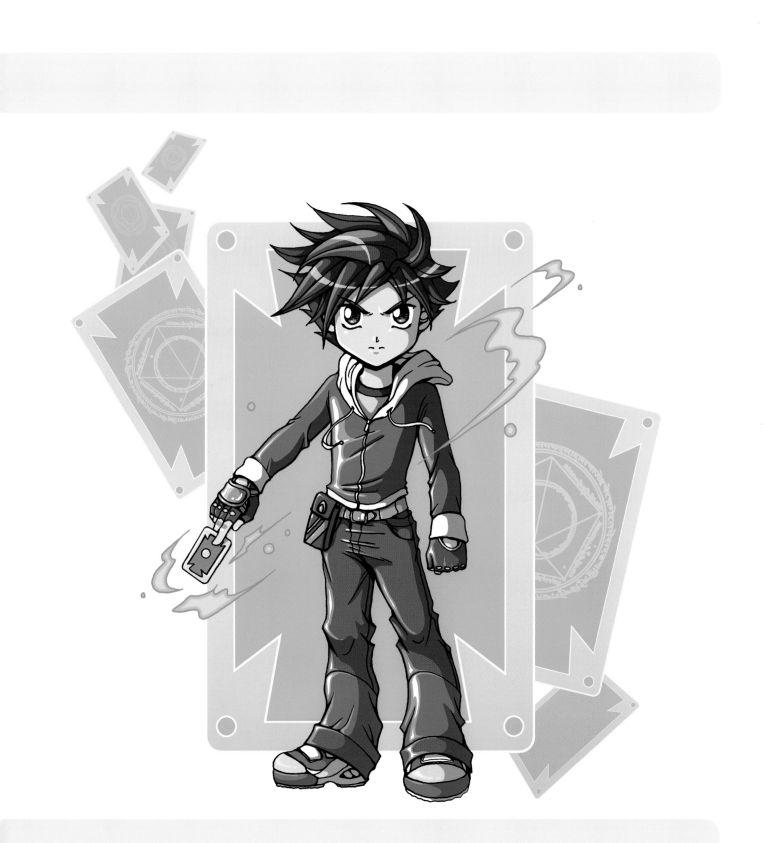

Finishing touches

Tips & tricks

- We generate the shadows with a lavender gradient on a new layer set to Multiply blending.

- The bright tones are applied using Soft Light blending.

- We create the highlight on his hair with white curves set to 70% opacity.

- White tones define volume for the character even more. We apply them on a new layer on top of every coloring layer, and set to Normal blending or Screen blending.

- We create the background with a black-to-blue gradient using the Gradient tool.

- We add some magical circles with a pentagon inside them and Oriental writing that finish setting the atmosphere.

- Lastly, we apply an Outer Glow effect around the character.

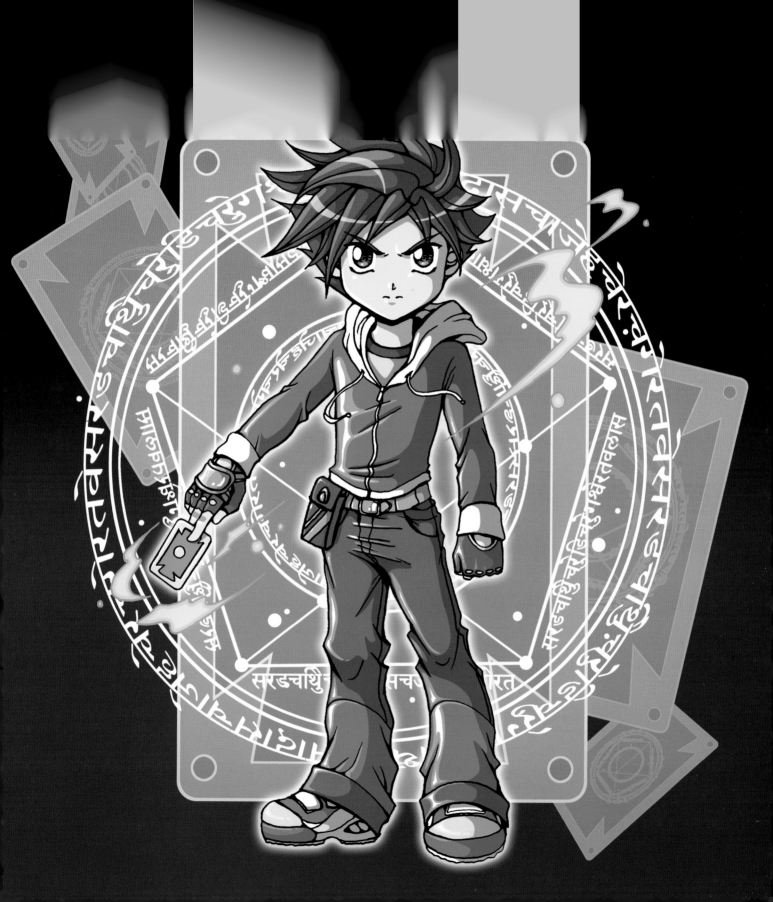

DINO-HUNTER

This scene is a meeting of past and future. A rift of the space-time continuum with fatal consequences. A young hunter lost in a prehistoric world. The latest technological breakthroughs facing primal monsters. This young Dino-Hunter is ready for some action.

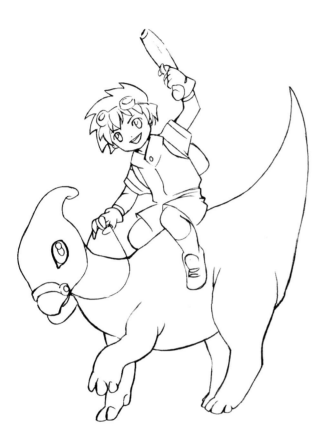

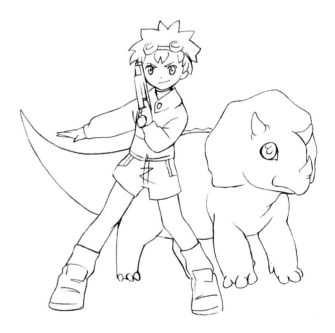

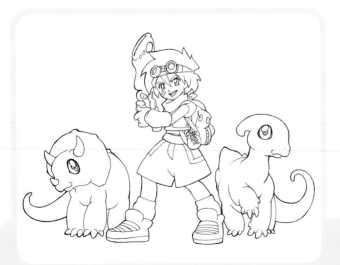

1. Sketches

We use both dinosaurs, but give them a more simplified and cartoonish look, as a contrast to the heroic image of the hunter, in position and ready to shoot.

2. Outlining

The triangle-like composition allows us to balance easily the arrangement for the characters. If we start with a structure composed of curves, the final result will be much more dynamic.

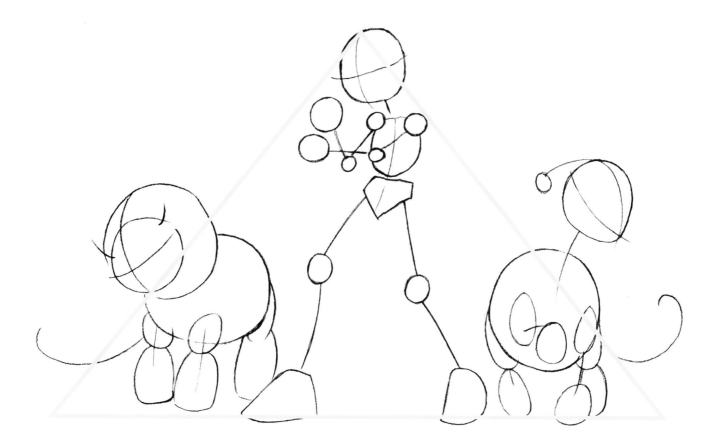

3. Volume

To make the dinosaurs look soft, we curve the lines outwards to get rounded extremities.

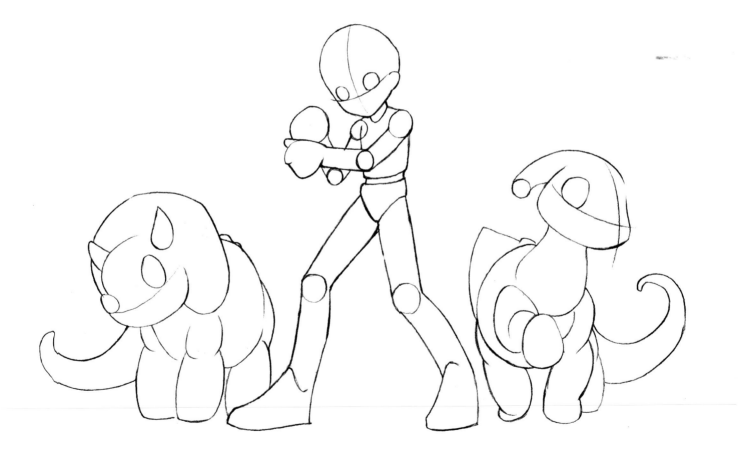

4. Anatomy

The body of our little dinosaur hunter measures five heads, although it may seem to be less than that because of his knees being slightly bent. The low angle shot means the extremities will look bigger. The dinosaur's raised leg, in a foreshortened perspective, will not be a problem to draw if we correctly defined the volumes in the previous step.

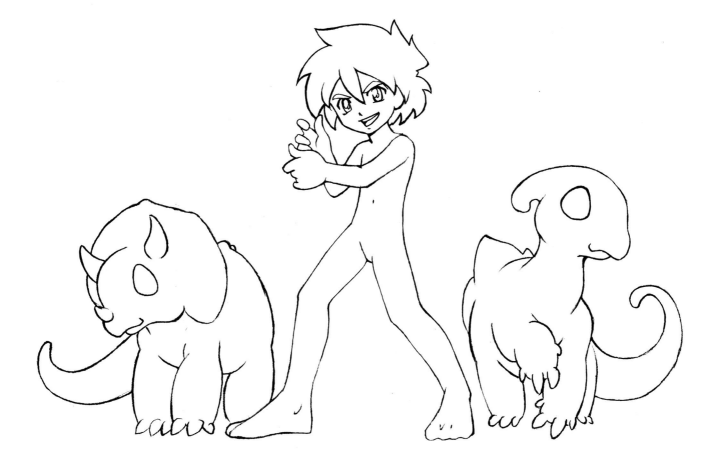

5. Details

Our dinosaur hunter has to wear comfortable explorer clothes, and also futuristic weapons rigged to confront any type of giant lizard from the past. He uses his goggles to shield his eyes from any flashes produced when he shoots his weapon.

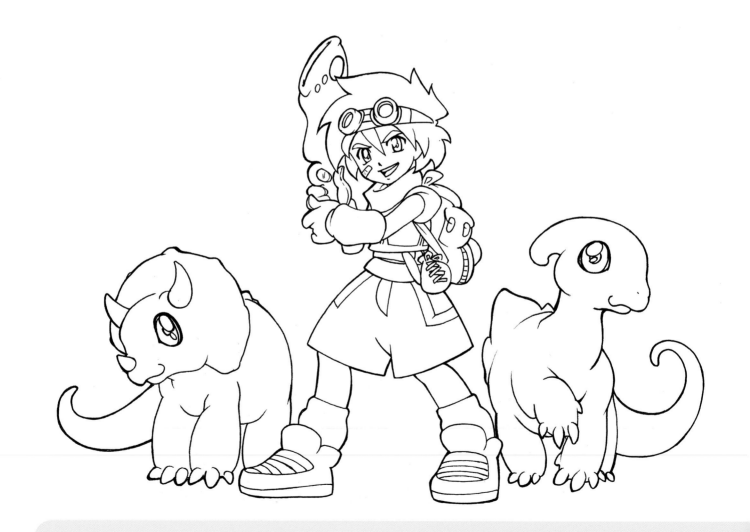

6. Inking and lighting

The line drawing is very simple, to make the color stand out.
On the horizon we draw darker areas to separate the fore-
ground from the background and to add depth.

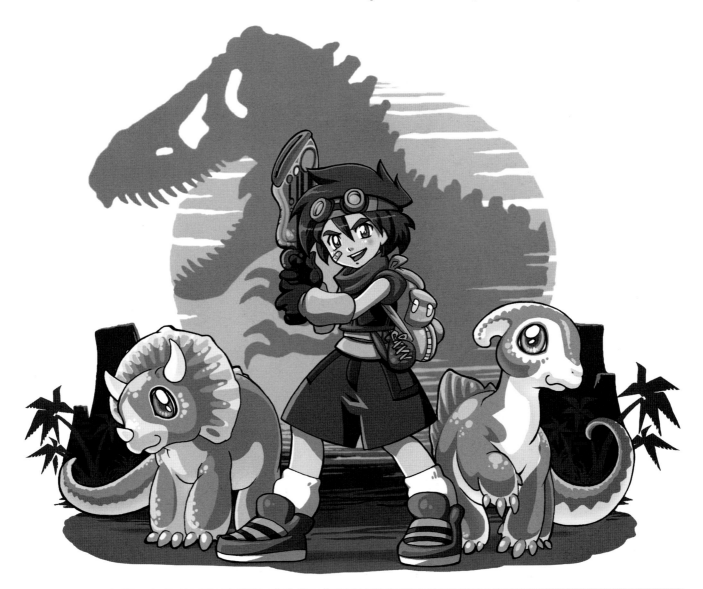

7.1. Color

We use earth-like tones for our hunter, while the dinosaurs next to him are colored with more vivid tones.

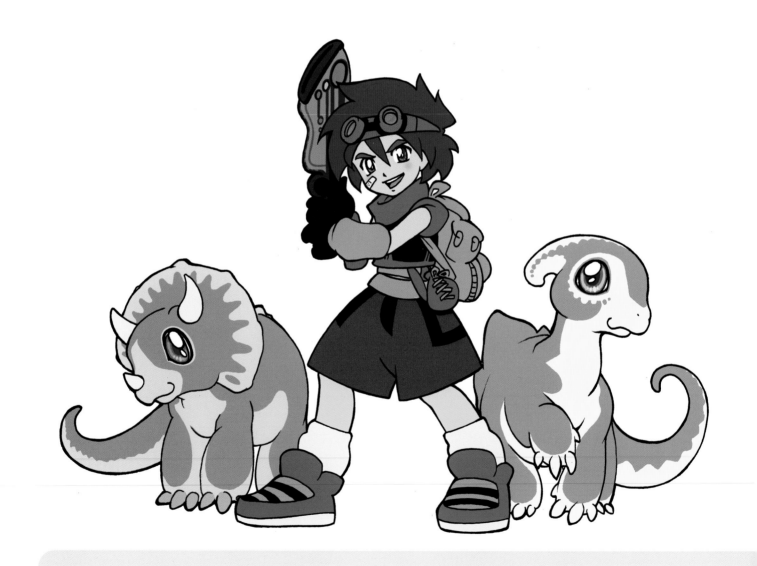

7.2. Color

We paint shadows and some mid-range tones, keeping in mind that light comes from the upper left corner.

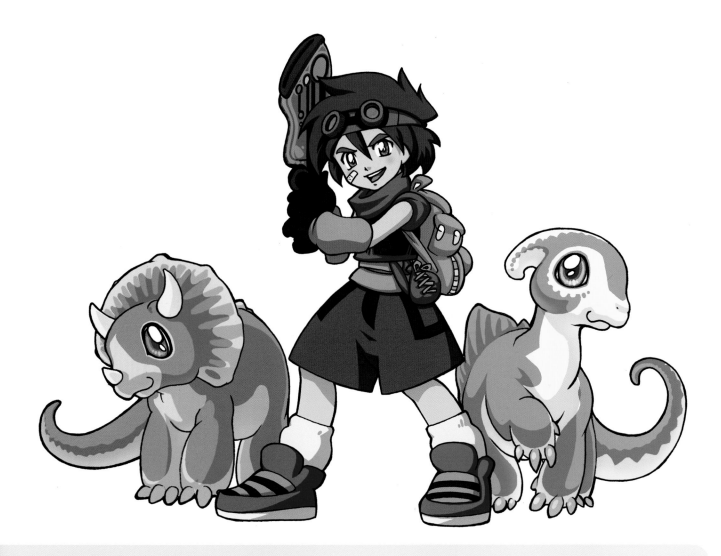

7.3. Color

After we add the highlights, the illustration is almost finished. We add touches of highly saturated colors to balance the base colors, which are somewhat muted.

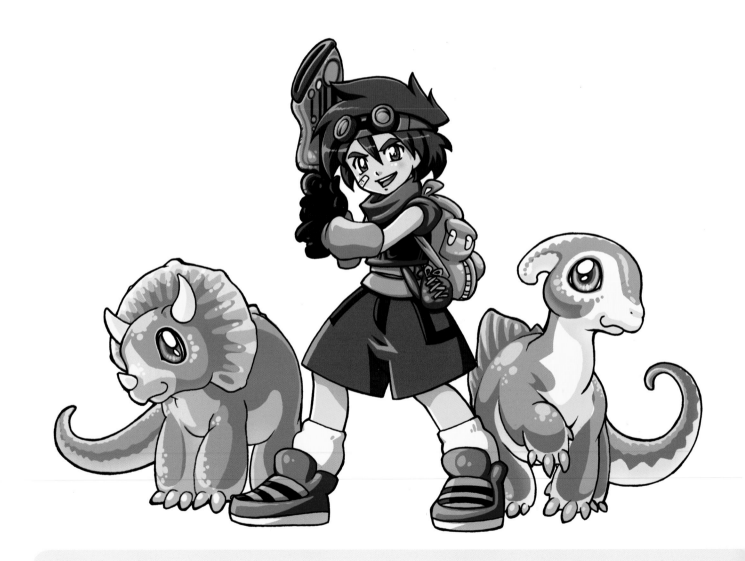

8. Background

We add the background, which has a silhouette of a dinosaur blended with the setting sun. The volcanoes and palm tress take us back to ancient times.

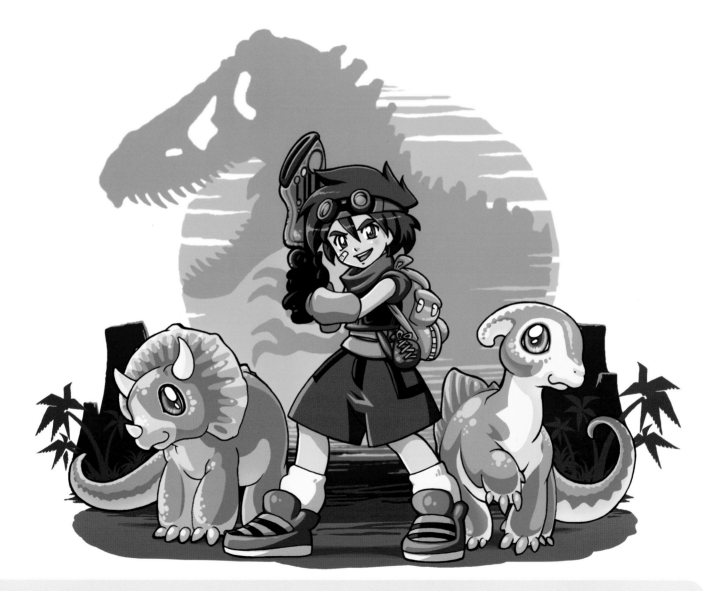

Finishing touches

Tips & tricks

- To give the character personality, every hue and element of the design for the costume and expression must convey the personality at first glance.

- To create the dinosaurs, we start from an existing graphic reference, but we give them a cartoonish look so they seem more appealing.

- Triangle-like compositions are easier to create and produce good results.

- We add a slight blue tint to the pants to make up for the lack of cold tones in the drawing.

- We lighten the colors of the hunter's outfit by setting the layer blending mode to Gradient Overlay, then choosing a Linear Gradient (white to black) with 34% opacity and Overlay blending.

- We use the same effect to brighten the weapon.

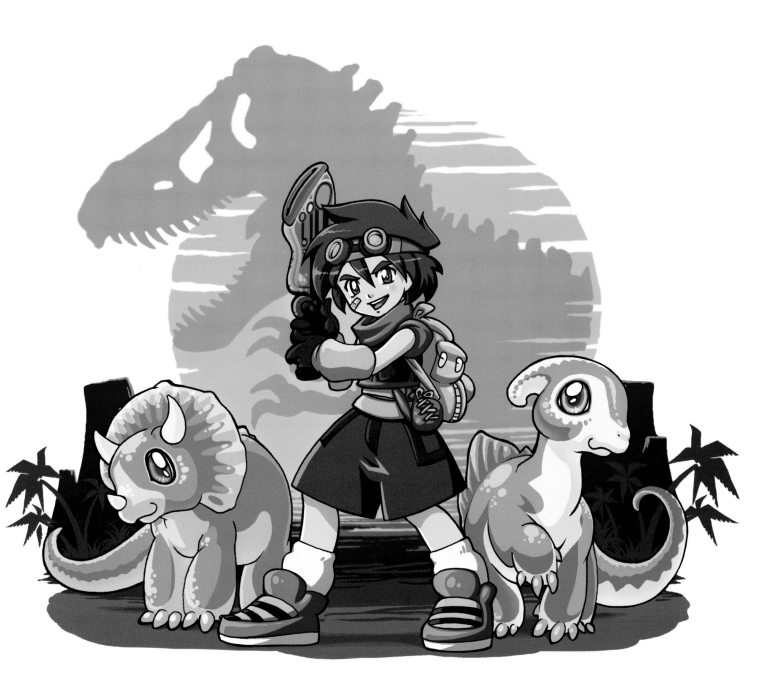

SUPER COWBOYS

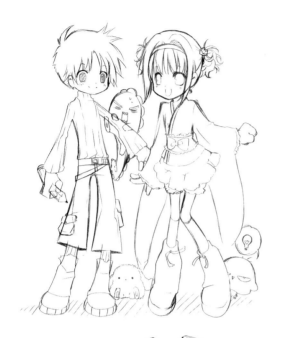

They are young, but also fast and deadly. They are the Super Cowboys, feared by every criminal in the galaxy. A boy and a girl, accompanied by their raccoon.

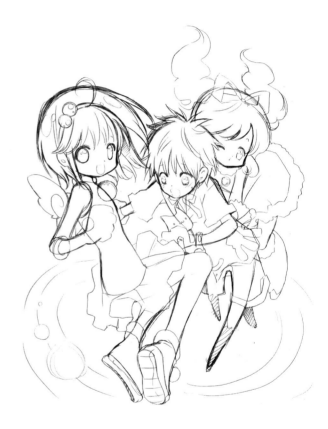

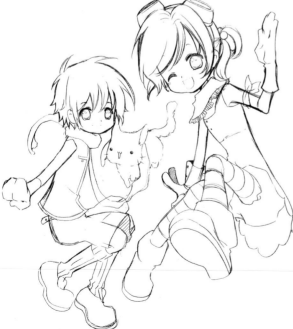

1. Sketches

After trying different superheroes, we picked the bravest and most daring ones, with a few tweaks.

The cat is now a raccoon, and the look on the boy's face is more stern; we also added their pistols.

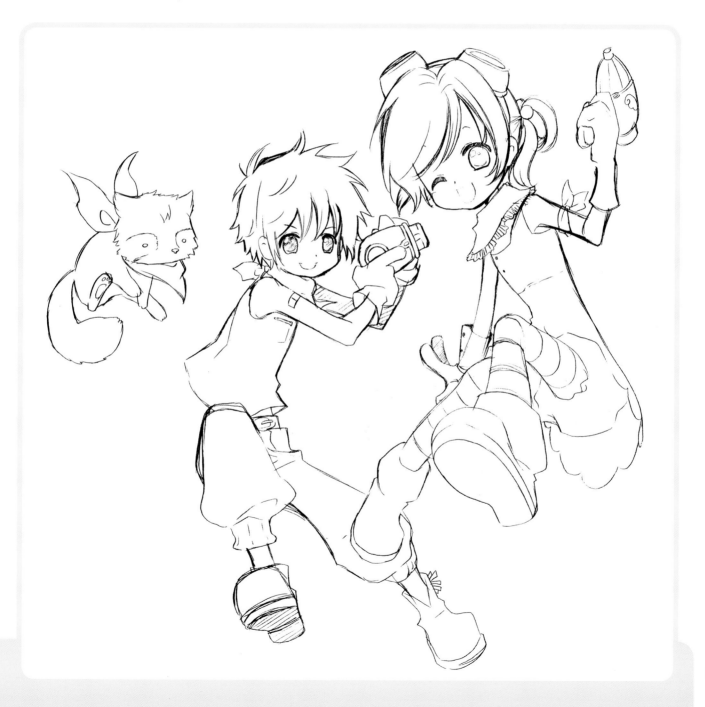

2. Outlining

The characters are floating in space, but their bodies are not re-laxed, they are stiff.

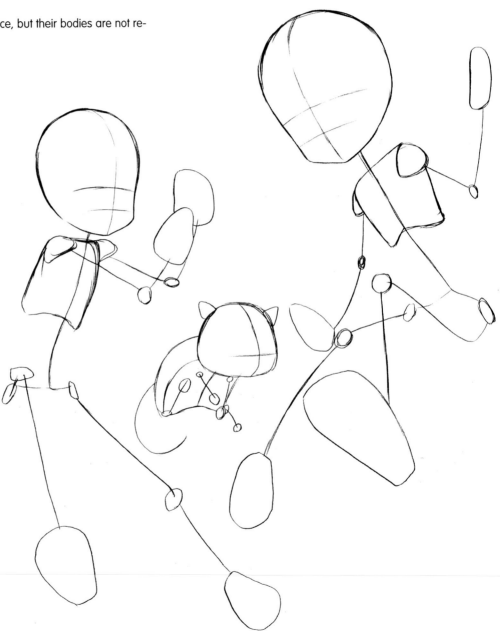

3. Volume

All these foreshortened elements should not be a problem by now.

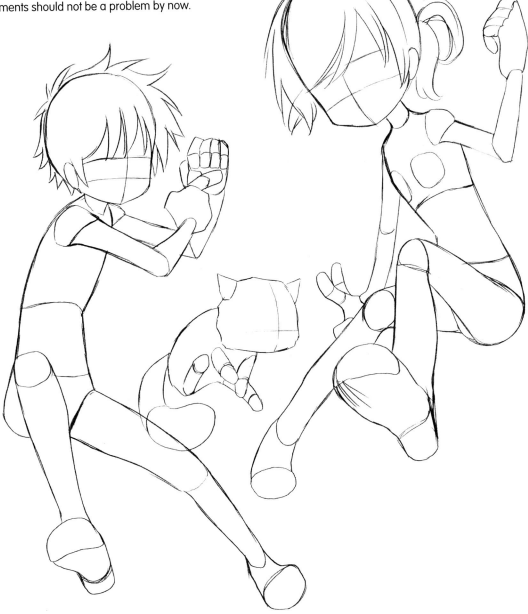

4. Anatomy

The bodies are stylized and measure five heads and a half.

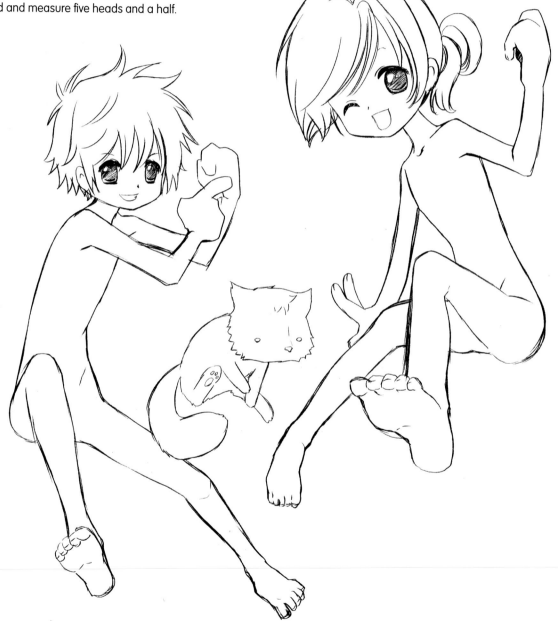

5. Details

They look like they just came out of the Western corner of the galaxy, and they are equipped with the latest laser technology.

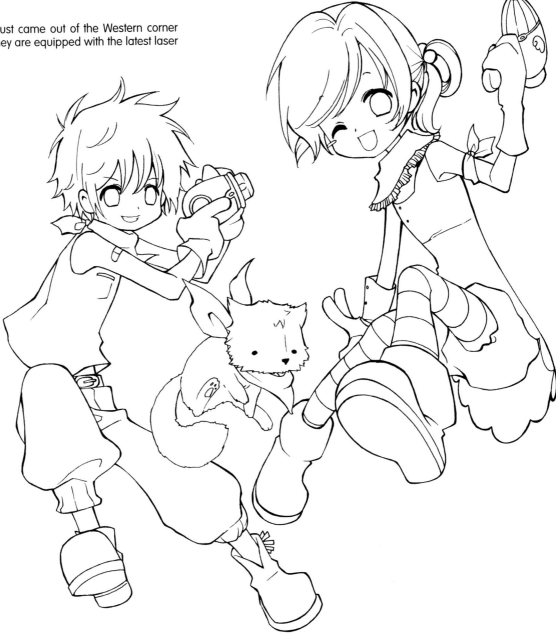

6. Inking and lighting

There is front light focus. Now we add deeper
shades in the darker shaded areas.

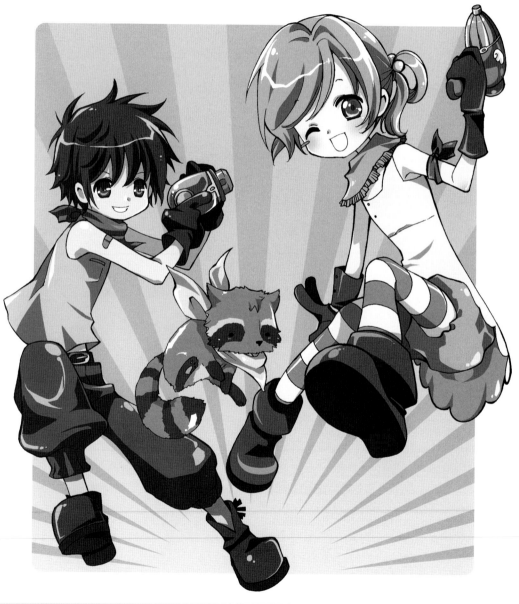

7.1. Color

Here we add flat base colors.

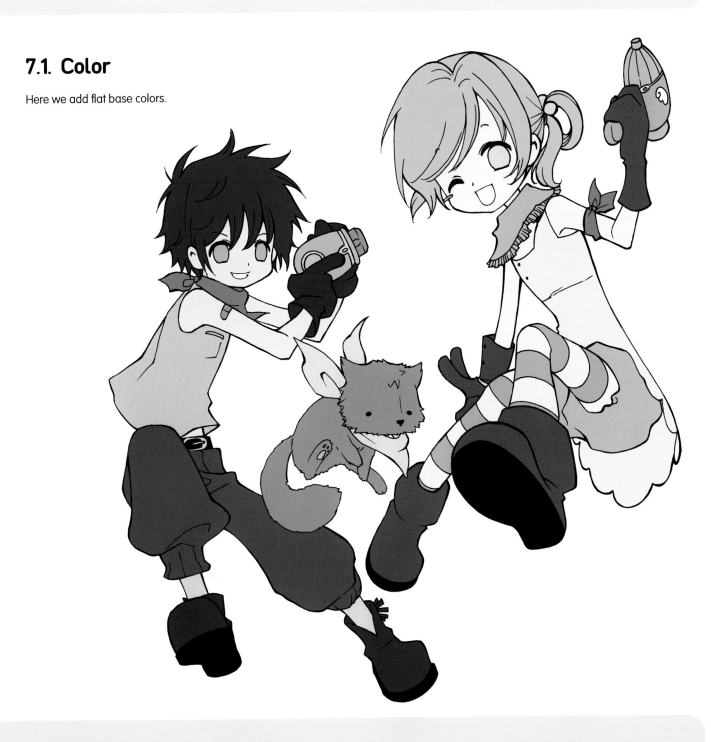

7.2. Color

Now we add shadow tones.

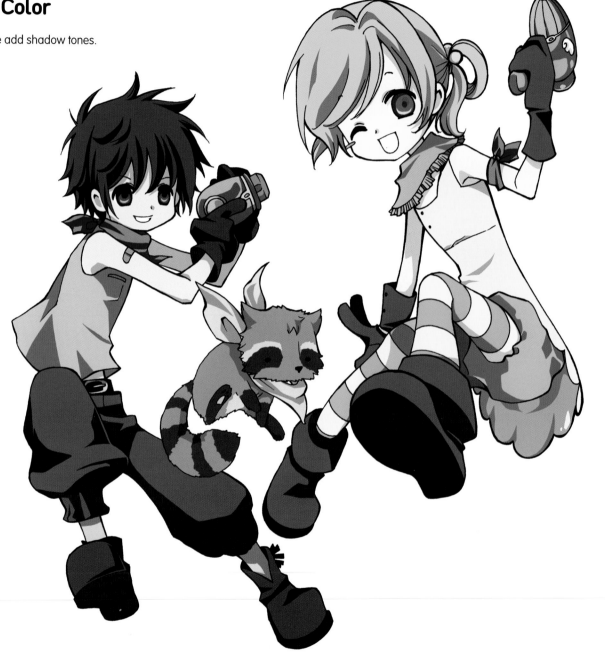

7.3. Color

Here we add final highlights.

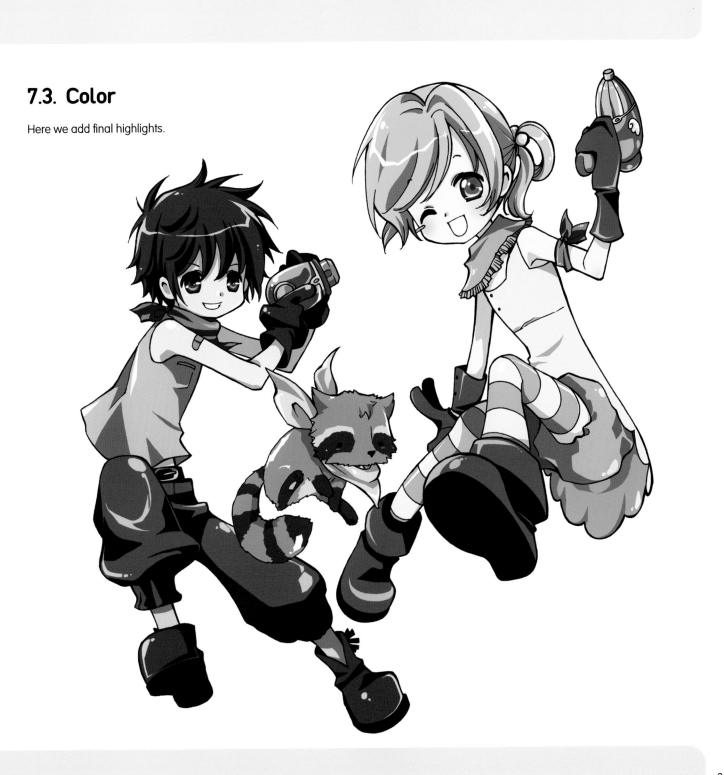

Finishing touches

Tips & tricks

- This is our final exercise, where everything we learned throughout the previous illustrations is put to the test.

- The greatest difficulty lies in the many foreshortened elements present in the illustration. They make the scene very dynamic but pose a greater challenge to those less experienced drawing anatomy in perspective.

- We create a background with vector stripes and gradients overlaid with 60% opacity.

- We add the characters and arrange them in a dynamic composition.

- The composition of this version is not the same as the one on the cover, as there is less room after including the titles.

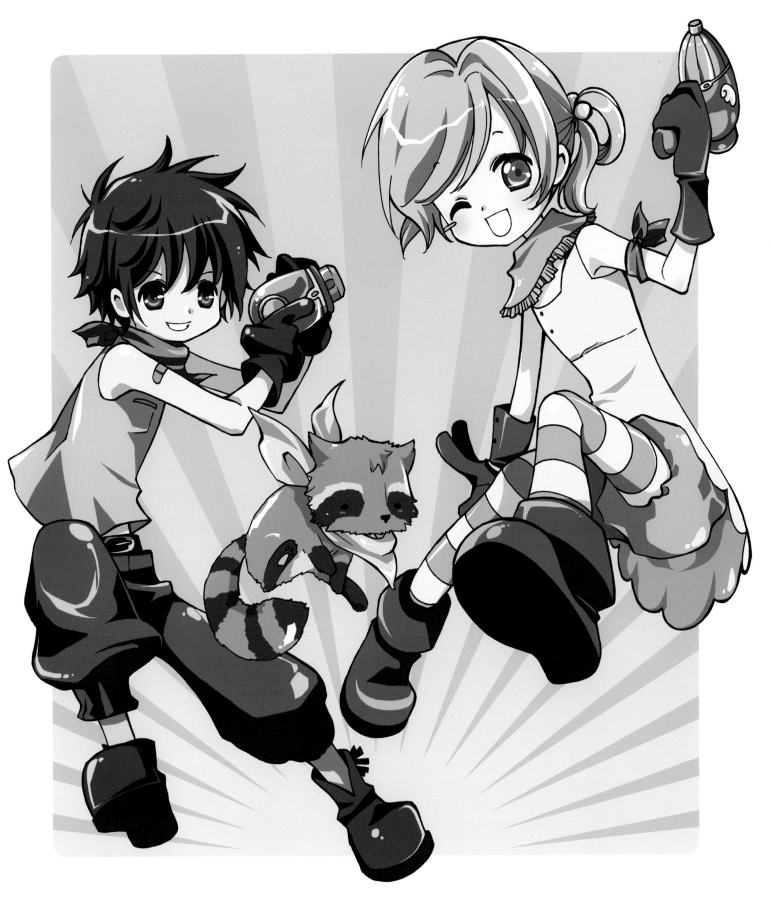

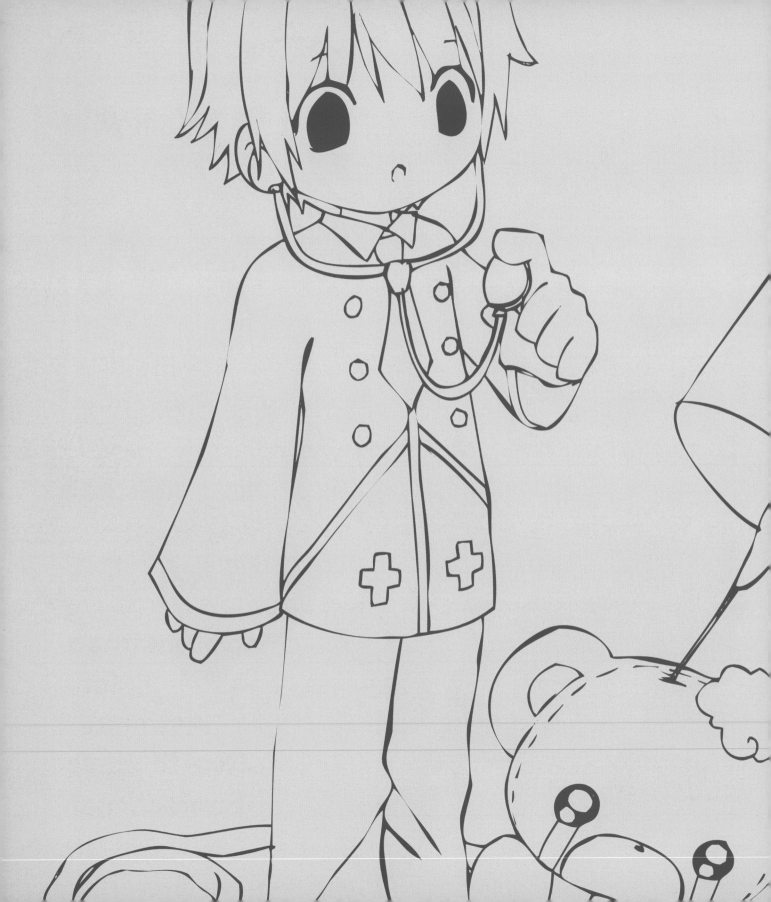

TRADES

Magic postman
Idol
Astronaut
Health clinic
Confectioner

MAGIC POSTMAN

The original idea for this illustration came from this very same author. She proposed an illustration with a magic mailman who lives in a strange world where every object is alive. She wanted to give the image a touch of melancholy, but in the end we tried to recreate an entertaining scene with soft, pastel-like tones.

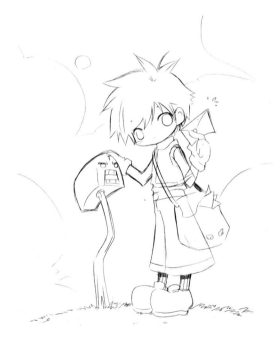

1. Sketches

This version is more childlike and minimalistic, but it also shows more of the environment where the mailman makes his delivery of magic letters.

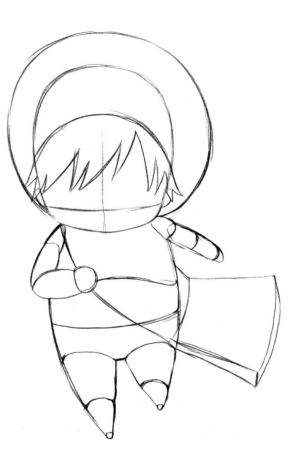

2. Outlining

We use this first step to lay out the elements in the composition, and have added more elements to the original sketch.

3. Volume

The body measures two and a half heads. This character must awaken a feeling of tenderness, so we will try to maintain a padded look, despite the extremities having pointy ends.

4. Details

His uniform is not easily recognizable as that of a mailman, so we have included some details to create a better impression that he is a mailman, such as the Japanese symbol of the postal service on his hat, letters flying out of his bag and the open mailbox that awaits his arrival.

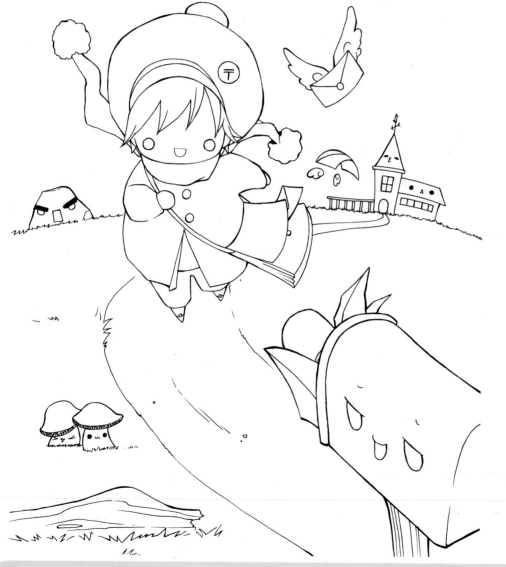

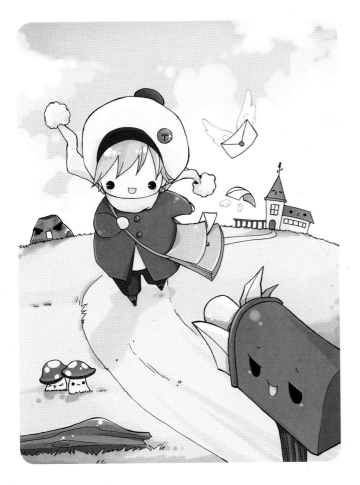

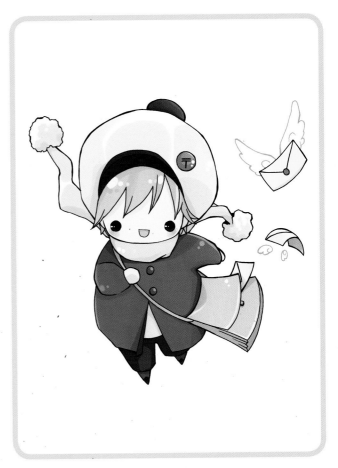

5. Inking and lighting

The line drawing is very thin, although it thickens a bit in areas where the clothing has creases. The uniform and the mailbox serve as a contrast for the soft tones present in most of the illustration. Light comes from behind the character, as indicated by the shadow in front of him, but we added several light spots in the foreground to prevent the character from looking backlit.

6. Color

We work with three very similar tones (base, shadow and highlight) for each color in the scene, which yields an image full of pastel-like colors. To counter this effect we finish the image adding white highlights, which will enrich the final appearance.

Although we only used flat colors for the character, the background will be done using brush strokes, which will give the illustration a greater sense of texture.

Finishing touches

Tips & tricks

- To create the impression that something is flying in midair, it is always a good idea to reserve a reasonable amount of space around that object so the sensation of weightlessness is enhanced.

- The line drawing of the letters' wings has been colored. To achieve this effect we select the line drawing of each letter with the Magic Wand tool and then use the Lasso tool (with the Alt key pressed) to subtract the unwanted parts from the selection. Then we fill in the resulting selection with magenta using the Paint Bucket tool.

- White highlights can be added at the end of the coloring process on a layer with the blending mode set to Screen.

- We draw the clouds directly with the brush using white color with varying opacity, so that the strokes will overlap the ones below. Brushes can also use the same blending modes that layers have, so we can also use the Brush tool set to Screen or Lighten to make the strokes brighter over the blue background.

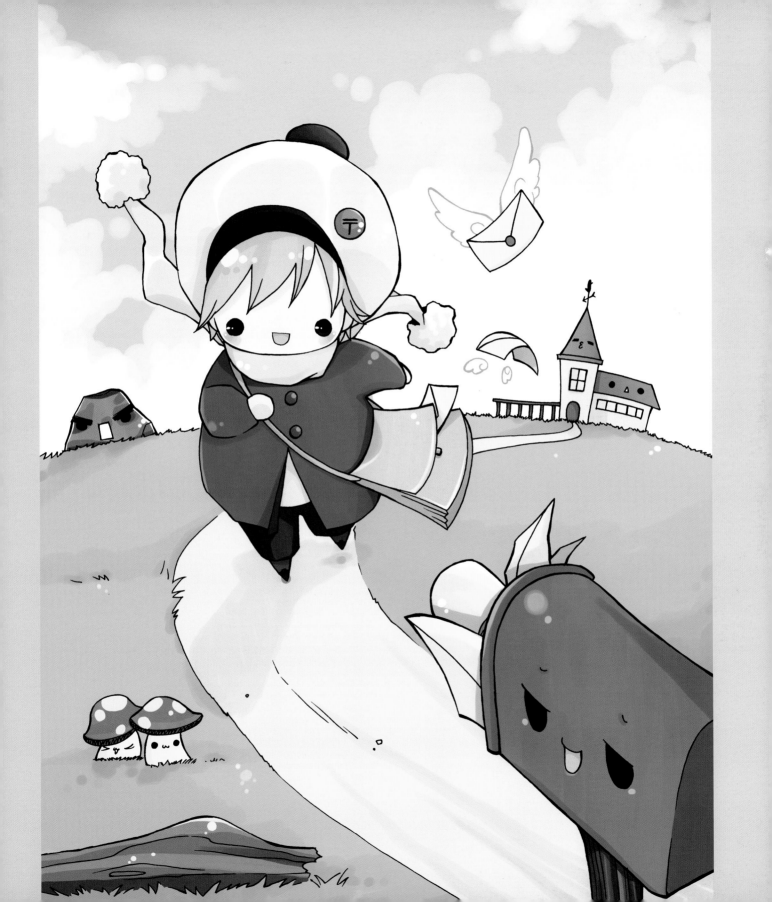

IDOL

Current Japanese singers are more sophisticated and not as flashy as they once were, but in the world of manga, costume designs are sometimes incredibly elaborate with garish colors.

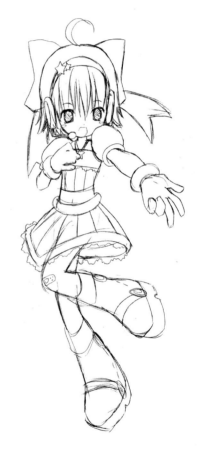

1. Sketches

We choose a classic pose, less complicated and easier to reproduce.

2. Outlining

The singer is somewhat tilted to the left, so the axis of the spine has a slight curvature which is balanced with the extended arm and hand.

3. Volume

We stylize the character as much as possible, as if we were drawing a doll, with thin arms and hip.

4. Anatomy

The hairdo is a fundamental part of an artist's look, so we pay special attention as we draw the curls on the ponytails, which give her an innocent and child-like look. The features of her face are very childish, too – she has very big eyes and a small nose.

To draw the hand, we can start with an oval for the palm and a triangle to lay out the fingers.

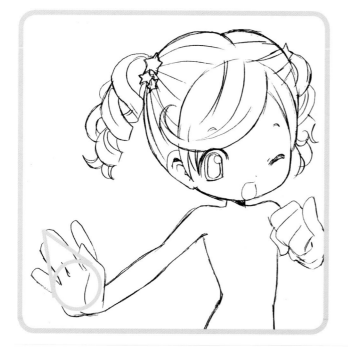

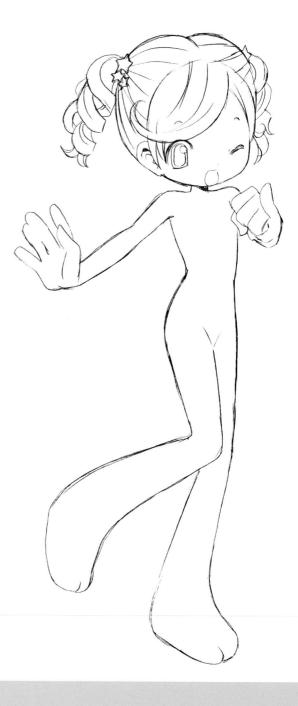

5. Details

This closeup of the skirt helps us notice the protruding fringes. They are easy to draw and give the skirt – which has a simple structure – more detail. We add barrettes and star-shaped ornaments, felt pointy ears, a big bow, and platform boots.

The skirt is rigid so it can swing from side to side.

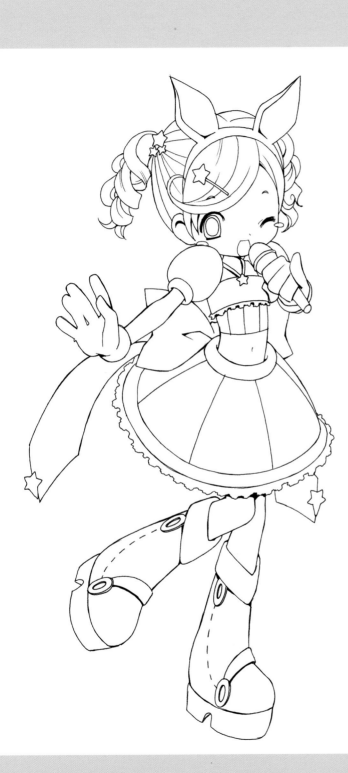

6. Inking and lighting

We play with the contrast between the rounded shapes and the dark, angled shadows present in some areas. Our singer is lit with a powerful spotlight, which is used in stage lighting, causing the shadows to be very sharp and colors to have a very well-defined contrast.

7.1. Color

Lavender and yellow are complementary colors. We use them for the base coloring and then define the rest of the character. We use two shades of lavender varying in brightness. We also utilize orangish and pinkish tones for the microphone and the barrette.

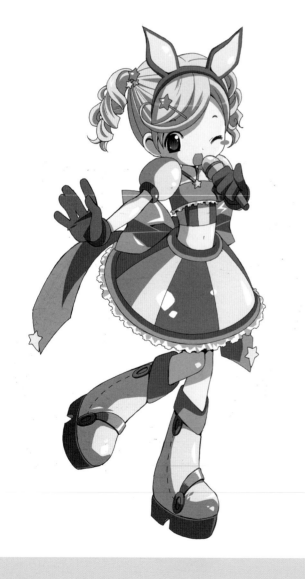

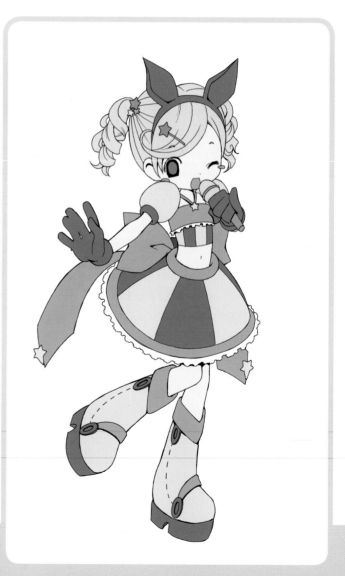

7.2. Color

We add the shadows in a new layer. Be careful when adding shadows to the hair, which must follow the strands of hair. Everything is done with flat colors, except for the gradient on the eye.

The third tone is a plain white; we use it to create the highlights on the hair, the skin, and the dress.

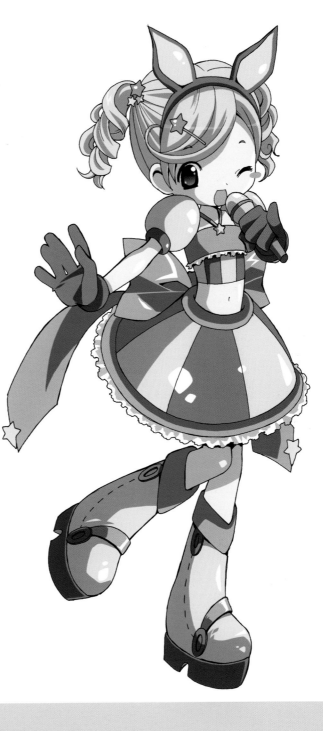

Finishing touches

Tips & tricks

- When we create the shadows in a drawing, we need to keep in mind the position of the light source at all times. If we notice a mistake after finishing the drawing, we can always retouch it. This is why working with separate layers is so important.

- It is not necessary to use many colors to create an eye-catching picture. Using a well-balanced palette yields an equally attractive coloring which can even be more homogeneous.

- To create the eye gradient we use the Magic Wand tool to select the pupil and fill in the selection on a new layer with the Gradient tool, creating a new gradient and using the eyedropper on the image to pick the colors for it: black and bright lavender.

- We use the shape tools to create stars, ellipses, and musical symbols.

- For the star we use the Polygon tool. In the menu that appears in the options bar we choose the number of sides – we enter five for a five-point star. Next to it there is a menu that allows us to pick the geometry, and we choose a star.

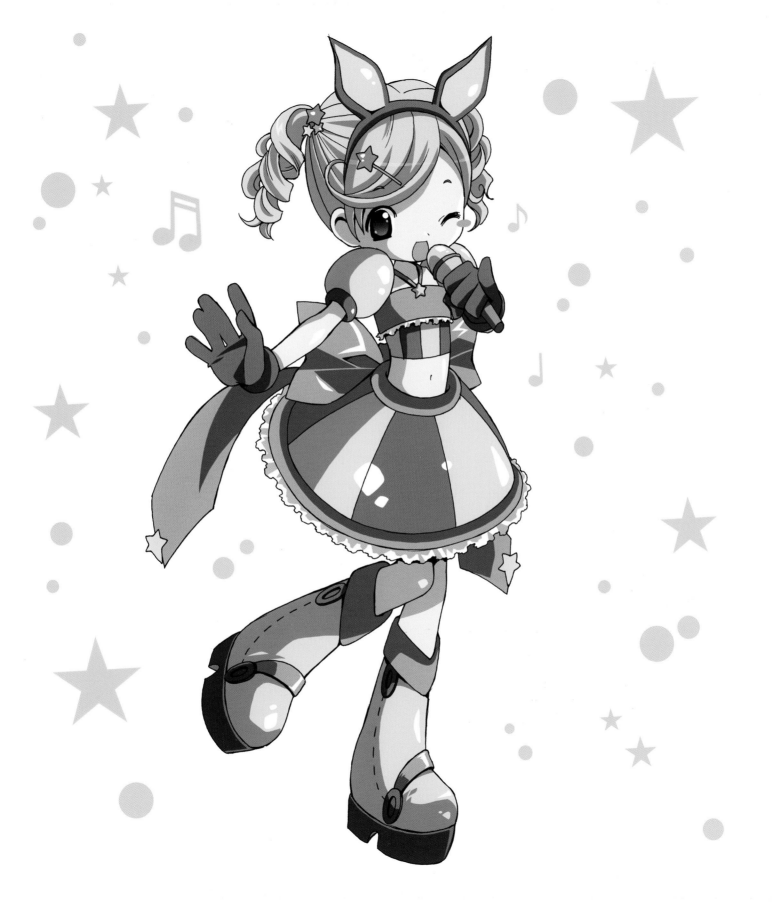

ASTRONAUT

Many people dream of going to outer space. Our little vector astronaut sets out to conquer new planets aboard his spaceship. Even though the whole illustration is digital, the first sketches are made in pencil. They're just rough drafts, so they are not too finished.

1. Sketches

Now we have made up our minds and know what idea we will develop: an astronaut exiting his spaceship and trying to catch a star, like a baby who discovers something new that awakens his curiosity.

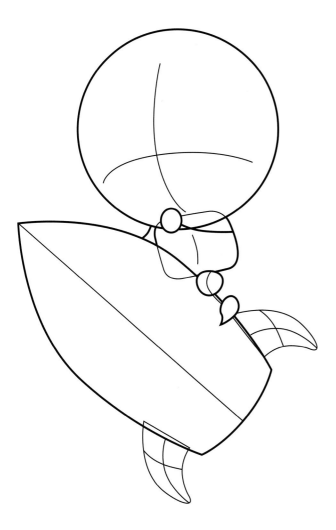

2. Outlining

We start by designing the basic shape of the astronaut and the ship and draw the axes where we will place the rest of the details.

3. Volume

We add the details on the face, the space suit and the ship, using circles.

4. Details

We forgo using a full helmet to make better use of the astronaut's face. The suit has simple lines, but we give it a sense of volume using gradients and adding a few decorative elements. The ship is smaller than the astronaut, but we must keep in mind that we are going for the effect, not realism.

5. Color

We use bluish and maroon tones for the astronaut, and pink, blue and yellow tones for the ship, which make it look like candy.

6.1. Background

Later we will add more elements to the background, such as planets, UFOs and stars. The background is added at the end of the process.

6.2. Background

The image is completed by a radial blended in to recreate space with increased brightness and the addition of new stars.

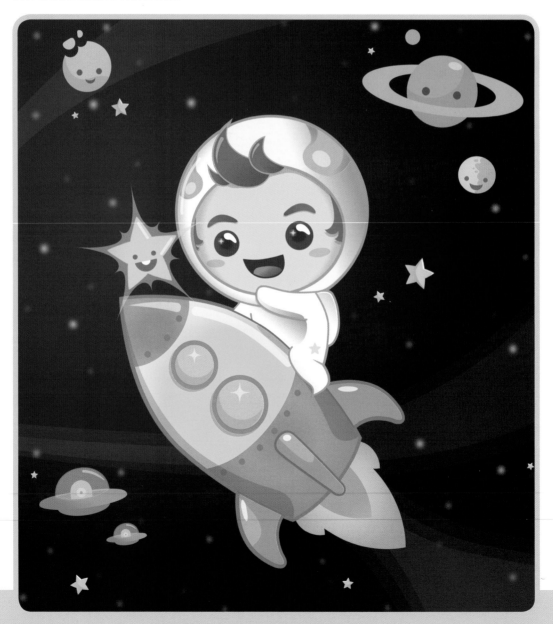

Finishing touches

Tips & tricks

- The latest versions of Adobe Illustrator provide a great number of graphic resources: complex gradients, blurs or layer blending modes that compare favorably to image editing programs like Photoshop.

- The gradients used on the helmet give it volume and make it look more three-dimensional.

- For the background, we use a radial gradient with the middle point off-center, moving it just slightly toward the upper left corner.

- We finish the background with semi-transparent waves and smoke coming out of the ship's nozzle.

- To create the lighting of the face, we draw a circle with the Ellipse tool, fill it with a yellow to white gradient, and make it overlay the astronaut's face using the Soft Light blending mode at 71% . Only these settings can be found in the Transparency window in Adobe Illustrator.

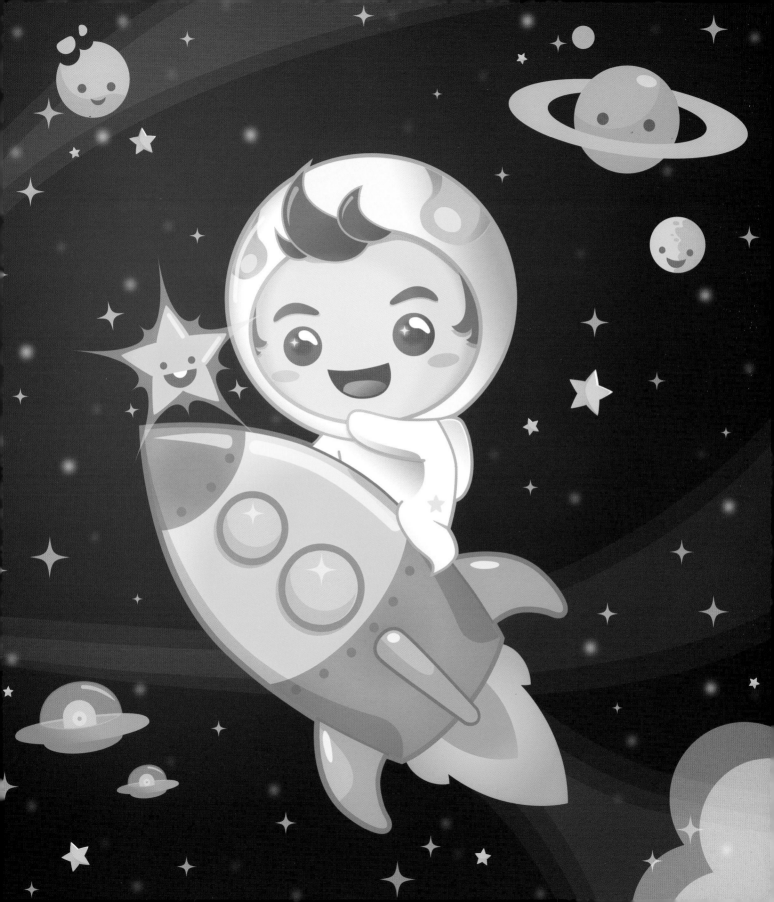

HEALTH CLINIC

If you are feeling ill, remember that our doctors will give you the best possible treatment. They have a great experience with all sorts of stuffed animals, giant syringes and make-believe stethoscopes. Our friendly nurse will give you her caring attention and our doctor will diagnose you in a heartbeat.

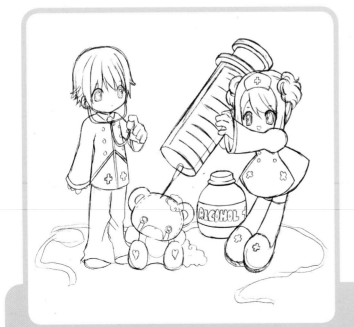

1. Sketches

This is the second version we developed. The first one can be seen at the end of the book, in the Kodomo Gallery. We changed it so that the characters were more comic-like. The idea is to show children playing doctor.

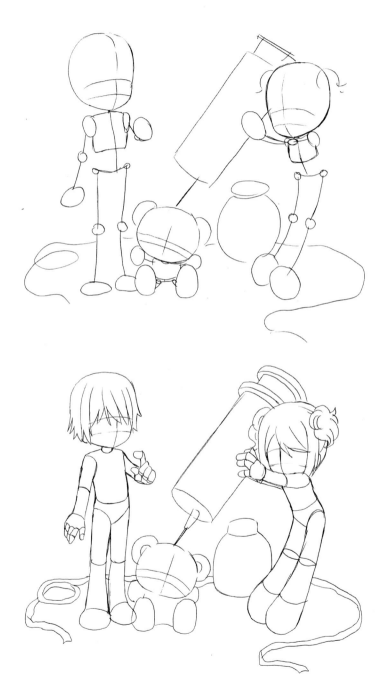

2. Outlining

We give the nurse character an incline to contrast the rigid pose of the doctor. Nevertheless, we tweak the axis of his waist to make him look a little less static.

3. Volume

We also include background elements to achieve a better composition for the illustration.

4. Anatomy

The bodies are as simplified as possible to simulate the look of dolls; their size is four heads, which helps to give that impression.

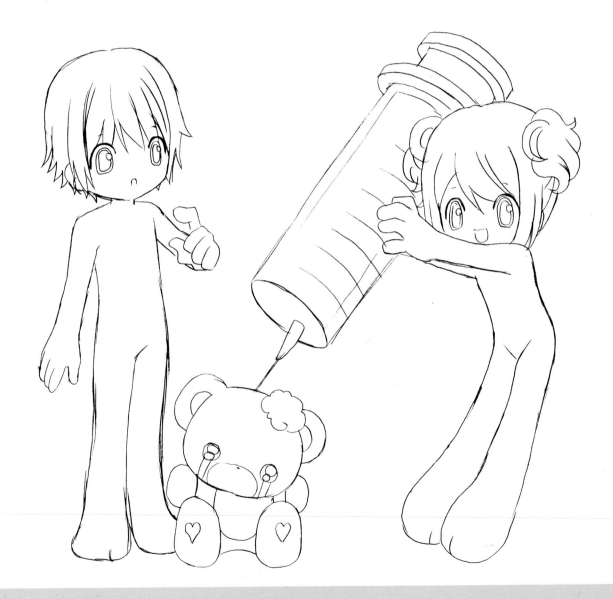

5. Details

The characters' outfits are a reference to a work by the author that took place in a magic boarding school. That is why they look like school uniforms, though they have been customized with details such as a cross and a stethoscope, hinting that they are a doctor and a nurse.

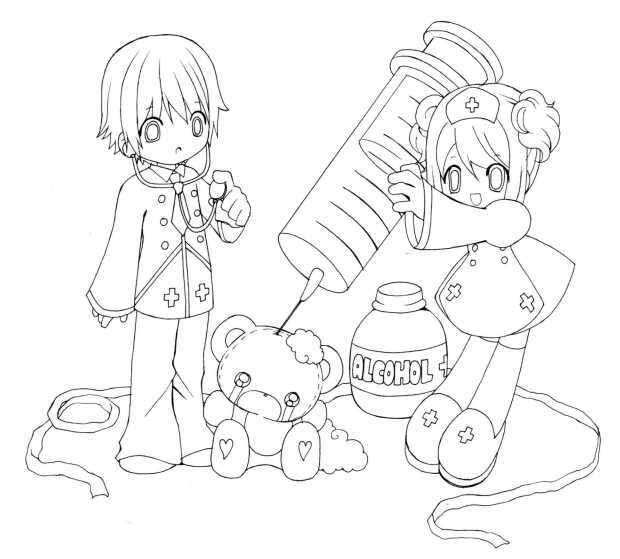

6. Inking and lighting

The light comes from above and hits the characters making colors contrast. The outer contour, thicker than the inner lines, making the characters, homogeneous with the background.

7. Color

We will basically use flat colors. Since both uniforms are white and blue with hints of pink, we differentiate the two characters by their hair color: the doctor's hair will be brown and the nurse will have pink hair.

In the following step we add the highlights on the hair and the shadows on their uniforms, following the wrinkles. The scene is lit profusely, so dark tones will be the exception.

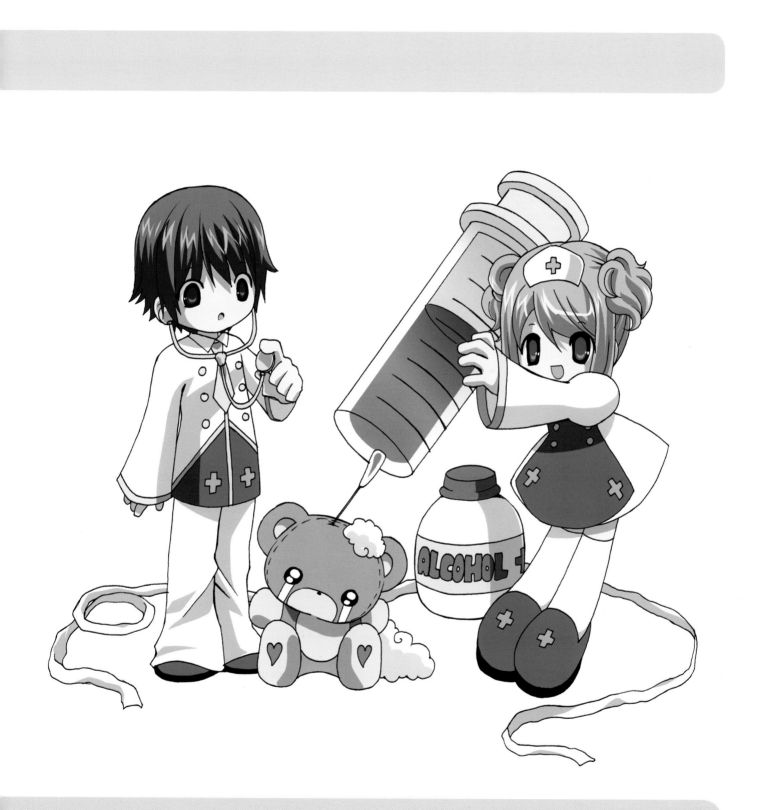

Finishing touches

Tips & tricks

- Although flat colors are predominant in the drawing, we use gradients for the syringe; they give it a colder look but also more volume.

- Red eyes without pupils make the nurse have a crazier look.

- Despite each trade's uniform being very well defined, we can always try to innovate and alter them to our liking.

- We generate a pattern from items one could find in an infirmary: bottles of antiseptic, Band-Aids, bandages, and surgical tape.

- We place the characters over the background, adding a black stroke around them.

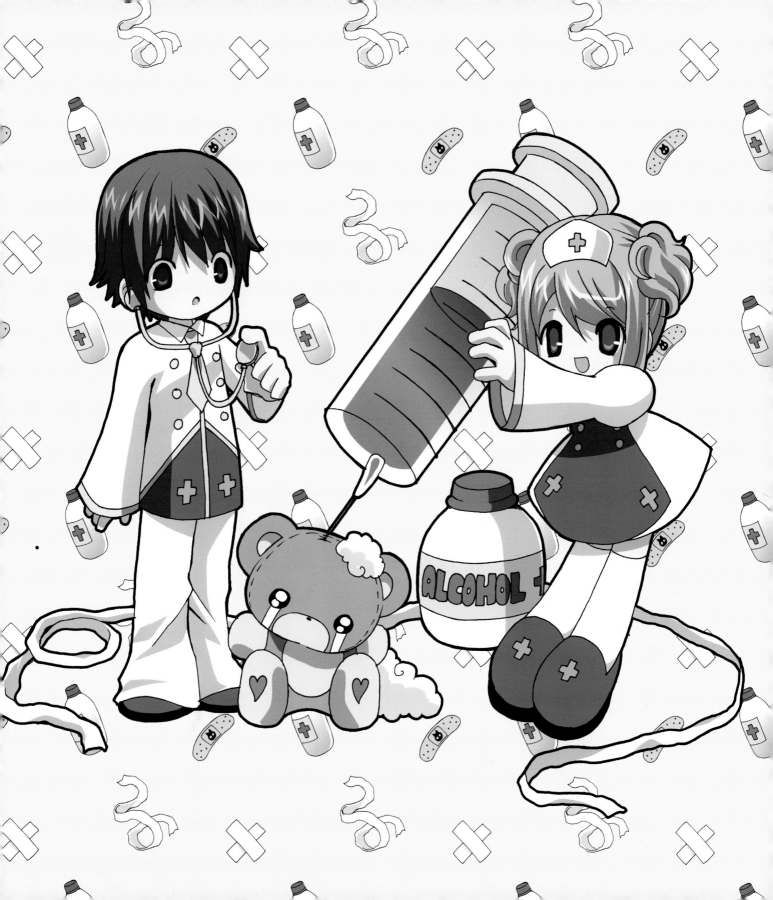

CONFECTIONER

The sweet touch is brought by our confectioner, a cheerful and hard working girl who is capable of giving life to her sweet creations. The illustration has to convey energy and is supposed to make you want to cook all kinds of tasty treats. The line and coloring were made digitally, with a vector illustration program.

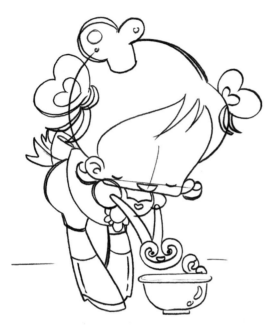

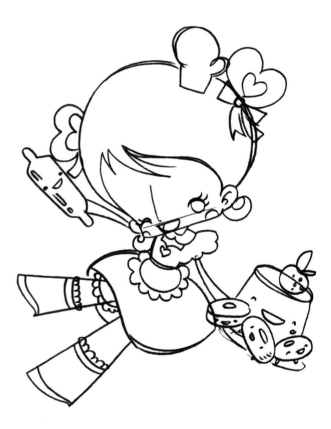

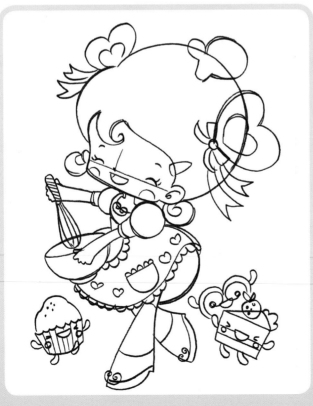

1. Sketches

In this version we see our confectioner in all her glory, with her hands busy and accompanied by cakes that just came out of the oven.

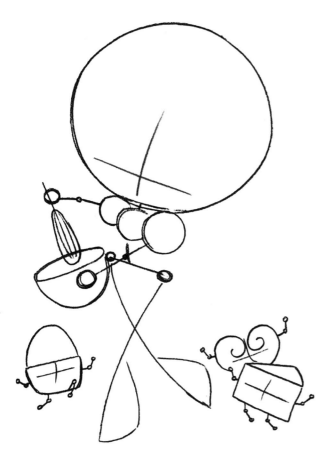

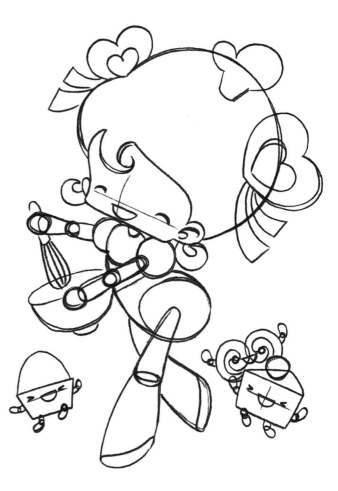

2. Outlining

If we also include the object with which she interacts, it is much easier to draw a pose that shows her beating. Placing the axis of the hip diagonally, we get a more dynamic pose and the feeling that she is walking as she beats.

3. Volume

The space reserved for the facial features is very small compared to the hair, which takes up a great portion of the oval we drew for the head. In the following step we will use this underdrawing as a guide to create the vector line drawing.

4.1. Details

The vector line drawing is now finished. Instead of the typical apron, we choose a full uniform, with pockets for the cooking utensils and pretzel-shaped ornaments on the collar and shoes.

The muffin and the two pastries that accompany the confectioner are also important. The key is to make them look as energetic as she is.

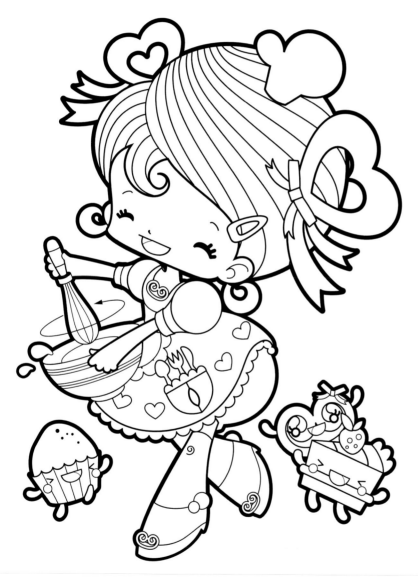

4.2. Details

Like we did with the drawing itself, first we sketch the background with a pencil; we will use it later as a guide to create the vector background. We also include the characters in the scene.

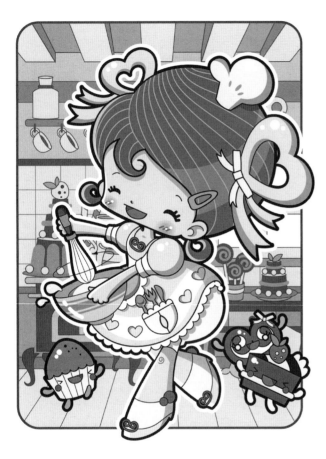

5. Inking and lighting

We should try not to make the image overelaborate with too many shadows. We will only apply them to the main character and dispense with those in the background, using only flat colors on it – no highlights or shadows.

6.1. Color

We emphasize several colors in the scene: yellow, brown, pink, blue, and fleshtone. For the lines in her hair we use a brighter pink and for the outer line a brown tone. In general, we use colors that are related to food: cream, chocolate, and strawberry.

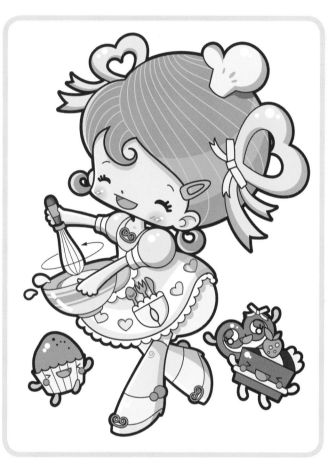

6.2. Color

We apply the rounded shadows with gray and paint two blurred red spots for the blushing cheeks, thus making the character more expressive.

6.3. Color

The highlights are the last step in coloring the confectioner and her sweet sidekicks.

Finishing touches

Tips & tricks

- To illustrate our character's trade better, it is important to include ornamental elements in her costume, such as the pretzel-like pastries, which reflect the mood and emphasize her work.

- If we create the background separately, we can add much more detail, even though they will be covered by the characters.

- Cheeks are a typical characteristic of Kodomo characters, so we do our best when creating them.

- We place our carefully created background.

- We place our characters, adding a white contour around our confectioner to make her stand out from the background.

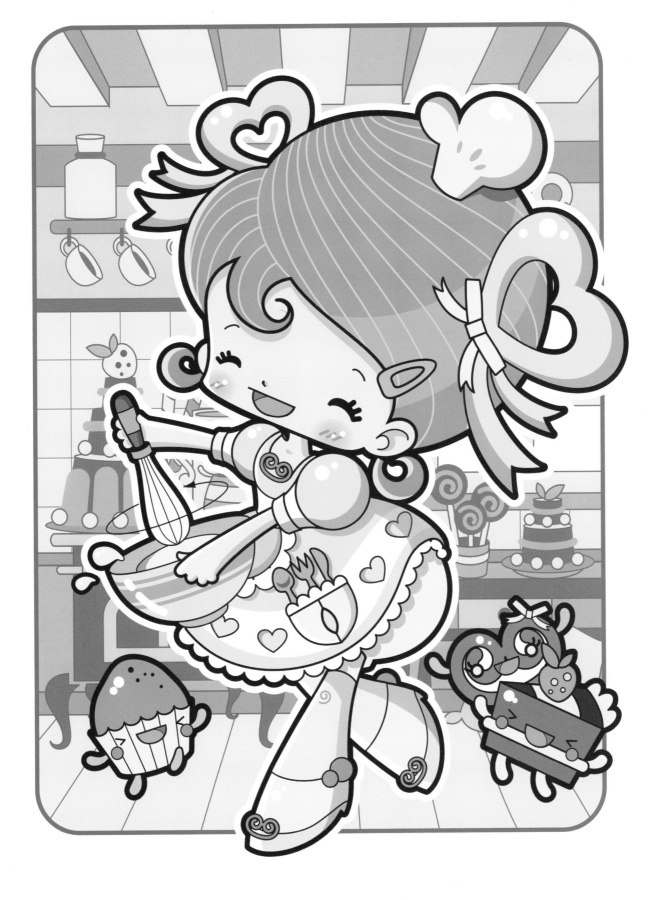

ANIMALS

THE FARM

Tales with animals have always been a source of success in animation, movies, and video games. The idea of looking after a pet, or even training or creating them, appeals to all types of audiences. We will portray a young farmer surrounded by his animals.

1. Sketches

This is the sketch we will develop. In it, the farmer is as prominent as the animals in the farm, and the pose is more dynamic. One feels like going to the countryside to work!

2. Outlining

The central axis of the farmer's body creates a curve, which gives dynamism to the pose. You must remember the movement of arms and legs. If the hand is advancing, then the feet are moving back. The animals are outlined with ovals and we use crosshairs to mark the place for the face and its features.

3. Volume

Besides outlining the details, we add some elements of the attire, such as the hat and the cowbell. It is not necessary that the animals look realistic, but their basic features must be present so that they can be easily recognized.

4. Details

A T-shirt gives the impression of summer weather and the coveralls are perfect for farm work. We add some detail to the straw hat to make it seem worn out.

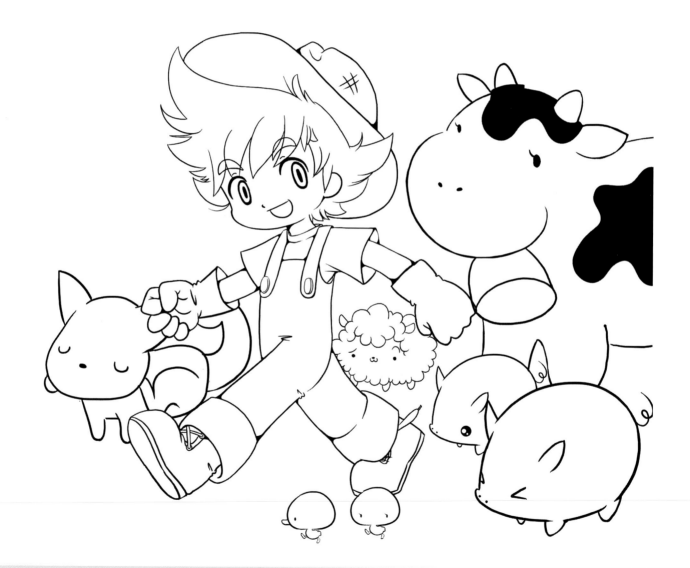

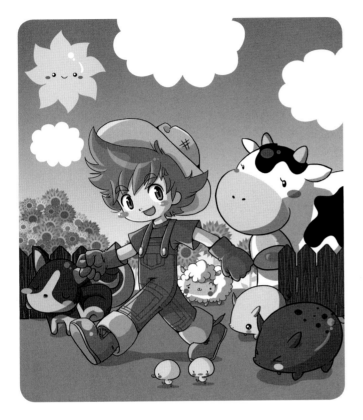

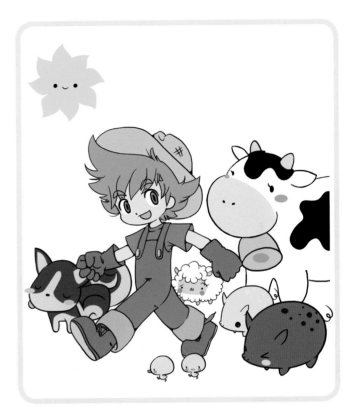

5. Inking and lighting

We reinforce the areas of shadow with thicker inking lines. The scene takes place in a very sunny environment, so we will add many highlights. The sun is in the upper left corner, so that is where light will come from.

6.1. Color

We use mainly warm colors: orange, red, yellow, and various shades of brown. Red and green, blue and orange: these are complementary colors, so we choose a bluish green for the coveralls, which complements both the hair and the T-shirt.

6.2. Color

We apply shadows following the contours of the rounded shapes that dominate the picture. In such a sunny environment, shadows have darker shades of color for a higher contrast. We have also applied a subtle gradient to the eye to enhance its texture.

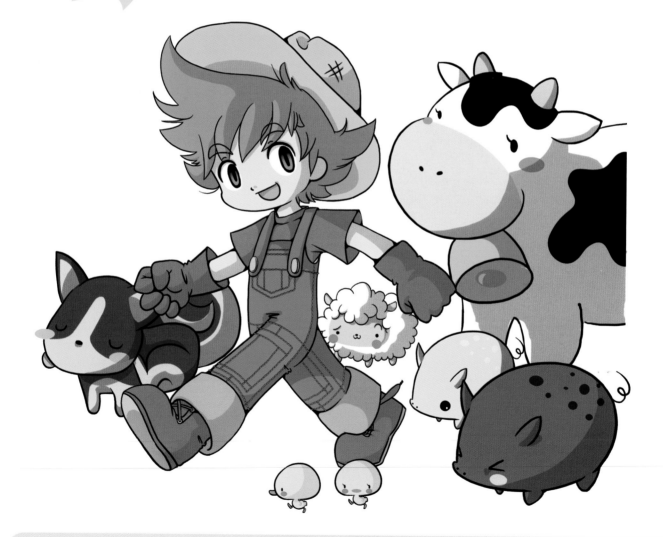

6.3. Color

Highlights help us light the characters and give them volume, thus having greater detail. The picture will have three color tones (highlight, base color, and shadow), something typical of Japanese animation series.

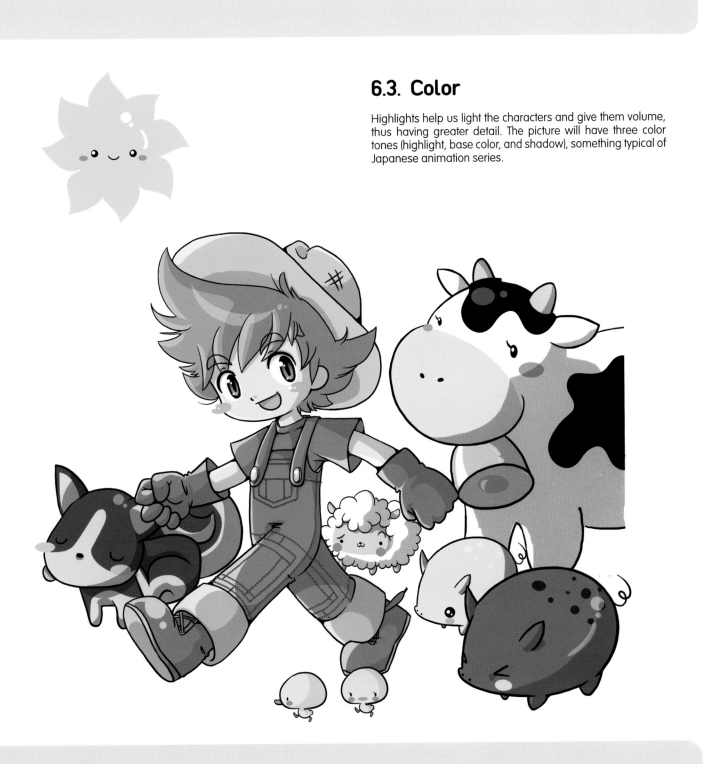

7. Background

We add some elements in the background, such as fences and sunflowers, which give depth and color to the illustration. In the next step, shown on the right, we add the sky, clouds, and grass using shapes filled with color.

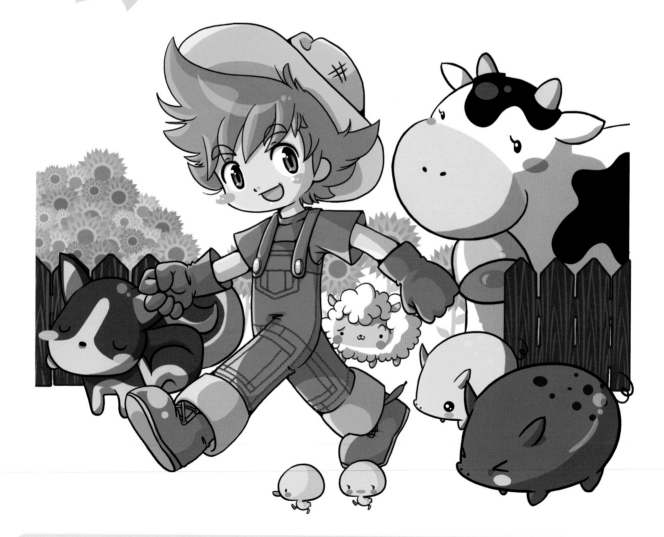

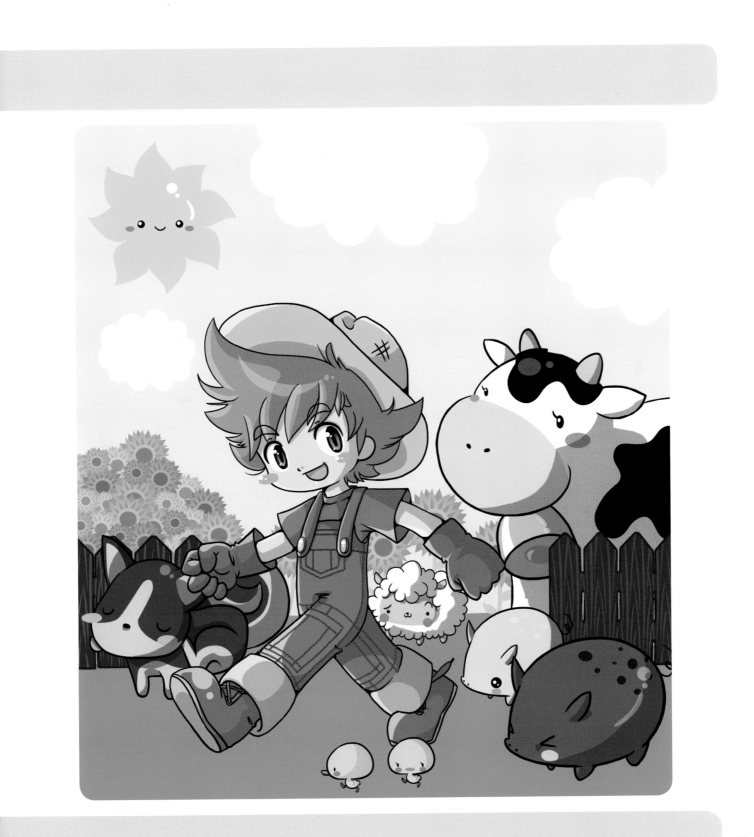

Finishing touches

Tips & tricks

- The key to this kind of coloring is using different layers for each element, and have all of them above the line drawing layer. For instance: one layer for the base color, another for the shadows, a third layer for details (cheeks, gradient of the eyes), and a last layer for the highlights.

- For the highlights in the hair we use the Soft Light layer blending mode set to 20% opacity. For the shadows we use maroon on a layer set to Multiply blending with 20% opacity.

- To create the gradient in the pupils easily we apply the Gradient Overlay effect in the Layer Styles menu. We set the blending mode to Darken, Linear Style, use an Angle of 105° and four colors: black, dark green, green, and white.

- We apply the Gradient Overlay layer style, Normal blending, Linear Style, angle of 90° and two colors: blue and white.

- We add the ground shadows with a darker green set to 50% opacity.

- To create the field of sunflowers we first create several models that we will then clone to make it look populated and varied.

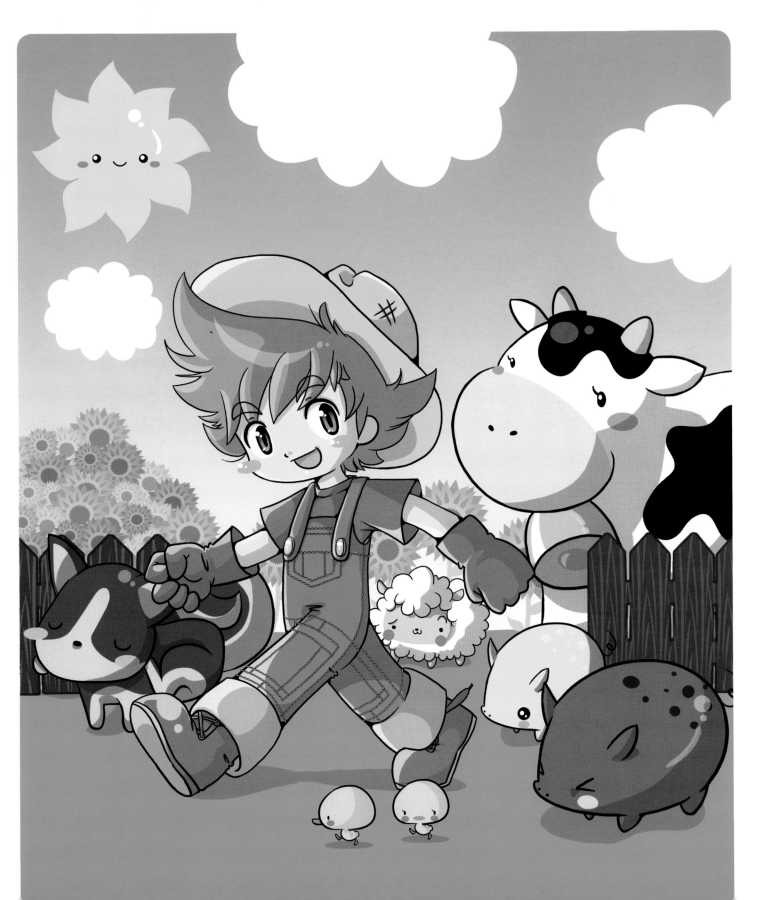

UNDER THE SEA

The bottom of the sea is full of animals that are featured in many illustrations for children. We thought about including a little mermaid as just another character, without her being the star of the image. Looking at the included sketches you can see how the idea evolved and how the drawing and the final look were polished.

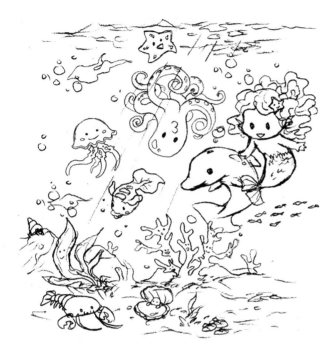

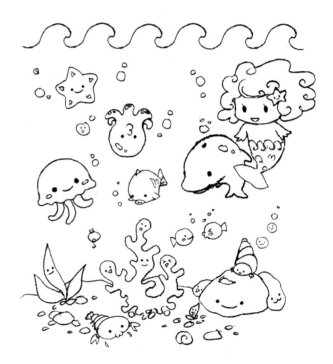

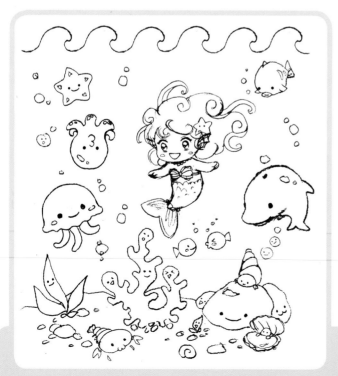

1. Sketches

After a few changes, we decided to give the little mermaid a look more akin to that of comics than illustrations in children's books, while maintaining a minimalistic aesthetic for the other animals.

2. Outlining

This first approach to the illustration allows us to place the objects in space and decide the final composition of the image.

3. Volume

We start with basic shapes based in ovals that we gradually refine and add detail to. Characters need to have a padded feel, like they were bubbles.

4. Details

A pearl necklace, a starfish and two small shells for the bust; that is all the attire a little mermaid needs to swim all over the sea.

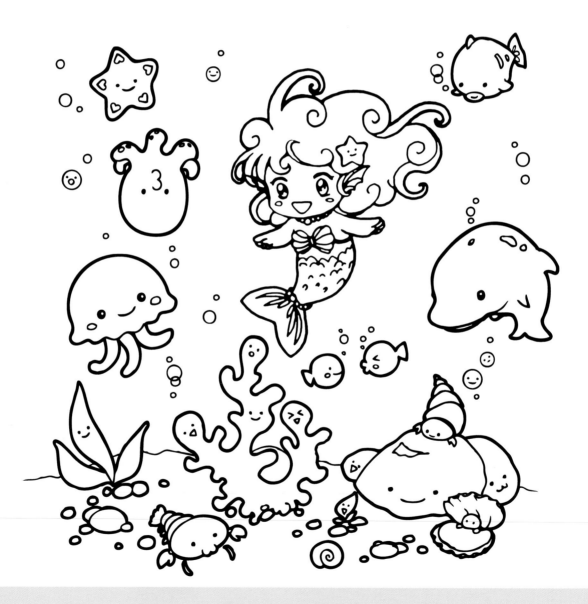

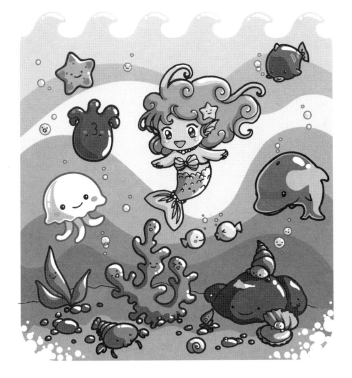

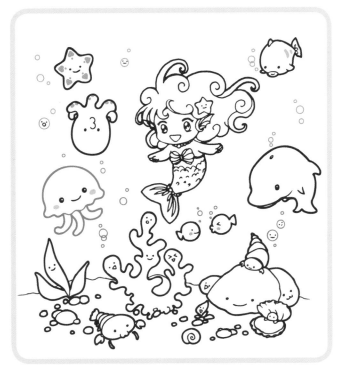

5. Inking and lighting

We converted the line drawing into vector outlines to create a more stylized finish. We imagine that the sun rays strongly light the scene from the right, thus creating areas of high contrast between light and shade, allowing us to play with the oval, rounded volumes of the sea animals.

6.1. Color

Color must have a blue tint to make the characters look like they are actually underwater. To begin, we give the lines a blue color and paint some details with bluish and orangish shades.

6.2. Color

In the following steps we will add respective new layers for the base color, shadows (set to Multiply blending mode) and white highlights (in Normal, Screen or Lighten blending mode).

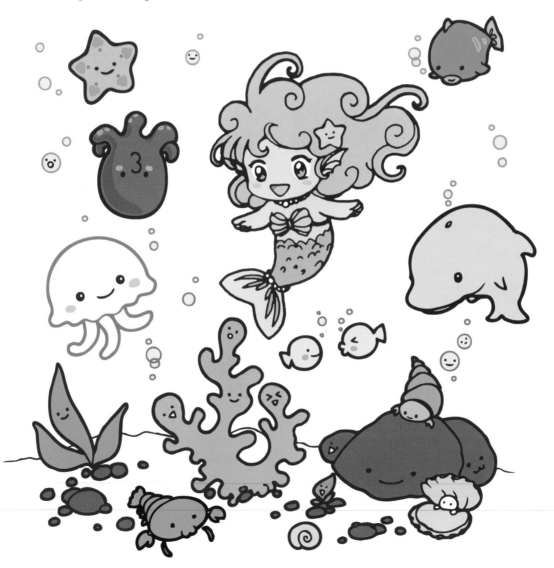

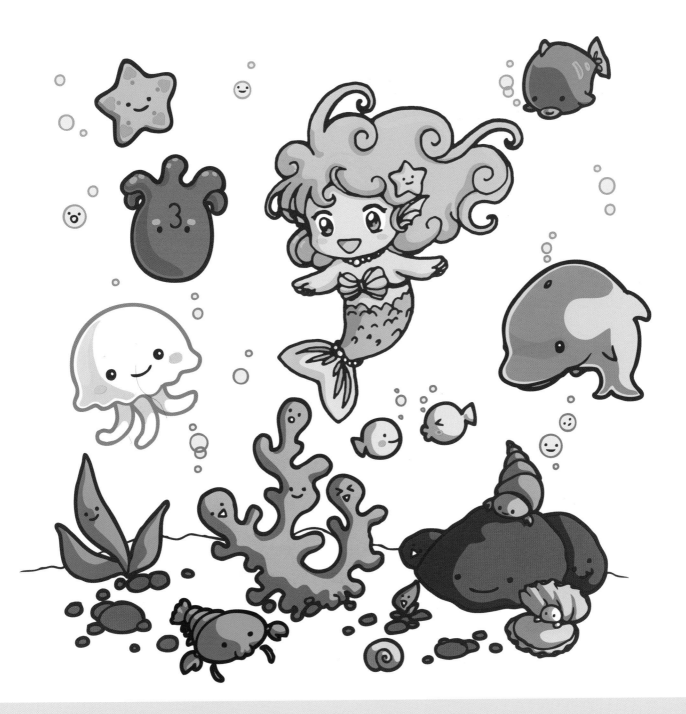

6.3. Color

As a final step, we draw the background digitally using wavy shapes created with vector drawing elements.

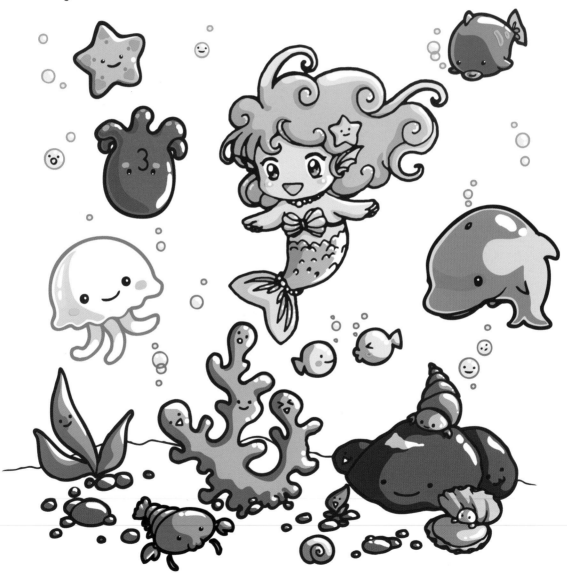

7. Background

Lastly, we digitally draw the background using undulating shapes created with the aid of vector graphics.

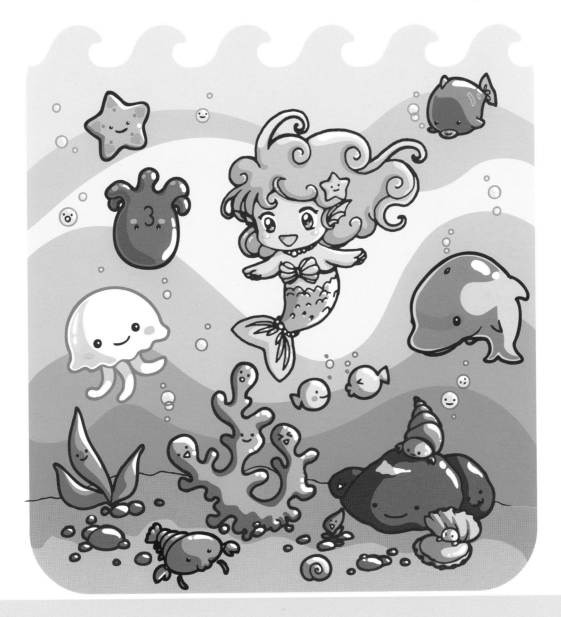

Finishing touches

Tips & tricks

- We add several white strokes in the lower corners of the illustration to simulate the look of bubbles.

- If we leave a space between the line and the shadow, the character gives a greater impression of volume, even though we are using only flat colors.

- We use two tones for highlights: a lighter shade of the original one, and a touch of white to give the image more light and volume. This is a commonly used in Japanese creations.

- There are many ways to create a vector outline from the line drawing. Vector drawing programs include automated tools to create vector drawing from bitmaps, but Adobe Photoshop CS3 also has the option to convert a selection into a vector outline. If we select all the black lines in the drawing, we can create a vector version of them.

- It is much easier to color lines in a vector drawing, as we only have to specify a color for the stroke. In other types of coloring software, the usual process means selecting the lines and filling the selection with the desired color in a new layer.

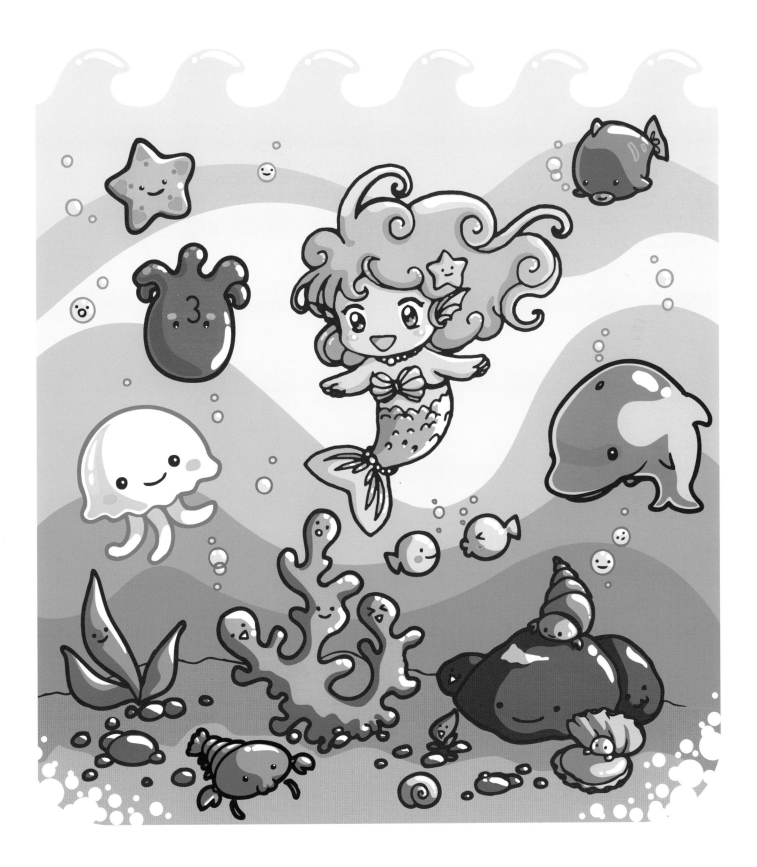

IN THE WOODS

Here, the only characters in the scene are these cute and lovable animals, out for a picnic in the woods. Their basic structure is based on simple geometric shapes, so it should not be too complicated to sketch them. The key is to make them look like stuffed animals, so the picture has to be as simplified as possible.

1. Sketches

Panda bears and rabbits are two of the most frequent animals in Japanese illustration. The sparse woods depicted here help the central scene to stand out and make the image look like it was taken right out of a children's book.

2. Outlining

The ovals that make up the heads of both animals have their lower halves flattened. To be precise, the upper half is twice as wide. The horizontal and vertical axes help us to place face features and also to split the available space.

3. Volume

We place eyes and mouth as close to each other as we can, thus achieving a more amiable expression. It is important to draw rounded shapes, without any corners.

4. Pencil

Once the drawing is defined, we erase the basic elements we used to construct it and emphasize the final lines, as well as the areas that will end up being darker. To prepare for an easier coloring process, we also use pencils to create gradients that will later act as a reference.

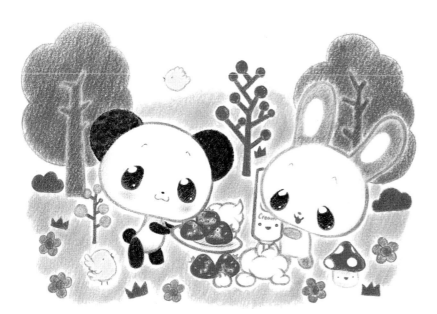

5. Lighting

Since we are working on an illustration that will have very vivid colors, we have to remember to leave some darker spots that will add richness to the image. We will also leave a subtle white margin around the characters to make them stand out from the background.

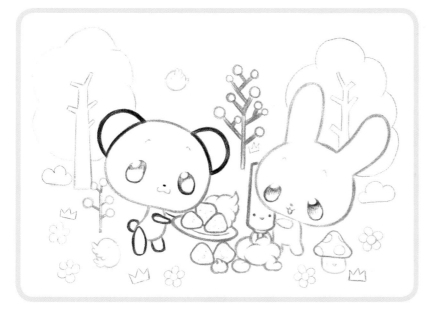

6. Color

All the line drawing is also colored, so we draw over the original line drawing with a slightly darker color than the one we will use for the inside.

Finishing touches

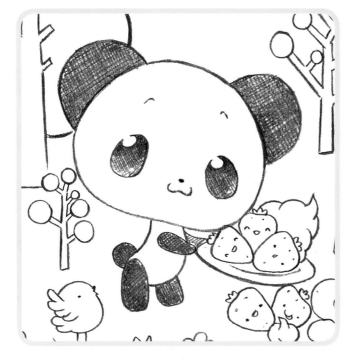

Tips & tricks

- The easiest way to create an illustration with colored lines is to use the finished pencil line drawing as a guide, tracing the image on a different sheet of paper using color pencils or inks.

- Once the line is colored, we fill in the interior and finish the details.

- When we scan the final illustration, it is best to do so using high resolutions, above 600 dpi, so that the texture from the pencils remains.

- Scanned images are saved as RGB, but for printing they must be in CMYK format, so we will have to convert them.

- When we convert an image like this from RGB to CMYK, light colors tend to get dull; we must try to retouch it with the editing software of our choice to try to make the image as faithful to the original one as we can.

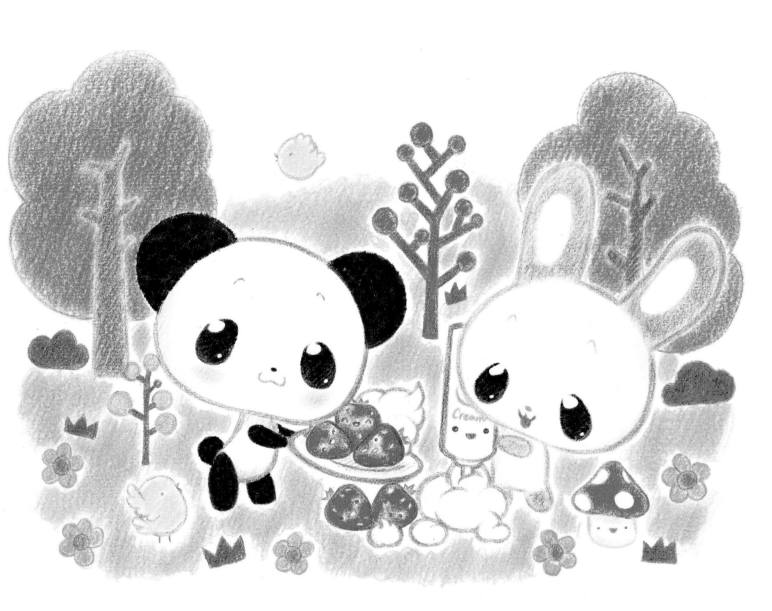

THE CIRCUS

The initial idea, as you can see in the image below, was to depict a circus of magical creatures, but in the end we went for a more realistic approach. We depicted a majorette surrounded by animals in a circus tent. It is an entertaining and dynamic scene.

1. Sketches

This character layout is more distinctive and complete, even though we are losing some details on the horse, since we are playing with a greater depth and space between the majorette and the other characters.

2. Outlining

The girl has a body that is three times the size of her head.
The animals are easier to construct from simple shapes.

3. Volume

The majorette's face is angular, whereas all the animals' faces are
rounded. This adds to the variety and contrast of the illustration.

4. Details

Besides the young girl, the animals are dressed as well, so we will try to create similar designs for all of them, but adapted to their respective sizes and anatomies.

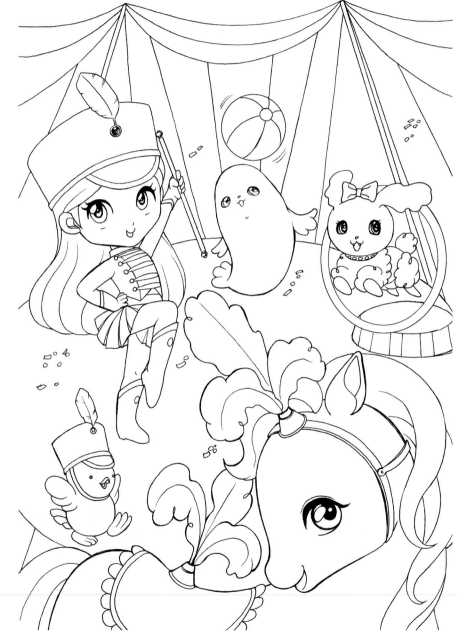

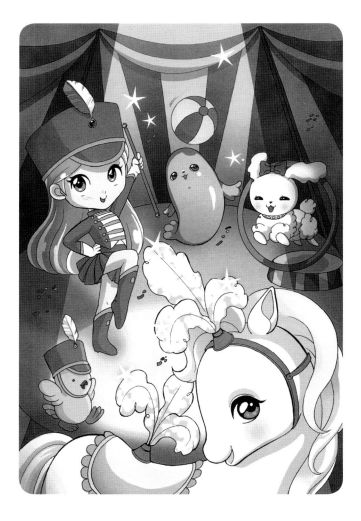

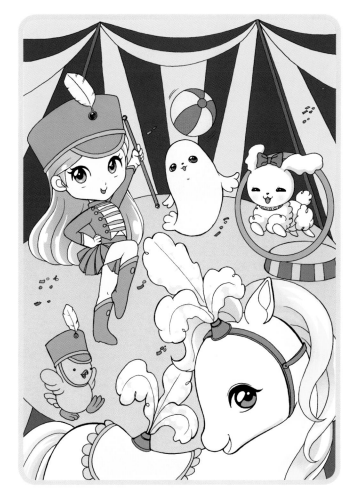

5. Inking and lighting

The central light source gives life to the scene, and takes us to the world of the circus. We add a few star-shaped twinkles and pay attention to the position of the shadows, because we have several characters in different places. We have to create the impression of different areas of light and shade, without losing detail in dark areas.

6.1. Color

In an illustration like this, with a great variety of characters and colors, we must try to find a balance of warm and cold colors, as well as the complementary ones. If a big portion of the illustration has red and yellow tones, we will add greenish and bluish colors as a counterpoint, to balance the scene.

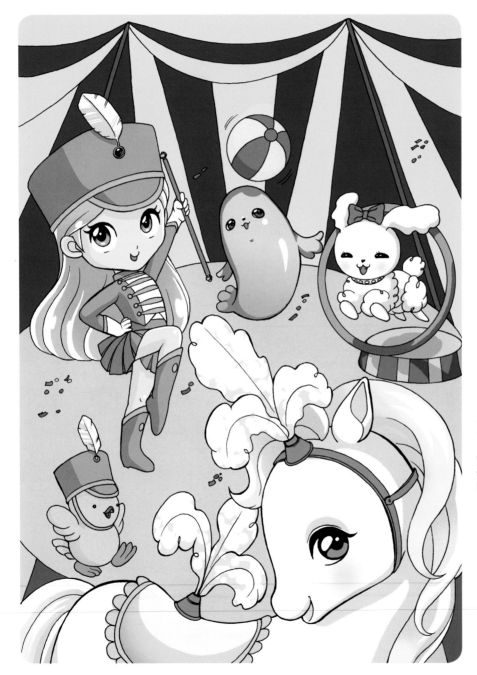

6.2. Color

We color general shadows and highlights taking into account the position of the light source.

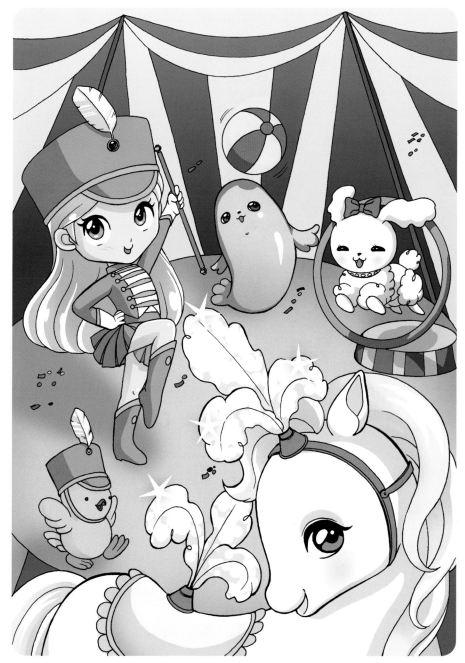

6.3. Color

We place a spotlight creating an overlaid white gradient that will lighten the upper part of the tent. We add the first highlights on the horse with a yellowish glare and paint blurred shadows on the ground.

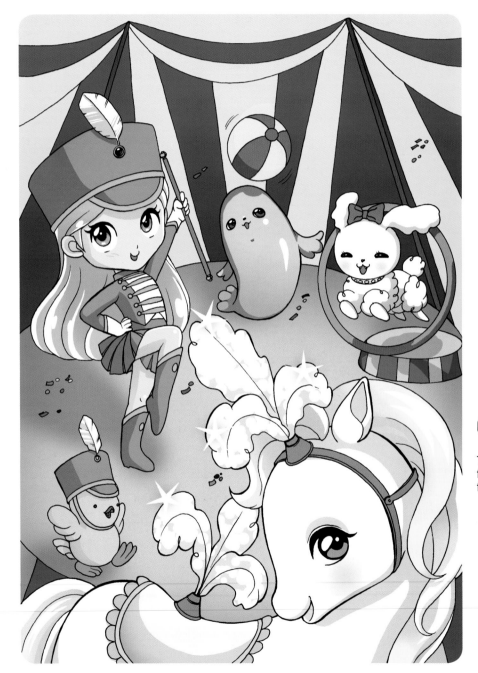

6.4. Color

The illustration is more detailed now; at this point we shift some colors, correct them and unify tones.

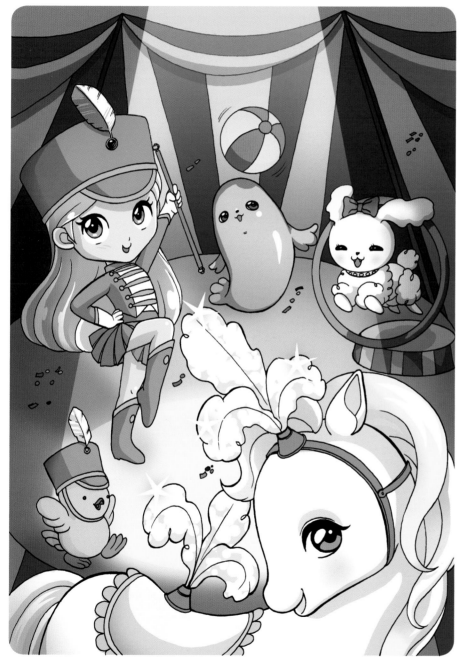

6.5. Color

Once the light cone emitted by the light source has been added, background colors turn warmer and the scene reaches a higher level of intensity.

Finishing touches

Tips & tricks

- In an illustration as complex as this one, we need to use a base layout as a guide or reference. We can do this using a pencil to mark the shadowed areas, or directly on the computer by testing colors.

- The secret to creating the light cone lies in the use of different layers, tones, and masks that define the area affected by that object, so it will only affect the background, not the characters.

- Another necessary feature is provided by the layer blending modes, which we can experiment with until we find the desired effect.

- We add more star-shaped twinkles to the picture's background.

- We darken the shadows on the ground to achieve a higher contrast.

- We harmonize the atmosphere of the background using maroon and brown tones that give the tent a warmer touch.

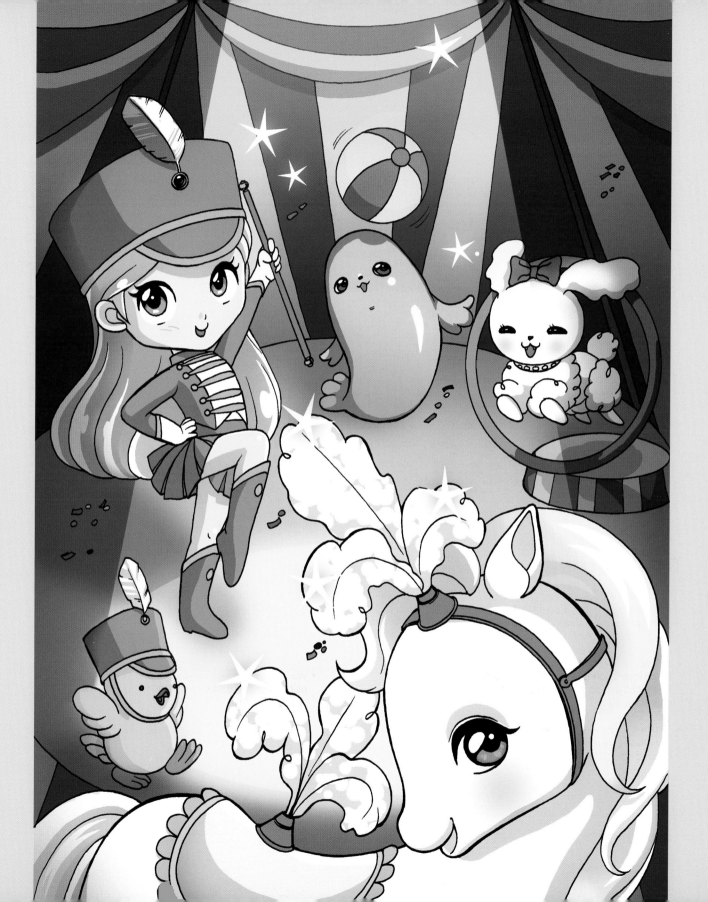

SAFARI

A scene with animals of the African savannah can be portrayed in multiple ways. We will try to create the most amusing one. The aesthetics is close to that of Japanese children's books, having a simpler finish which we will compensate with a more detailed coloring that imitates watercolor.

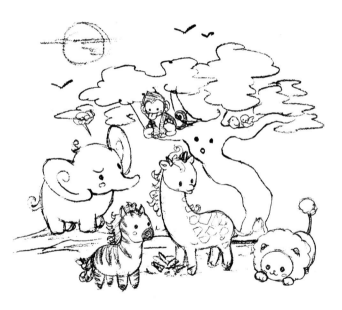

1. Sketches

Our common idea of a safari includes a lot of animals running in front of a pursuing Jeep.

2. Outlining

We draw the basic structure of each animal using simple, schematic lines, giving them a stretched pose so they seem to be running.

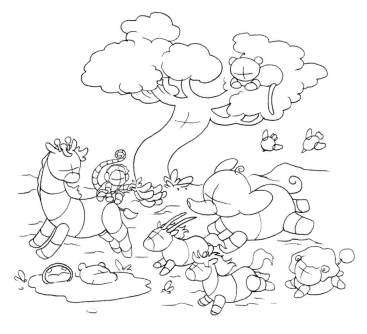

3. Volume

The animals must look padded, so we will make extensive use of rounded shapes.

4. Anatomy

The animal characters are drawn like toy animals and end up looking somewhat chubby.

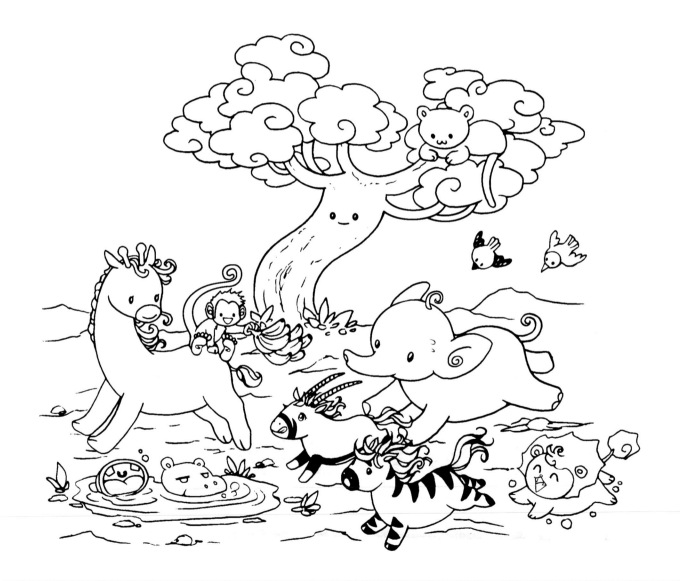

5. Inking and Lighting

The thin lines practically disappear after applying color to the image. The sunlight at dusk softens both highlights and shadows, producing a relatively homogeneous tone, without much contrast.

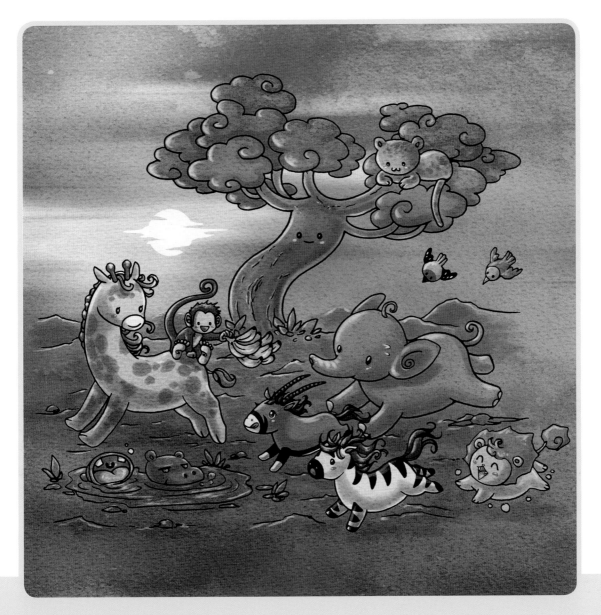

6.1. Color

Ocher-like tonalities are predominant in this scene, as in sunset. We provide a sense of warmth, without losing the original colors of the animals.

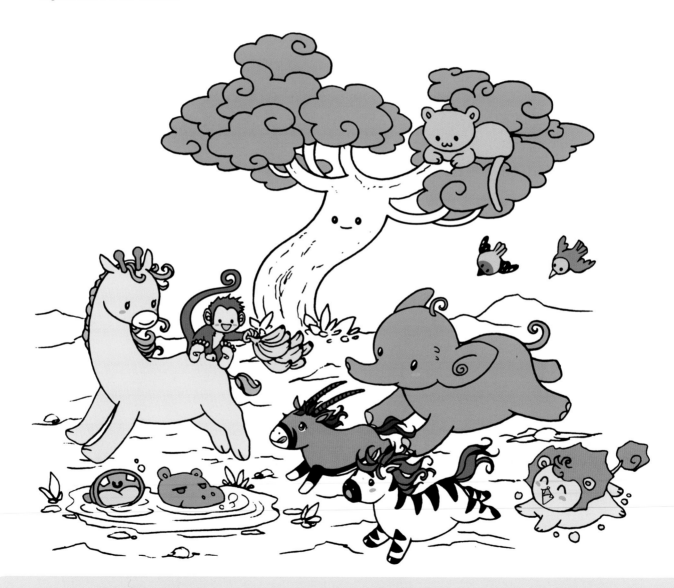

6.2. Color

We create shadows with a soft brush, applying diluted strokes as if we were working with watercolors, making sure to leave some areas untouched, which will have a lighter color.

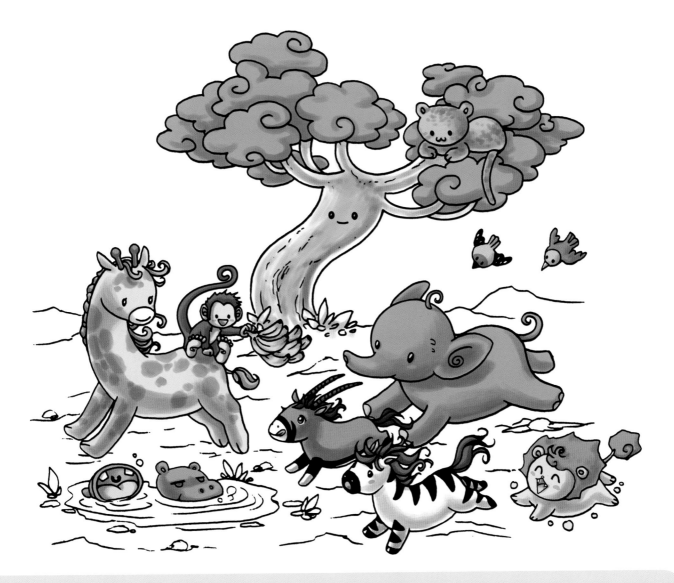

6.3. Color

Using a light color we apply strokes to create the highlights on animals.

7.1. Background

The next step will be adding to the background the gradient that recreates the clouds and the ground in this misty atmosphere at dusk in the savannah.

7.2. Background

We apply two different textures to the
surface of the image.

Finishing touches

Tips & tricks

- To achieve the background's misty look, first we apply some strokes with warm colors, typical of a sunset; then we apply a motion blur filter that will yield the right look.

- We can make the drawing look organic and hand-made by applying two textures: a watercolor paper texture using the Overlay layer blending mode, and a paint stains texture using the Hard Light layer blending mode.

- We finish defining the lighting on the animals with a few additional highlights that were previously attenuated by the blended textures we applied earlier.

- These visual tweaks and retouches are necessary when we work with textures; otherwise we may lose some detail applied in the coloring phase.

EXTRA

Artists
Kodomo gallery
Credits

Artists

Alicia Ruiz

Hardened in the world of dôjinshis, she began publishing the manga series *Yaruki! St. Cherry High School* at the same time as her sister, totalling five published volumes. But what really made her an acclaimed artist have been online video games and the fan arts she creates from characters of her favorite series.

Web: www.cursedmoons.com
Specialty: Manga moe

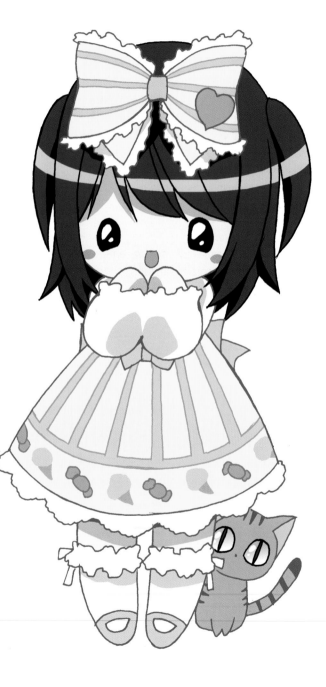

Àneu Martínez

Besides working as a designer for companies like La Caixa or Grangel Studio, she has made illustrated Flash games for Wambie.com, Christmas cards for Tourline Express and showcased her work in exhibitions at different venues in Barcelona. Her latest professional foray has seen her creating a series of illustrated banners for a web-based project developed by the transnational Kiwi, a manufacturer of shoe products.

Web: www.aneumartinez.com
Specialty: Vector illustration for advertisements and kodomo illustration, corporate identity, and character design.

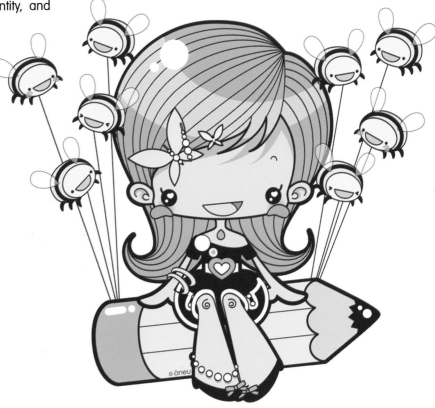

Artists

Aurora García

Her first works were the monthly series *[Lêttera]*, published in the magazine *Shirase*, and a series called *Garou-chan* in collaboration with her colleague Diana Fernández. Years later, they landed on the American market with two yaoi pieces that were also licensed for publication in various European countries: *Saihôshi* and *Stallion*. *Saihôshi* received the Expocómic award "Best Manga by a Spanish Author" in 2006. Her most recent work is a series called *Daemonium* for the publishing house TOKYOPOP. In the field of illustration, she has been commissioned work for the magazines *Maxim* and *Rolling Stone*, two learning books by Norma Editorial: Japonés en Viñetas 1 & 2, and *"How to Draw..."* books by Christopher Hart, to name a few; others include work for music albums by bands or singers such as Ailyn, Firestorm or Charm.

Web: www.stkosen.com
Specialty: Manga and illustration.

Belén Ortega

Her career began with illustration and manga for independent publications such as *Sugoi Magazine, Ohayo!, Generación sur* and magazines focused on manga & anime like *Shirase, Dokan* or *Minami*. During these first few years, she did some outstanding work for several music albums, including *Vitek Anime Music Experience, Melodía Eterna* by Ailyn, *En lo profundo del bosque* by Charm and *Maison Ikkoku las canciones de la serie*. Her illustration work has been in magazines, posters and promotional imagery for diverse events, as well as some work for a role-playing game by Anima Proyect Studio and the website Wambie. com. As a manga illustrator, she has achieved recognition through her work Himawari, which received awards at different competitions. She perfected her knowledge at the Human Academy of Osaka, thanks to a grant awarded by the Fine Arts Faculty of Granada.

Web: www.chiisa.deviantart.com
Specialty: Graphic design, illustration, and video editing.

Artists

Bénelo Nsé

He started his career sending drawings to specialized video game magazines, which slowly helped him build a reputation. He specializes in vector design. His most important works have been illustrations for *Chupachups'* special edition Asian flavors range, character design and a manga called El Mundo de Line (Line's World) for *Line Magazine* as his Flash games for Wambie. This has allowed him to specialize, creating a small company that does character design work for companies combining kodomo illustration with web design media, and entering other fields like digital photography. His illustrations and designs have been featured in publications such as *Art Media, Como tú, Grupo Zeta, Arte & Diseño, Yeah! Fanzine*, and *Vectortucs*.

Web: www.sugarnines.com
Specialty: Design and kodomo vector illustration.

Eli Basanta

Her work has been shaped by two specific projects: the manga titled IN DREAMS, published in the *Misión Tokio* magazine, and posters for the events promoted by the TV network Canal Buzz. She specializes in design illustration, and has a versatile style that allows her to work with all kinds of techniques and finishes, digital or traditional. She has done illustration work for albums such as *Melodía Eterna* (Eternal Melody) or *Maison Ikkoku: Las canciones de la serie* (Maison Ikkoku: songs from the TV series), Flash games for Wambie.com, and has also been hailed as one of Spain's finest manga illustrators. She has given specialized drawing and coloring lessons during many manga-related events and has had her work featured at several exhibitions.

Web: www.elibasanta.com
Specialty: Realistic manga, shojo, and design illustration.

Artists

Helena Écija

Her first work that was released nationally was the design of the animated version of the host of a TV show called Diario del Analista Catódico, which aired on the network *La Sexta* in 2005. Her creations have been published on the Internet, where she shines as a game designer. She lives in the United States, where she attended The School of the Art Institute of Chicago, and is currently working as an illustrator at a U.S. toy maker.

Web: www.helenaecija.com
Specialty: Manga for teenagers and illustration for kids.

Inma Ruiz

She became known in Spain thanks to the series *3x1*, a 6-volume manga for teenagers. Her work as a mangaka and illustrator has earned her the Best Spanish Manga Award of 2005 at Madrid's Expomanga, and she also won the annual manga contest at Ficomic on two occasions. After winning the annual manga contest organized by *Norma Editorial*, she is finishing her new title for that same publishing house: *O.U.T.*

Web: www.golden-nights.com
Specialty: Manga for teenagers.

Artists

Irene Rodríguez

Back in 2003, she won her first comic contest at a manga expo, the 4th Salón del Manga in Jerez de la Frontera, Spain, and then again in 2007 she won 1st place in the 13th Comic Contest in Ciudad de Dos Hermanas. She had previously shown her work in publications for manga enthusiasts, like *Nimbus*. In 2008, she was in charge of the poster for an event called Primeras Jornadas de Manga y Anime de la Ciudad de Sevilla (a conference on manga and anime held in Seville), after which she embarked on her first manga project (still in preparation as of this writing): a series of monthly magazines.

Web: www.irenerodriguez.net
Specialty: Illustration for kids and teenagers, manga illustration.

Miriam Álvarez

After becoming one of the most recognizable illustrators of manga and anime magazines, her work was seen in publications such as *Ohayo!*, *Dokan*, *Kame*, and *Dokan*. She specialized in video editing and did some work for Calvin Klein and KLB Studio. As a designer, she excels in logos, flyers, brands, and photo retouching. One of her latest pieces of work has been illustrations for games for the website *Wambie.com*. She has also worked in the fashion industry, doing illustration work for the childen's clothing lines Magic kids and Coolhunter, as well as designing patterns for the brands Harry and Arviva.

Web: www.mimiloverwomen.deviantart.com
Specialty: Graphic design, illustration and video editing.

Artists

Rosa Iglesias

She began her career in 2000 in the animation industry, working in a company called Animacor. She then specialized in the field of 3D, and worked for documentaries, video games, only animation short films, and films such as *Dragon hill 2, the magic cube* and *RH+, el vampiro de Sevilla*. After that, she joined Kandor Graphics, where she worked for the feature-length 3D animation film *Góleor, la balanza y la espada*.

Web: www.my3dblog.blogspot.com
Specialty: 3D design and modeling.

Kodomo gallery

Nursing
Illustration: Alicia Ruiz

Fruitnines
Illustration: Bénelo Nsé

Monster of the sea
Illustration: Bénelo Nsé

Maui Wambie
Illustration: Bénelo Nsé

My diary
Illustration: Eli Basanta

Piggybank
Illustration: Bénelo Nsé

Lolita in Arcadia
Illustration: Eli Basanta

Otaku Expression BCN
Illustration: Eli Basanta
Background: Rubén García

Siren
Illustration: Miriam Álvarez

Diary Girl
Illustration: Àneu Martínez

© àneu 2008

Baby Mia
Illustration: Àneu Martínez

La belle Isabelle
Illustration: Àneu Martínez

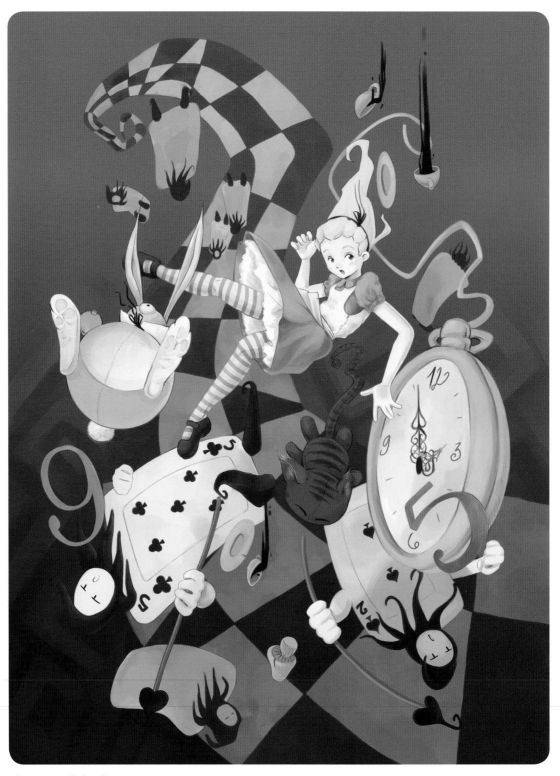

Alice in Wonderland
Illustration: Helena Écija

Aviatrix
Illustration: Helena Écija

Pastel and Misaki
Illustration: Alicia Ruiz

Gogi and Gobo
Illustration: Inma Ruíz

Chibi
Illustration: Inma Ruíz

Fangirl
Illustration: Inma Ruiz

Ravenclaw
Illustration: Inma Ruiz

Kawaii skull
Illustration: Miriam Álvarez

Ice cream of strawberry
Illustration: Miriam Álvarez

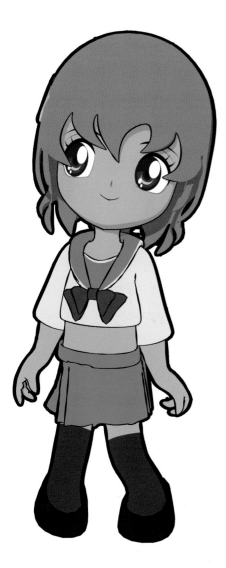

Kochan 3D
Illustration: Rosa Iglesias

Credits

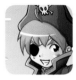

Sleeping Beauty
Inma Ruiz

Pirate of the Caribbean
Helena Écija

Little Red Riding Hood
Eli Basanta

Alice
Àneu Martínez

Snow White
Line and color: Irene Rodríguez
Final adjustments: Eli Basanta

Wizard
Inma Ruiz

Elf
Line and color: Alicia Ruiz
Background: Rubén García

Angel
Irene Rodríguez

Fairies
Eli Basanta

Dragon warrior
Belén Ortega

Orange sprite
Original illustration: Bénelo Nsé
3D: Rosa Iglesias

Halloween
Alicia Ruiz

Vampire
Aurora García

Haunted house
Line and color: Inma Ruiz
Final adjustments: Eli Basanta

Devil girl
Inma Ruiz

Ghost temple
Aurora García

Batter
Belén Ortega

Adventurer
Miriam Álvarez

Ninja and Samurai
Belén Ortega

Kodomo Island
Bénelo Nsé

Master of cards
Aurora García

Dino-hunter
Belén Ortega

Super Cowboys
Line and color: Inma Ruiz
Background: Rubén García

Magic postman
Inma Ruiz

Idol
Alicia Ruiz

Astronaut
Bénelo Nsé

Health clinic
Alicia Ruiz

Confectioner
Àneu Martínez

The farm
Miriam Álvarez

Under the sea
Aurora García

In the woods
Irene Rodríguez

The circus
Line and color: Irene Rodríguez
Final adjustments: Eli Basanta

Safari
Aurora García